Food Design

teNeues

Editor in chief: Paco Asensio

Editor: Oscar Asensio (www.lineaeditorial.com)

Art director: Lorena Paula Damonte

Layout: Lorena Paula Damonte, Cris Tarradas Dulcet

Text: Cristian Campos

English translation: Jane Wintle

French translation: Marion Westerhoff

German translation: Susanne Engler

Italian translation: Donatella Talpo

Published by teNeues Publishing Group

teNeues Publishing Company
16 West 22nd Street, New York, NY 10010, USA
Tel.: 001-212-627-9090, Fax: 001-212-627-9511

teNeues Book Division
Kaistraße 18, 40221 Düsseldorf, Germany
Tel.: 0049-(0)211-994597-0, Fax: 0049-(0)211-994597-40

teNeues Publishing UK Ltd.
P.O. Box 402, West Byfleet, KT14 7ZF, Great Britain
Tel.: 0044-1932-403509, Fax: 0044-1932-403514

teNeues France S.A.R.L.
4, rue de Valence, 75005 Paris, France
Tel.: 0033-1-55766205, Fax: 0033-1-55766419

teNeues Iberica S.L.
Pso. Juan de la Encina 2-48, Urb. Club de Campo
28700 S.S.R.R., Madrid, Spain
Tel./Fax: 0034-916 595 876

www.teneues.com

ISBN-10: 3-8327-9053-5
ISBN-13: 978-3-8327-9053-0
© 2005 teNeues Verlag GmbH + Co. KG, Kempen

Editorial project: © 2005 LOFT Publications
Via Laietana 32, 4º Of. 92
08003 Barcelona, Spain
Tel.: 0034 932 688 088
Fax: 0034 932 687 073
e-mail: loft@loftpublications.com
www.loftpublications.com

Printed in Spain

Bibliographic information published by
Die Deutsche Bibliothek.
Die Deutsche Bibliothek lists this publication
in the Deutsche Nationalbibliografie;
detailed bibliographic data is available
in the Internet at http://dnb.ddb.de

Contents

6

Mandala, 1987 by Philippe Starck

Food and Design

Perhaps now, with world-renowned cooks appearing in *Time* magazine, taking up pages formerly occupied by presidents and celebrities; with gastronomy on an equal standing with architecture, fine art or classical music; with new culinary techniques being developed in research laboratories more akin to the NASA space shuttle control desk than your traditional kitchen, the time has finally come for giving food design the consideration it deserves. As the architecture and design editor for the British daily *The Guardian*, Jonathan Glancey, says: Human beings do not merely wish to eat, but to "eat decoratively".

Whereas in the early 11th century food was exclusively intended to satisfy the palate, and people ate with their hands which they would then wipe on the own clothes, by the 21st century eating had become a more ambitious occupation altogether. Today, one thousand years on, gastronomy appeals to all five senses: sight, touch, smell, hearing and, naturally, (good) taste.

Scores of industrial designers all over the world have spent time and effort in this specialized field, and the results can be appreciated in the pages of this book. Besides the best-known and most outstanding references such as Philippe Starck's work for Alessi, for example, there is a whole galaxy of individuals, design studios, brand names and advertising agencies taking the act of selecting a few ingredients, cooking them and eating the results, and turning this into a first-rate experience for the senses. New produce, new forms, and new uses are thought up for traditional methods and utensils, whilst innovative solutions are applied to age-old problems.

Who said everything in the realm of gastronomy had been invented ever since Leonardo da Vinci added a third prong to the fork?

Essen und Design

Heutzutage erscheinen die besten Köche der Welt in der Zeitschrift *Time* dort, wo früher Politiker und Persönlichkeiten aus der Welt der Kultur ihren Platz hatten; die Gastronomie hat den gleichen gehobenen Status erreicht wie die Architektur, die Kunst oder die klassische Musik, und die neuen kulinarischen Techniken werden in Forschungslaboren entwickelt, die eher dem Steuerpult der Raumfähre Discovery der NASA als den alten, traditionellen Küchen gleichen. Deshalb ist vielleicht endlich der Moment gekommen, in dem man dem Gastronomiedesign die Bedeutung zuerkennt, die ihm zusteht. Es ist nämlich so, wie Jonathan Glancey, der Herausgeber für Architektur und Design der britischen Tageszeitung *The Guardian* sagt, dass der Mensch nicht lebt, um zu essen, sondern um „dekorativ zu essen".

Wenn man zu Beginn des 11. Jh. mit dem Essen nur den Geschmackssinn zufrieden stellen wollte, denn man aß mit den Händen und benutzte die Kleidung als Servietten, so sind die Bestrebungen zu Beginn des 21. Jh. etwas ehrgeiziger als 1000 Jahre zuvor. Die Gastronomie will zu einer totalen Erfahrung werden, die alle fünf Sinne, Sehen, Tastsinn, Geruch, Gehör und selbstverständlich den (guten) Geschmack zufrieden stellen möchte.

In den letzten Jahren haben sich zahlreiche Industriedesigner auf der ganzen Welt diesem Ziel gewidmet, und die Ergebnisse stellen wir Ihnen auf den Seiten dieses Buches vor. Neben den offensichtlichen Referenzen wie Philippe Starcks Arbeiten für Alessi gibt es unzählige Namen, Designstudios, Marken und Werbeagenturen, die die einfache Tatsache, ein paar Zutaten auszuwählen, sie zu kochen und das Gekochte zu essen, zu einem unglaublichen Sinneserlebnis machen. Neue Materialien, neue Formen, neue Anwendungen für alte Utensilien, innovative Lösungen für alte Probleme ...

Wer sagte, dass im Gastronomiedesign bereits alles erfunden sei, seitdem Leonardo da Vinci der Gabel den dritten Zinken hinzufügte?

Alimentation et design

A l'heure où certains des meilleurs cuisiniers du monde apparaissent dans la revue *Time*, occupant l'espace réservé autrefois aux présidents et aux grands noms du monde culturel, où le statut de la gastronomie s'est élevé au rang de l'architecture, l'art ou la musique classique, où les nouvelles techniques culinaires sont concoctées dans des ateliers de recherche, à l'instar du tableau de bord de la navette Discovery de la NASA plus qu'à l'image de nos bonnes vieilles cuisines, il est peut-être temps de donner au design gastronomique la place d'honneur qui lui revient. Car, selon les paroles de Jonathan Glancey, directeur de publication d'architecture et de design du quotidien britannique *The Guardian*, l'être humain ne vit pas pour manger, mais pour « manger avec art ».

Si au début du XIe siècle, il n'y avait qu'un seul sens à satisfaire en prenant ses repas, à savoir le goût, – les gens mangeaient avec les mains et les vêtements servaient de serviettes – au début du XXIe siècle, notre objectif est légèrement plus ambitieux qu'il y a 1000 ans : la gastronomie se voudrait se transformer en expérience parfaite pour satisfaire, la vue, le toucher, l'odorat, l'ouïe et, bien sûr, le (bon) goût.

Au cours de ces dernières décennies, des designers industriels du monde entier se sont consacrés à ce thème. Vous pourrez en juger par vous-mêmes au fil des pages de cet ouvrage. Au-delà des constellations connues – Philippe Starck travaillant pour Alessi – il existe toute une pléiade de noms, studios de design, enseignes et agences de publicité qui sont en train de métamorphoser le simple fait de sélectionner quelques ingrédients, de les cuisiner et de les déguster en une expérience sensorielle de premier ordre. Matières, formes, utilisations innovatrices pour vieux ustensiles, solutions modernes pour problèmes anciens...

Qui a dit qu'il n'y avait plus rien a inventé sur le plan du design gastronomique dès lors où Leonardo da Vinci rajouta une troisième dent à la fourchette?

Comida y diseño

Ahora que algunos de los mejores cocineros del mundo aparecen en la revista *Time* aca-
parando el espacio que antes ocupaban presidentes y popes del mundo de la cultura;
ahora que la gastronomía ha adquirido el mismo elevado status que la arquitectura, el arte
o la música clásica; ahora que las nuevas técnicas culinarias se gestan en talleres de inves-
tigación más similares al panel de control del transbordador Discovery de la NASA que a
las viejas cocinas de toda la vida, quizá ha llegado finalmente la hora de colocar el diseño
gastronómico en el lugar que le corresponde. Y es que, como dice Jonathan Glancey, el edi-
tor de arquitectura y diseño del diario británico *The Guardian*, el ser humano no vive para
comer, sino para "comer decorativamente".

Si a principios del siglo XI el único sentido que se aspiraba a satisfacer mediante la comi-
da era el del gusto —se comía con las manos y se usaban las ropas como servilleta—, a prin-
cipios del siglo XXI el objetivo ha pasado a ser levemente más ambicioso que hace mil
años: la gastronomía pretende convertirse en una experiencia total que debe satisfacer
vista, tacto, olfato, oído y, por supuesto, (buen) gusto.

A ello se han dedicado durante los últimos años decenas de diseñadores industriales de
todo el mundo con los resultados que pueden apreciarse en las páginas de este libro. Más
allá de los referentes obvios —Philippe Starck trabajando para Alessi— existe toda una gala-
xia de nombres, estudios de diseño, marcas y agencias de publicidad que están convir-
tiendo el simple hecho de seleccionar unos cuantos ingredientes, cocinarlos y comer lo
cocinado en una experiencia sensorial de primer orden. Nuevos materiales, nuevas for-
mas, nuevos usos para viejos utensilios, innovadoras soluciones para viejos problemas...
¿Quién dijo que en el diseño gastronómico estaba todo inventado desde que Leonardo da
Vinci le añadió el tercer diente al tenedor?

Mangiare e design

Adesso che alcuni dei migliori cuochi del mondo appaiono nella rivista *Time* accaparrando lo spazio in passato occupato da presidenti e rappresentanti del mondo della cultura; adesso che la gastronomia ha acquisito lo stesso status d'alto livello dell'architettura, l'arte o la musica classica; adesso che le nuove tecniche culinarie si creano nei laboratori di ricerca più simili al pannello di controllo del trasbordatore Discovery della NASA che non alle vecchie e tradizionali cucine, forse è finalmente arrivata l'ora di situare il design gastronomico nel luogo che gli corrisponde. Il fatto è, come dice Jonathan Glancey, l'editore d'architettura e design del quotidiano britannico *The Guardian*, l'essere umano non vive per mangiare, ma per "mangiare in modo decoroso".

Se agli inizi del XI secolo l'unico senso che si cercava di soddisfare con il cibo era il gusto — si mangiava con le mani e si usavano i vestiti come tovagliolo —, agli inizi del XXI l'obiettivo è diventato leggermente più ambizioso rispetto a 100 anni fa: la gastronomia vuole trasformarsi in un'esperienza totale che deve soddisfare la vista, il tatto, l'olfatto, l'udito e, chiaramente, il (buon) gusto.

Nel corso degli ulti anni decine di designer industriali di tutto il mondo vi si sono dedicati con i risultati che si possono apprezzare nelle pagine di questo libro. Al di là dei referenti ovvi — Philippe Starck che lavora per Alessi — esiste tutta una galassia di nomi, di studi di design, case ed agenzie di pubblicità che stanno trasformando il semplice fatto di selezionare alcuni ingredienti, cucinarli e mangiare quanto cucinato, in un'esperienza sensoriale di prim'ordine. Nuovi materiali, nuove forme, nuovi usi per vecchi utensili, soluzioni innovatrici per vecchi problemi...

Chi ha detto che nel design gastronomico era già stato tutto inventato da quando Leonardo da Vinci aggiunse il terzo dente alla forchetta?

Historical background

If we type the word "design" alongside "food" or "gastronomy" in any search engine, we are led to hundreds of websites on the man who seems to have been the very first gastronomical designer in history. This was, of course, none other than Leonardo da Vinci (1452–1519), who was also an inventor, sculptor, painter, architect and cosmologist. In his capacity as banqueting master at the court of Ludovico il Moro in Milan, and chef at *The Three Snails* tavern in Florence, Leonardo da Vinci spent much of his time compiling recipes and comments on the culinary arts in his codex *Romanoff* (discovered in 1981). He invented the corkscrew, the extractor fan, machines for slicing and chopping meat, the fire-extinguisher, the pepper mill, an appliance for making "spago mangiabile", the "edible string" known today as spaghetti, or the above-mentioned three-pronged fork, among other mind-boggling devices. We could also mention here the napkin, which was the practical answer to a problem suffered by aristocratic guests dining at their lord's table, who had to wipe their hands on their fellow guest's robes or on the tablecloth, if the woolly dog specially provided for this purpose was not to hand. The solution was simple enough: the tablecloth was cut up so that each guest was given his own individual portion.

With the exception of Leonardo, gastronomical design as a branch of industrial design has only just begun. Knives and forks have only been used as a matter of course for the last two centuries, and in 1910 the kitchen was still thought of as an inferior quarter of the house. Advertising, as we know it today, was unheard of when it came to food products. Humans have eaten with their hands for the greater part of their history and the use of cutlery was introduced by aristocracy not for practical reasons but rather to distinguish themselves from the lower classes. The Enlightenment and Rationalism's first notions of hygiene gradually brought technology to the world of gastronomy.

Industrial design makes its appearance in the middle of the 19th century, but it was not until

the Bauhaus was founded in 1919 that the beauty of objects themselves, in isolation from their ornamental qualities, began to be appreciated. The *Futurist Cookbook,* written by Marinetti in 1932, extols the sensual value of food and advocates that the traditional penchant for pasta, "this Italian religion", should become a thing of the past, a conventional relic. The New Cuisine, according to Marinetti, should be built upon synthetic fats and capsules, with names like the famous avant-garde recipe for "Sunlit Alaskan salmon Mars sauce".

These days, designing products for gastronomical purposes follows paths parallel to other branches of industrial and graphic design. The distinguishing features, which justify the existence of a book such as this one, are the consolidation of completely new approaches to understanding and experiencing gastronomy. In many instances, kitchen artefacts have become status symbols. The world's most famous designers are not afraid to re-design such mundane objects as saltcellars or orange squeezers, while kitchen facilities at major international restaurants have become full-blown laboratories. Graphic designers, for their part, seem to have forgone forever the unspoken law that said food packaging should always suggest traditional, home-made qualities for the products they contained.

13

The future of gastronomical design lies in its connections with inventiveness and the development of new culinary techniques. Some international chefs such as Ferran Adrià and Martín Berasategui of Spain, the Frenchman Pierre Gaganaire, or Alex Atala of Brazil have developed new techniques for their restaurants. These include liquid nitrogen; culinary nanotechnology, which requires a knowledge of molecular cuisine; or vacuum cooking. In this situation, the challenge facing future industrial designers is to make these techniques accessible to the unspecialised consumer, so that simple dishes like melon caviar or bacon with egg ice-cream become as easy to prepare, or easier, than phoning up a pizza.

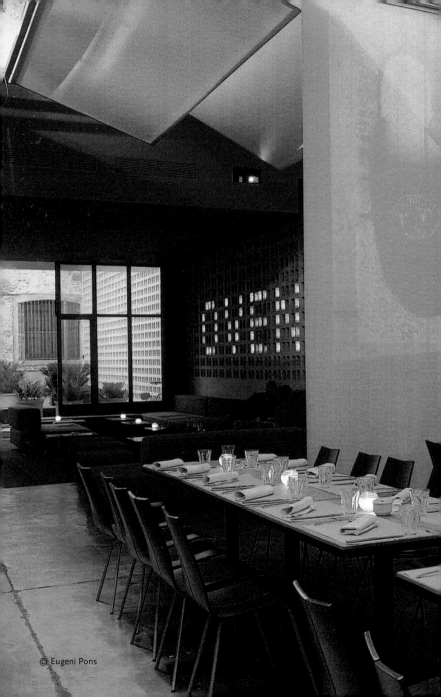

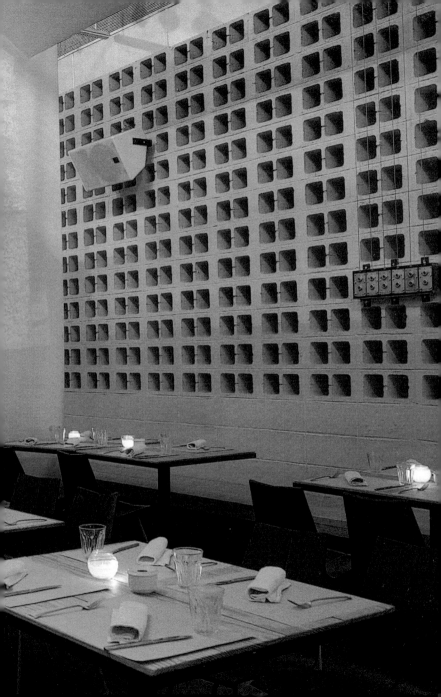

Historische Einführung

Wenn man das Wort „Design" zusammen mit dem Wort „Essen" oder „Gastronomie" in irgendeine Internet-Suchmaschine eingibt, findet man Hunderte von Seiten, die dem gewidmet sind, den man allen Anzeichen nach als den ersten Designer der Gastronomie in der Geschichte der Menschheit bezeichnen kann. Wir reden hier von Leonardo da Vinci (1452–1519), Erfinder, Bildhauer, Maler, Architekt und Kosmologe. Als Chef unter Ludovico Sforza, genannt il moro, der Dunkle, und als Küchenchef der Taverne *Die drei Schnecken* in Florenz widmete Leonardo da Vinci einen großen Teil seiner Zeit der Zusammenstellung des sogenannten Codex *Romanoff* (entdeckt im Jahr 1981), der Kochrezepte und gastronomische Kommentare über die verschiedensten Themen enthält. Außerdem war er der Erfinder von vielen merkwürdigen Utensilien, unter anderem des Korkenziehers, der Abzugshaube, der Maschinen zum Schneiden und Hacken von Fleisch, des Feuerlöschers, der Pfeffermühle und einer Maschine zur Herstellung von „spago mangiabile" (essbare Schnüre), also Spagettis, und der bereits erwähnten Gabel mit drei Zinken. Auch die Erfindung der Serviette muss erwähnt werden, eine praktische Lösung für das Problem, das Aristokraten hatten, die an den Tisch ihres Herren geladen wurden und sich die Hände an den Kleidern der Tischnachbarn oder am Tischtuch reinigten, wenn der Pudel, der diesem Zwecke diente, sich nicht zeigte oder sich drückte. Die Lösung war einfach, man musste nur die Tischdecke in kleine Stücke zerteilen, damit die Gäste ihr eigenes Stück Stoff haben konnten.

Wenn man nun Leonardo ausnimmt, scheint es doch offensichtlich zu sein, dass diese Art von Design als ein Gebiet des Industriedesigns gerade erst entstanden ist. Der allgemeine Gebrauch von Besteck ist eigentlich erst seit zwei Jahrhunderten üblich. Noch 1910 wurden Küchen noch als zweitrangige Räume in den Häusern betrachtet, und die Werbung für Lebensmittel, so wie wir sie heute kennen, war zu jener Zeit noch gänzlich unbekannt. Der Mensch hat während des größten Teils seiner Geschichte mit den Händen gegessen und die Tatsache, dass die Adligen anfingen, Bestecke zu benutzen, war zu jener Zeit nicht auf praktische Gründe zurückzuführen, sondern man wollte sich von den Plebejern unterscheiden. Die Aufklärung und die ersten hygienischen Vorschriften, die durch

den Rationalismus entstanden, führten allmählich die Technologie in die Welt der Gastronomie ein.

Das Industriedesign begann sich Mitte des 19. Jh. zu entwickeln, aber erst seit der Gründung des Bauhauses 1919 begann man, der Schönheit eines Objektes an sich Aufmerksamkeit zu widmen, und nicht nur seiner Verzierung. In dem *Manifest zur futuristischen Küche*, das Marinetti 1932 verfasste, wird die Verherrlichung der Sinne in Bezug auf das Essen verteidigt, und es soll mit der Tradition der italienischen Nudeln gebrochen werden, „dieser italienischen Religion", die als ein Emblem der Vergangenheit und des Konventionellen betrachtet wird. Die neue Küche, so Marinetti, soll auf synthetischen Fetten und Pillen basieren und Namen wie das berühmte avantgardistische Rezept „Sonnenbeschienener Lachs aus Alaska mit Marssauce" tragen.

Heutzutage folgt das Design für Gastronomieprodukte einem Weg, der parallel zu den übrigen Bereichen des Grafik- und Industriedesigns verläuft. Das unterscheidende Element, das ein Buch wie dieses rechtfertigt, ist die Konsolidierung einer neuen Art und Weise, die Gastronomie zu verstehen und zu erleben. Die Küchenobjekte sind in einigen Fällen zu wahren Statussymbolen geworden. Die berühmtesten Designer der Welt haben heute keine Bedenken, so prosaische Objekte wie Salzstreuer oder Orangenpressen zu entwerfen, während die Küchen der besten internationalen Restaurants zu wahren Forschungslaboren wurden. Die Grafikdesigner ihrerseits scheinen definitiv dieses ungeschriebene Gesetz verletzt zu haben, dass die Verpackung eines Lebensmittelproduktes ein traditionelles und hausgemachtes Bild des Produktes vermitteln sollte.

Die Zukunft des Gastronomiedesigns ist definitiv mit der Erfindung und Entwicklung neuer kulinarischer Techniken verbunden. Da Köche wie die Spanier Ferran Adrià und Martín Berasategui, der Franzose Pierre Gaganaire und der Brasilianer Alex Atala für ihre Restaurants Techniken wie flüssigen Stickstoff und die kulinarische Nanotechnologie entwickelt haben, für die man Kenntnisse der molekularen Küche benötigt, oder das Vakuumieren, besteht die Herausforderung für die Industriedesigner der Zukunft darin zu erreichen, dass diese Techniken zum Verbraucher gelangen, ohne dass man dazu spezialisierte Küchenkenntnisse benötigt. So wird vielleicht eines Tages die Zubereitung eines einfachen Melonenkaviars und eines Bacon mit Eis aus Ei so einfach oder noch einfacher sein wie das Bestellen einer Pizza per Telefon.

17

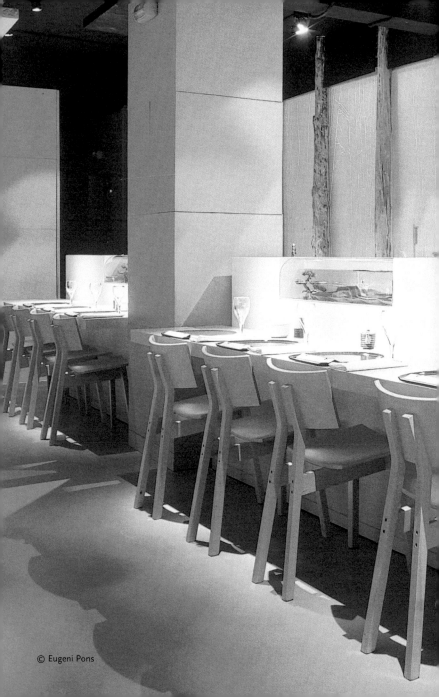

© Eugeni Pons

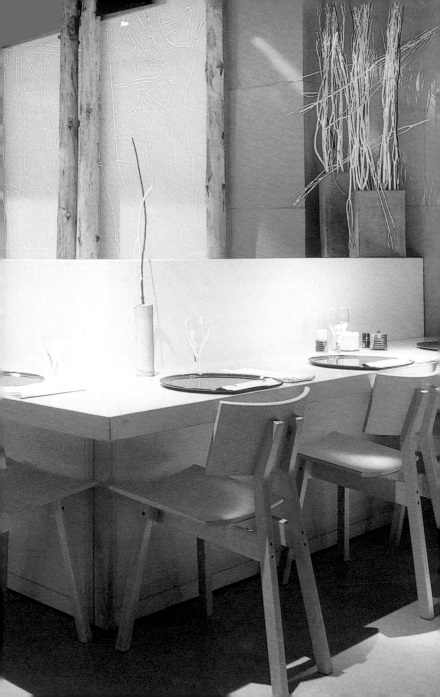

Introduction historique

Tapez le mot « design » à côté des mots « repas » ou « gastronomie » sur un moteur de recherche Internet, et vous trouverez une centaine de pages consacrées à celui, qui selon toutes les informations, est le premier designer gastronomique de l'histoire de l'humanité. Il s'agit, de toute évidence, de Léonard de Vinci (1452–1519), inventeur, sculpteur, peintre, architecte et astrologue. Maître de banquets à la cour milanaise de Ludovic le Maure et chef de cuisine de la taverne florentine *Les trois escargots*, Léonard de Vinci passa une bonne partie de son temps à compiler, dans le code *Romanoff* (découvert en 1981), des recettes culinaires et des appréciations gastronomiques sur les thèmes les plus divers. Il fût en outre l'inventeur de certains ustensiles insolites : tire-bouchons, extracteurs de fumée, machines à couper et hacher la viande, extincteurs d'incendies, moulins à poivre, machine à fabriquer le « spago mangiabile » (cordes comestibles) – à savoir, nos spaghettis – et la fourchette à trois dents, précitée. Sans oublier de mentionner l'invention de la serviette, une solution pratique pour remédier aux habitudes des aristocrates qui, invités à la table de leur maître, se nettoyaient les mains dans les vêtements de leurs voisins de table ou sur le nappe, lorsque le chien en laine prévu à cet effet était introuvable ou ne passait pas assez vite. La solution était évidente : partager la nappe en petits morceaux pour que tous les invités en aient un morceau chacun.

Léonard de Vinci mis à part, le design gastronomique, considéré de toute évidence comme un secteur supplémentaire du design industriel, est nouveau-né sur la place. L'emploi généralisé de couverts remonte à peine à deux siècles, car en 1910, les cuisines étaient encore considérées comme des espaces de vie de second plan dans toutes les maisons et la publicité alimentaire telle que nous la connaissons était totalement inconnue à l'époque. L'être humain a mangé avec ses mains pendant une grande partie de son histoire et si, à un moment donné, l'aristocratie commence à utiliser la fourchette ce n'est pas pour des raisons d'ordre pratique mais tout simplement pour se distinguer

de la plèbe. L'esprit philosophique du Siècle des Lumières et les premières normes d'hygiène dictées par le rationalisme introduirent peu à peu la technologie dans le monde de la gastronomie.

Le design industriel apparaît au milieu du XIXe siècle, mais ce n'est qu'à la fondation de la Bauhaus en 1919 que l'on accorde de l'importance à la beauté de l'objet lui-même plus qu'à sa qualité d'ornement. Le *Manifeste de la cuisine futuriste*, écrit par Marinetti en 1932, défend les sens en rapport avec le repas et se fait l'avocat de la rupture avec la tradition des pâtes italiennes, « cette religion italienne », considérée comme la marque du passé et du conformisme. La nouvelle cuisine, selon Marinetti, doit être réalisée à partir de graisses synthétiques et de pilules, et se parer de nom à l'instar de la fameuse recette avantgardiste « Saumon d'Alaska aux rayons de soleil à la sauce Mars ».

De nos jours, le design de produits liés à la gastronomie suit un chemin parallèle au reste des secteurs du design graphique et industriel. La nouvelle façon de comprendre et de vivre la gastronomie justifie un tel ouvrage. Les objets de cuisine se sont transformés, pour certains, en symbole authentique de haut niveau. Les plus célèbres designers du monde n'ont aucune réticence à concevoir des objets aussi prosaïques que des salières ou presse orange, à l'heure où les cuisines des meilleurs restaurants internationaux se métamorphosent en véritables laboratoires de recherches. Les designers graphiques, de leur côté, paraissent avoir violé définitivement cette loi non écrite disant que le packaging d'un produit alimentaire doit donner une image traditionnelle et familiale du produit.

Le futur design gastronomique est définitivement lié à l'invention et au développement de nouvelles techniques culinaires. Si les cuisiniers à l'instar des espagnols Ferran Adrià et Martín Berasategui, du français Pierre Gaganaire et du brésilien Alex Atala ont développé pour leurs restaurants des techniques comme le nitrogène liquide, ou la nanotechnologie culinaire – requérant des connaissances de cuisine moléculaire – ou celle de la cuisine sous vide, le défi posé aux designers industriels du futur est de faire parvenir ces techniques aux consommateurs sans connaissances spéciales de cuisine, pour qu'un jour, préparer un simple caviar de melon ou une assiette de bacon à la glace aux œufs soit aussi facile, ou plus, que commander une pizza par téléphone.

21

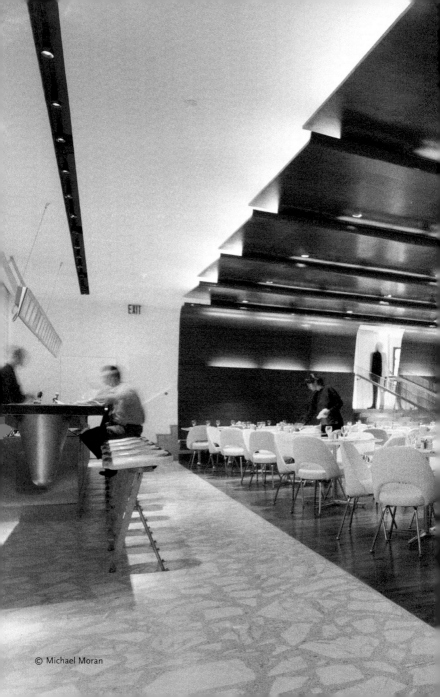

EXIT

© Michael Moran

Introducción histórica

Si se escribe la palabra "diseño" junto a las palabras "comida" o "gastronomía" en cualquier buscador de internet nos encontraremos con centenares de páginas dedicadas a quien, según todos los indicios, es el primer diseñador gastronómico de la historia de la humanidad. Hablamos, obviamente, de Leonardo da Vinci (1452–1519), inventor, escultor, pintor, arquitecto y cosmólogo. Como maestro de banquetes en la corte milanesa de Ludovico el Moro y como jefe de cocina de la taberna florentina *Los tres caracoles*, Leonardo da Vinci dedicó buena parte de su tiempo a recopilar, en el llamado códice *Romanoff* (descubierto en 1981), recetas culinarias y comentarios gastronómicos sobre los más variados temas; fue además el inventor, entre otros delirantes utensilios, del sacacorchos, los extractores de humo, las máquinas para cortar y picar la carne, los extintores de incendios, los molinillos de pimienta, de una máquina para fabricar "spago mangiabile" (cordel comestible) —es decir, espaguetis— y del ya mencionado tenedor de tres puntas. Por no mencionar la invención de la servilleta, una solución práctica al problema que suponía que los aristocráticos convidados a la mesa de su señor se limpiaran las manos en los ropajes de los vecinos de mesa o en el mantel, cuando el perro de lanas habilitado al efecto no hacía acto de presencia o se mostraba remolón. La solución era obvia: dividir el mantel en pequeños trozos para que todos los invitados tuvieran su porción individual.

Con la excepción de Leonardo, parece claro que el diseño gastronómico, considerado una rama más del diseño industrial, acaba de nacer. El uso generalizado de cubiertos se remonta a hace apenas dos siglos, todavía en 1910 las cocinas eran consideradas como estancias de segundo orden en todas las casas y la publicidad de productos alimenticios tal y como la entendemos hoy en día era totalmente desconocida por aquel entonces. El ser humano ha comido con las manos durante la mayor parte de su historia y el hecho de que las clases aristocráticas empezaran a usar cubiertos no obedeció, en su momento, a razones prácticas, sino al deseo de distinguirse de la plebe. La Ilustración y las primeras normas de higiene dictadas por el racionalismo fueron introduciendo poco a poco la tecnología en el mundo de la gastronomía.

El diseño industrial aparece a mediados del siglo XIX, aunque no fue hasta la fundación de la Bauhaus en 1919, cuando se empezó a prestar atención a la belleza del objeto en sí más allá de su ornamentación. En el *Manifiesto de la cocina futurista*, escrito por Marinetti en 1932, se defiende la exaltación de los sentidos en relación con la comida y se aboga por romper con la tradicional pasta italiana, "esa religión italiana", considerada un emblema del pasado y de lo convencional. La nueva cocina, según Marinetti, debe basarse en grasas sintéticas y píldoras, y ostentar nombres como el de la ya famosa receta vanguardista "Salmón de Alaska a los rayos de sol con salsa Marte".

Hoy en día, el diseño de productos relacionados con la gastronomía sigue un camino paralelo al del resto de las ramas del diseño gráfico e industrial. El elemento distintivo, lo que justifica un libro como éste, es la consolidación de una nueva manera de entender y de vivir la gastronomía. Los objetos de cocina se han convertido, en algunos casos, en auténticos símbolos de alto estatus. Los más famosos diseñadores del mundo no muestran actualmente reparo alguno en diseñar objetos tan prosaicos como saleros o exprimidores de naranjas, mientras que las cocinas de los mejores restaurantes internacionales se han convertido en auténticos laboratorios de experimentación. Los diseñadores gráficos, por su lado, parecen haber violado definitivamente aquella ley no escrita que decía que el packaging de un producto alimenticio ha de dar una imagen tradicional y casera del producto.

El futuro del diseño gastronómico ha quedado definitivamente ligado a la invención y al desarrollo de nuevas técnicas culinarias. Si cocineros como los españoles Ferran Adrià y Martín Berasategui, el francés Pierre Gaganaire y el brasileño Alex Atala han desarrollado para sus restaurantes técnicas como la del nitrógeno líquido, la de la nanotecnología culinaria –que requiere conocimientos de cocina molecular– o la de la cocina al vacío, entonces el reto de los diseñadores industriales del futuro consiste en lograr que esas técnicas lleguen al consumidor sin conocimientos especializados de cocina, para que, algún día, elaborar un sencillo caviar de melón o un plato de bacón con helado de huevo sea tan fácil, o más, que encargar una pizza por teléfono.

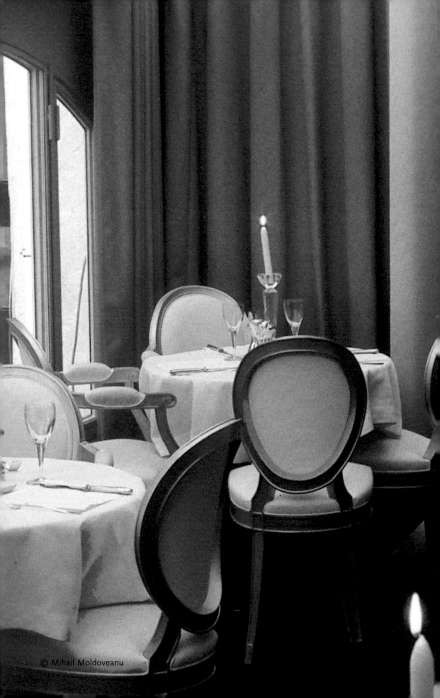

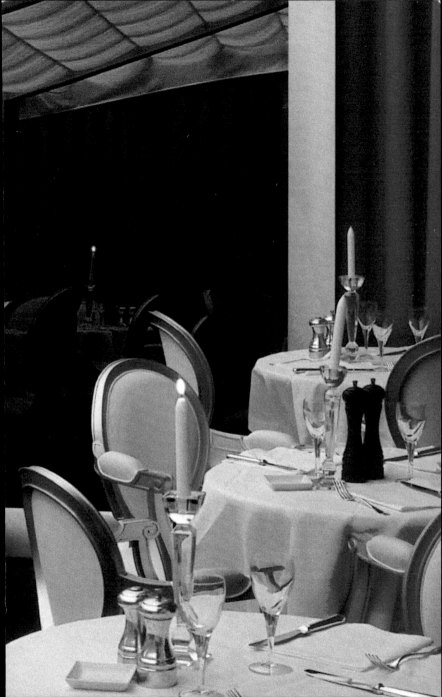

Introduzione storica

Lanciando su internet la parola "design" insieme alle parole "mangiare" o "gastronomia" in qualsiasi motore di ricerca troveremo centinaia di pagine dedicate a colui che, secondo tutti gli indizi, è il primo designer gastronomico della storia dell'umanità. Parliamo, chiaramente, di Leonardo da Vinci (1452–1519), inventore, scultore, pittore, architetto e cosmologo. Come maestro dei banchetti presso la corte milanese di Ludovico il Moro, e come capo cucina della taverna fiorentina *Le tre lumache*, Leonardo da Vinci dedicò buona parte del suo tempo a riunire, nel cosiddetto codice *Romanoff* (scoperto nel 1981), ricette culinarie e commenti gastronomici sui temi più svariati; fu inoltre l'inventore, tra tanti altri utensili deliranti, del cavatappi, gli estrattori di fumo, la macchina per tagliare e tritare la carne, gli estintori d'incendi, il macina pepe, una macchina per fabbricare "spago mangiabile" – ovvero, gli spaghetti – e della già citata forchetta a tre punte. Per non menzionare poi l'invenzione del tovagliolo, una soluzione pratica per il problema cui erano confrontati gli aristocratici invitati alla corte del loro signore che dovevano pulirsi le mani sui vestiti dei vicini di tavola o sulla tovaglia, quando il cane di lana abilitato a tale effetto non faceva atto di presenza, o si mostrava svogliato. La soluzione era ovvia: dividere la tovaglia a pezzetti in modo che tutti potessero averne uno.

Ad eccezione di Leonardo, pare chiaro che il design gastronomico, considerato come un settore in più del design industriale, è appena nato. L'uso generalizzato delle posate risale appena a due secoli, ancora nel 1910, le cucine erano considerate come stanze di second'ordine in tutte le case, e la pubblicità di prodotti alimentari come l'intendiamo oggi giorno era totalmente sconosciuta a quel tempo. Per gran parte della sua storia, l'essere umano ha mangiato con le mani ed il fatto che le classi aristocratiche iniziarono ad usare le posate non ubbidì, a suo tempo, a ragioni pratiche, ma al desiderio di contraddistinguersi dalla plebe. L'illustrazione e le prime norme d'igiene dettata dal razionalismo introdussero piano, piano la tecnologia nel mondo della gastronomia.

Il design industriale sorge nel XIX secolo, ma solo alla fondazione della Bauhaus nel 1919, inizia a prestare attenzione alla bellezza dell'oggetto in sé andando, al di là, della sua funzione ornamentale. Nel *Manifesto della cucina futurista*, scritto da Marinetti nel 1932, si difende l'esaltazione dei sensi in relazione al cibo e si vuole rompere con la tradizionale pasta italiana, "quella religione italiana", considerata come un emblema del passato e di quanto convenzionale. La nuova cucina, secondo Marinetti, deve essere basata su grassi sintetici e pillole, ed ostentare nomi come quello della già nota ricetta avanguardista "Salmone dell'Alaska ai raggi del sole con salsa Marte".

Oggigiorno, il design di prodotti relativi alla gastronomia segue una strada parallela a quella dei restanti settori del design grafico ed industriale. L'elemento distintivo, cosa che giustifica un libro come questo, è il consolidamento di un nuovo modo di intendere e di vivere la gastronomia. Gli oggetti da cucina sono diventati, in alcuni casi, autentici status symbol. I più famosi designer del mondo non mostrano nessun inconveniente nel disegnare oggetti così prosaici come saliere o spremi agrumi, mentre le cucine dei migliori ristoranti internazionali sono diventate degli autentici laboratori di sperimentazione. I disegnatori grafici, dal canto loro, sembrano aver violato definitivamente quella legge non scritta che sanciva che il packaging di un prodotto alimentare deve dare un'immagine tradizionale e casalinga del prodotto.

Il futuro del design gastronomico è rimasto definitivamente legato all'invenzione ed allo sviluppo di nuove tecniche culinarie. Se dei cuochi come gli spagnoli Ferran Adrià e Martín Berasategui, il francese Pierre Gaganaire, ed il brasiliano Alex Atala hanno creato per i loro ristoranti delle tecniche come l'azoto liquido, quella della nanotecnologia culinaria – che richiede conoscenze di cucina molecolare – o della cucina sotto vuoto, allora la sfida dei disegnatori industriali del futuro consiste nel fare in modo che quelle tecniche arrivino al consumatore privo di conoscenze specializzate di cucina, per fare in modo che, un bel giorno, elaborare un semplice caviale di melone o un piatto di pancetta con gelato d'uovo sia altrettanto facile, o più, che ordinare una pizza per telefono.

30 *Name, year* | D DESIGNER | M MANUFACTURER | P PHOTOGRAPHER

Industrial Design The last few years have produced a colossal explosion of creativity consolidating the discipline of designing kitchen utensils, including re-designing old favourites or re-interpreting and giving new uses to objects from different fields totally unrelated to gastronomy (such as medicine, for instance), as a branch of fine arts, open to anyone with the time to spare, a hand for crafts and an eye for good taste.

Industriedesign Seit der Erfindung von Küchenutensilien bis zum neuen Design dieser alten Bekannten oder der Neuinterpretation und Wiederbenutzung von Objekten aus Bereichen wie der Medizin, die von der Gastronomie weit entfernt sind, hat sich die Kreativität im Bereich der Gestaltung von Küchenobjekten mit einer unglaublichen Geschwindigkeit entwickelt, insbesondere in den letzten Jahren. Gleichzeitig gewinnt dieser Bereich als eine weitere Disziplin der Schönen Künste an Bedeutung und ist für jeden erreichbar, der über ein Minimum an Zeit, eine gewisse handwerkliche Geschicklichkeit und einen guten Geschmack verfügt.

Design industriel De la création d'ustensiles de cuisine au nouveau design de vieux classiques ou à la nouvelle interprétation et réutilisation d'objets appartenant à des univers très éloignés de la gastronomie, comme la médicine, la créativité dans le domaine du design d'objets de cuisine a connu, au cours de ces dernières années, un envol extraordinaire, couronné par sa consécration comme nouvelle discipline des beaux-arts à la portée de quiconque disposant d'un peu de temps, d'une certaine habileté manuelle et de bon goût.

Diseño industrial Desde la creación de utensilios de cocina hasta el nuevo diseño de viejos conocidos o a la reinterpretación y reutilización de objetos pertenecientes a ámbitos, como la medicina, muy alejados de la gastronomía, la creatividad en el terreno del diseño de objetos para la cocina ha vivido durante los últimos años una explosión de proporciones colosales, que corre paralela a su consolidación como una disciplina más de las bellas artes, al alcance de cualquiera que disponga de un mínimo de tiempo, cierta habilidad manual y buen gusto.

Design industriale Dalla creazione degli utensili da cucina sino al nuovo design di vecchi noti o alla re-interpretazione e, nuovo uso di oggetti che appartengono ad ambiti, come la medicina, molto lontani dalla gastronomia, la creatività nel terreno del design d'oggetti per la cucina ha vissuto durante gli ultimi anni un'esplosione di colossali proporzioni, che corre parallela al suo consolidamento come una disciplina aggiuntiva delle belle arti, alla portata di qualsiasi persona che disponga di un po' di tempo, di una certa abilità manuale, e del buon gusto.

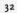

32

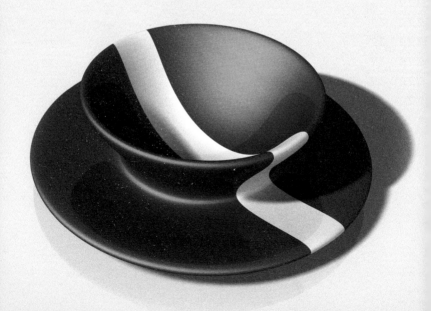

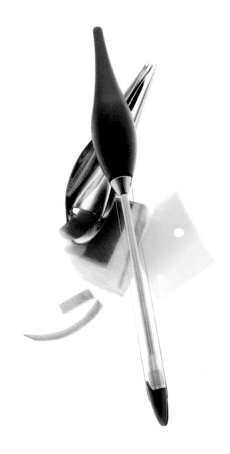

33

Cheese Slicer, 1998 | **D** TOOLS DESIGN | **M** EVA DENMARK | **P** TOOLS DESIGN

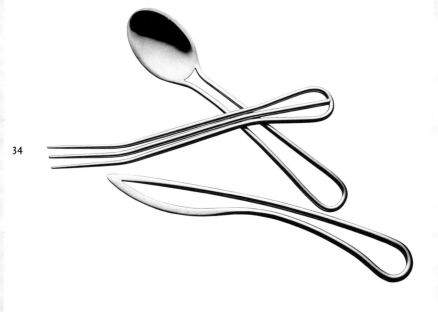

Alex Cutlery, 2003 | **D** JACK FREDERICK | **M** FORM FRESH | **P** MARCEL CHRIST

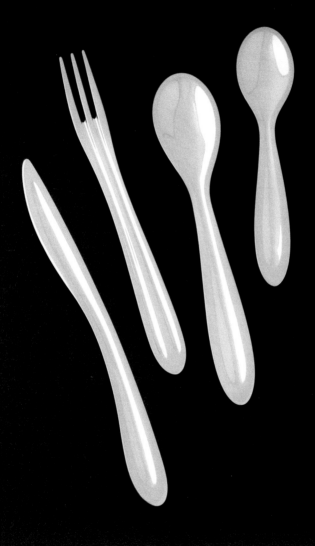

35

Naji Cutlery, 2004 | **D** JACK FREDERICK | **M** FORM FRESH | **P** JACK FREDERICK

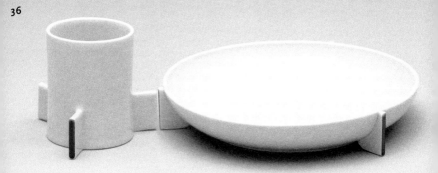

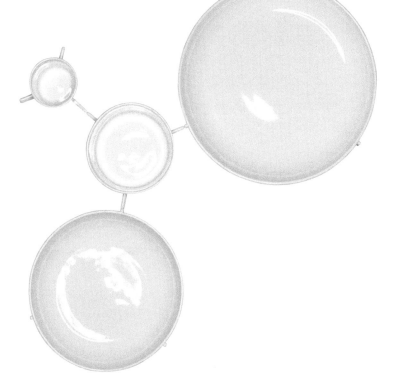

Hi.link, 2003 | **D** Matali Crasset | **M** Hi Hotel | **P** Patrick Gries

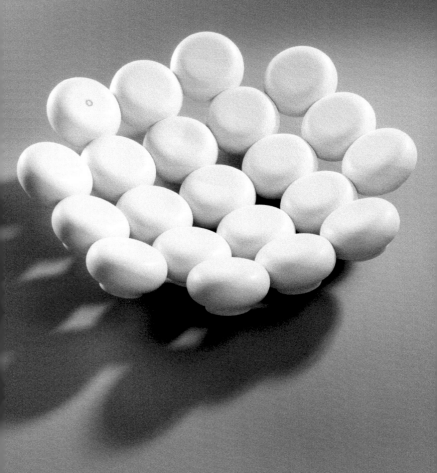

40

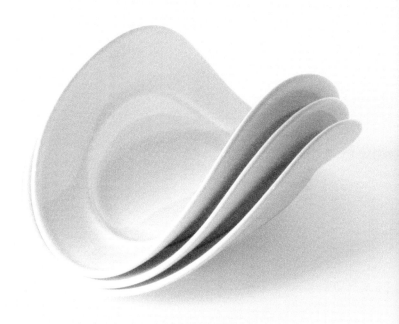

Shake, 1999 | **D** Brian Keaney & Tony Alfström | **M** Tonfisk Design Ltd. | **P** Jefunne Gimpel

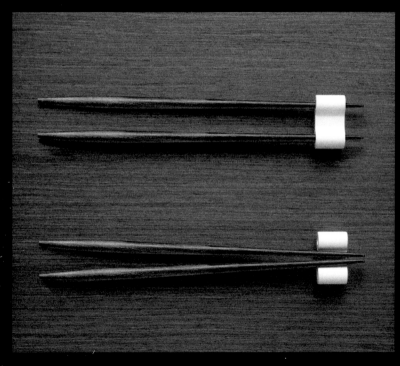

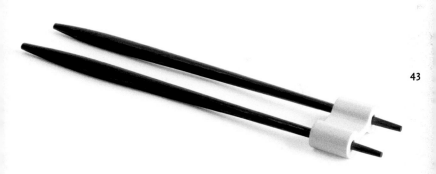

43

Chowbella, 2003 | **D** Joe Doucet | **M** Intoto | **P** Russell Gera

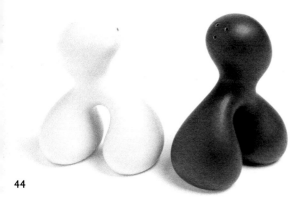

44

Amoeba Condiment Set, 2000 | **D** Dominic Bromley | **M** Scabetti | **P** Mofo Creative Photography

Gourmet, 1997 | **D** Storz | **M** Berndorf | **P** Fritz Hauswirt

45

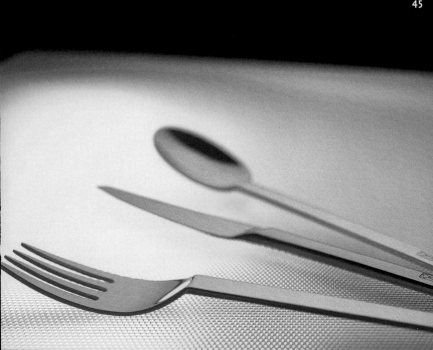

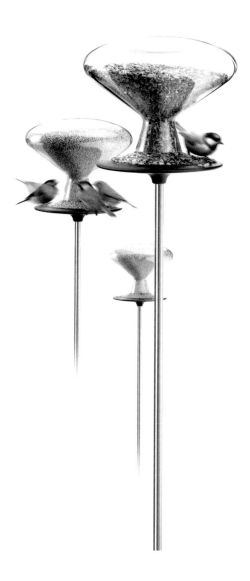

Exclusively Spaghetti

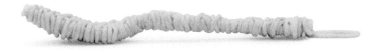

Exclusively for Spaghetti

No Spaghetti around the neck Squared off for a better twist

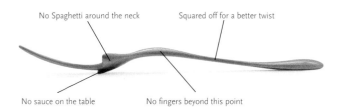

No sauce on the table No fingers beyond this point

Duspaghi, 1999 | **D** Sam Sannia | **M** Concept | **P** Sam Sannia

48

Homewear Collection, 2000 | **D** MATALI CRASSET | **M** TEFAL | **P** PATRICK GRIES

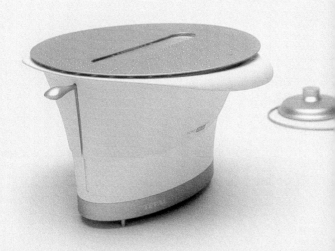

50

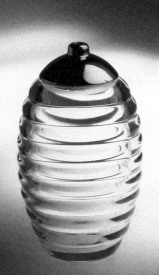
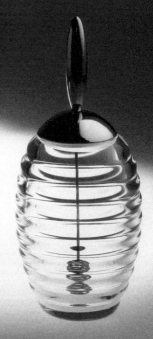

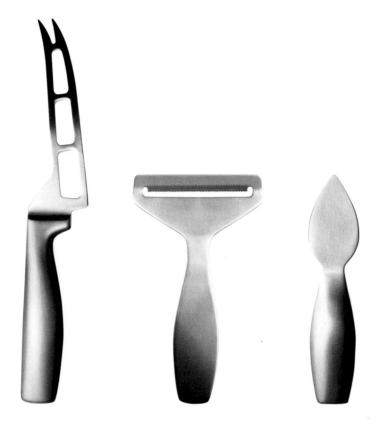

Collective Tools, 2000 | **D** Antonio Citterio, Glen Oliver Löw | **M** Iittala

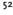

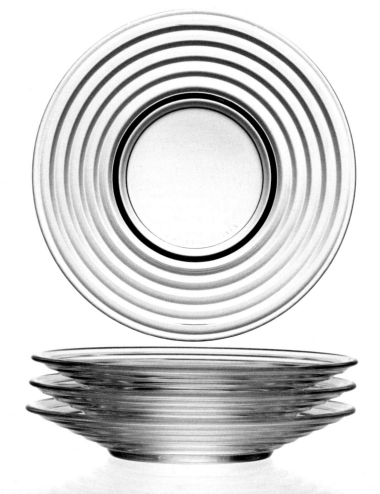

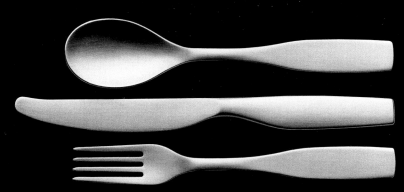

53

Citterio, 2000 | **D** Antonio Citterio, Glen Oliver Löw | **M** Iittala

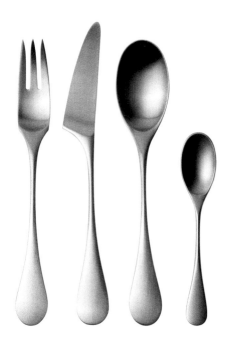

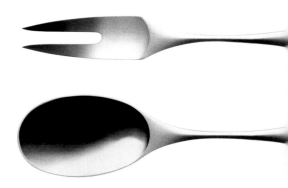

Mango, 1973 | D Nanny Still | M Iittala

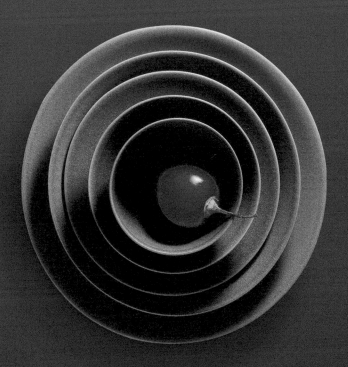

Green Plates, 2003 | D IITTALA | M IITTALA

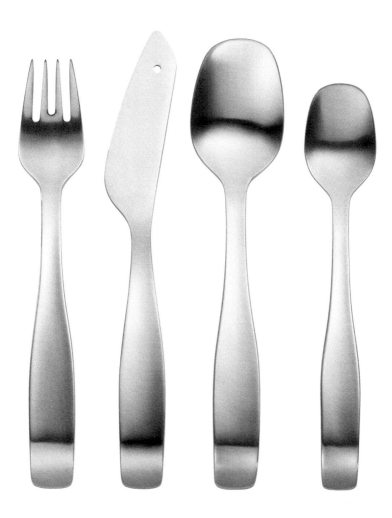

57

Kids Stuff, 2003 | D ALFREDO HÄBERLI | M IITTALA

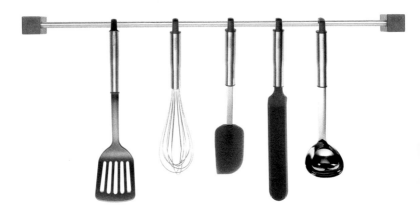

Kitchen Utensils, 2002 | **D** Harri Koskinen | **M** Iittala

Lindfors, 1998 | **D** Stefan Lindfors | **M** Iittala

60

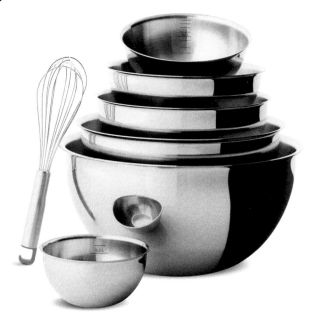

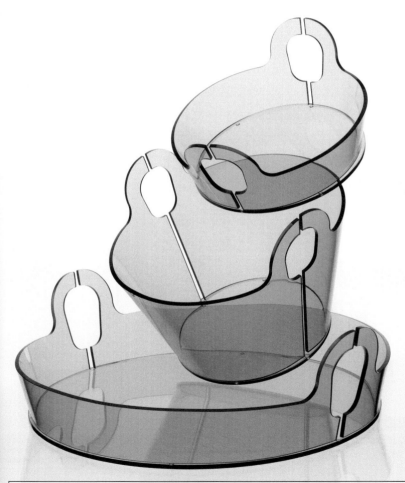

Akasma, 2003 | **D** Satyendra Pakhalé | **M** RSVP | **P** RSVP

62

Cutlery 01 Matt, 2004

Cutlery 01, 1999

63

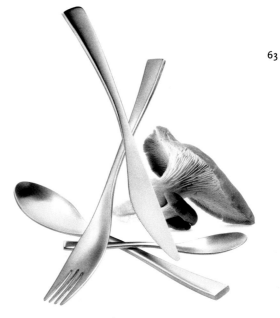

Cutlery 02, 2004

D Tools Design | **M** Eva Denmark | **P** Tools Design

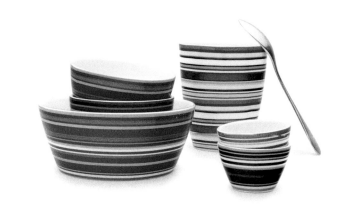

64

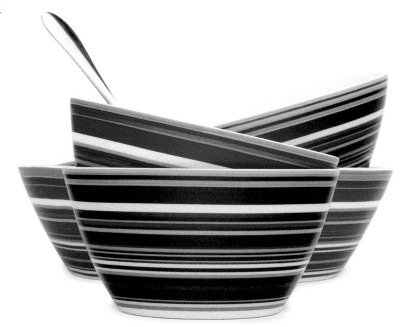

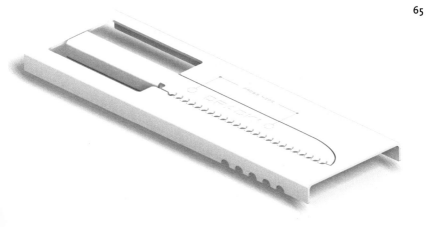

Crack, 2004 | **D** Julian Appelius | **M** Concept | **P** Andreas Velten

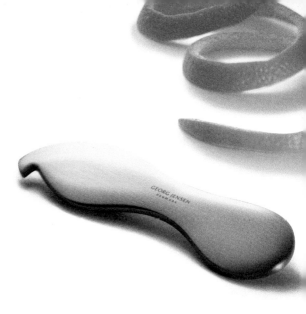

66

Fruit Knife, 1981 | **D** Andreas Mikkelsen | **M** Georg Jensen

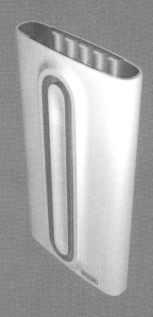

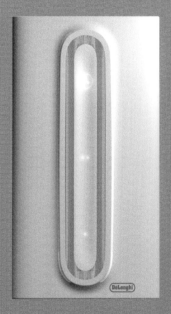

Versatile, 2003 | **D** G. Germe, F. Laine, T. Brisebras, N. Montabone | **M** Concept | **P** Digital Rendering

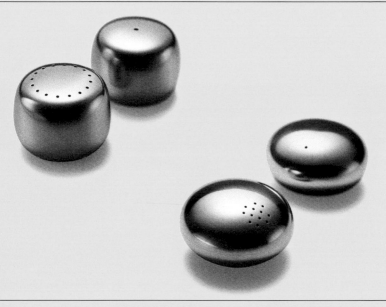

Castors Salt and Pepper, 1980 | **D** Arne Pedersen | **M** Georg Jensen

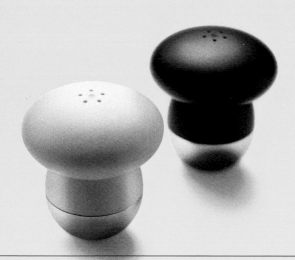

Castors Salt and Pepper, 1998 | **D** Søren Ulrik Pedersen | **M** Georg Jensen

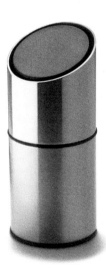

Complet Pepper Grinder, 1993 | **D** JØRGEN MØLLER | **M** GEORG JENSEN

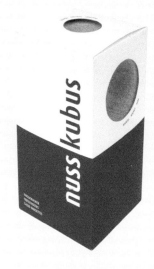

Nusskubus, 2003 | **D** Adam und Harborth | **M** Siebensachen | **P** Studio Gallandi

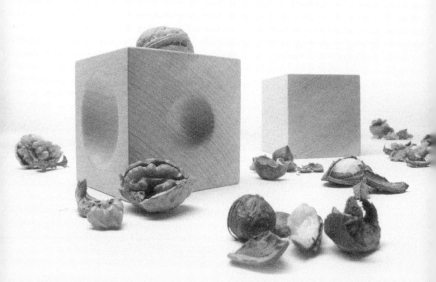

Pizza-pasta-plate, 2002 | **D** ADAM UND HARBORTH | **M** CONCEPT | **P** BIG TORINO

Hand Blender, 2002 | **D** George J. Sowden, Hiroshi Ono | **M** Guzzini | **P** Ilvio Gallo

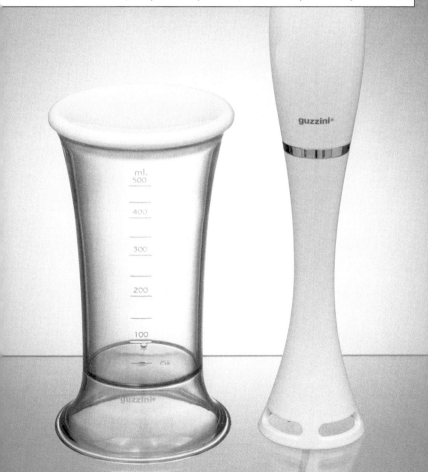

Cheese Grater, 2002 | **D** George J. Sowden, Hiroshi Ono | **M** Guzzini | **P** Ilvio Gallo

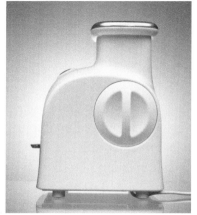
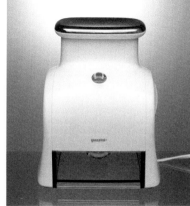

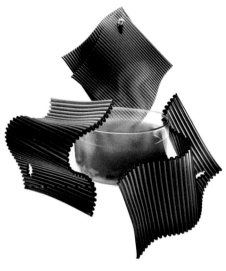

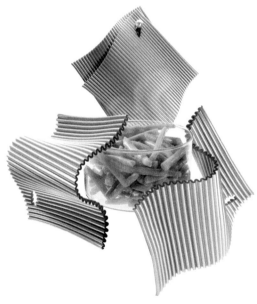

Potholders in Silicone, 1997 | **D** Tools Design | **M** Eva Denmark | **P** Tools Design

Amoeba Long Dish, 2001 | **D** Dominic Bromley | **M** Scabetti | **P** Mofo Creative Photography

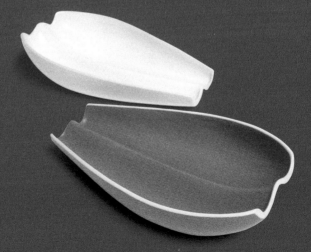

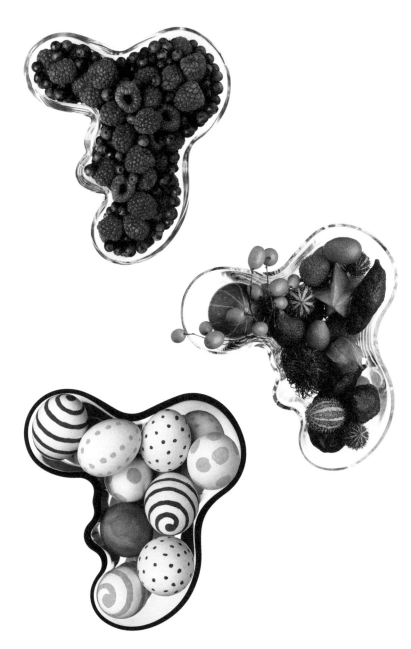

Aalto, 1932 | D ALVAR AALTO | M IITTALA

79

Had Salad Service, 2003 | **D** Iittala | **M** Iittala

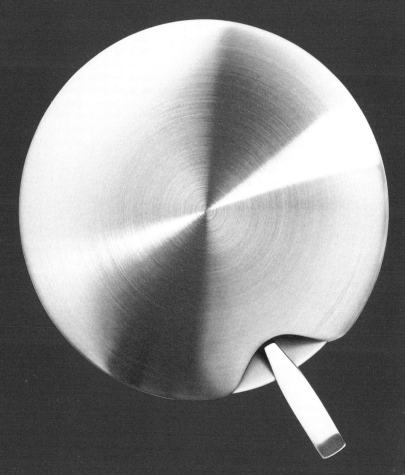

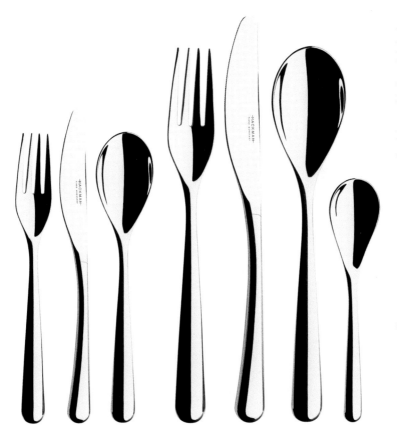

Piano, 1998 | **D** Renzo Piano | **M** Iittala

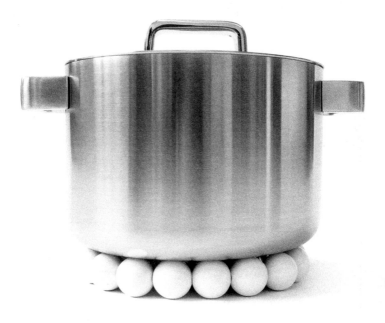

82

83

Spice, 2002 | **D** Constantinos Hoursoglou | **M** Own Production | **P** Anne-Laure Oberson

84

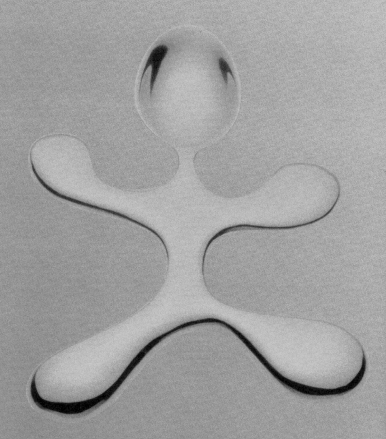

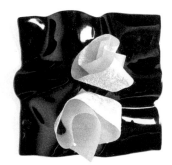

Tiny Follies Tray, 1996 | **M** EL BULLI | **P** FRANCESC GUILLAMET

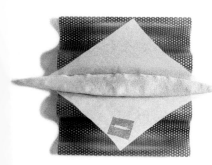

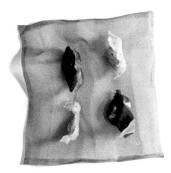

Snack Supports, 2004 | **D** LUKI HUBER | **M** EL BULLI | **P** FRANCESC GUILLAMET

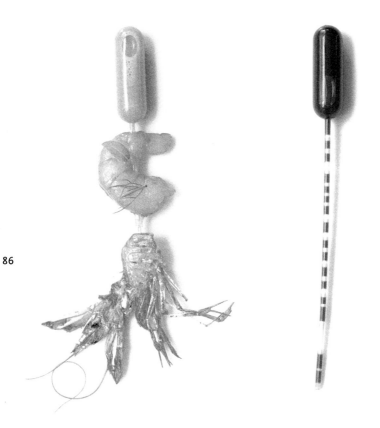

86

Knife Block, 2002 | **D** B. Daemmer, D. Sebel | **M** Zwilling J. A. Henckels AG | **P** Ursula Raapke

87

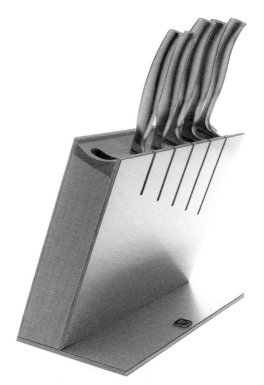

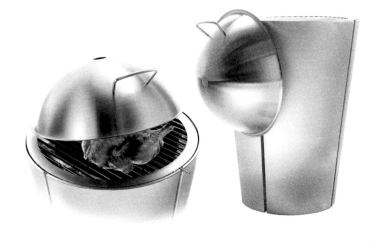

88

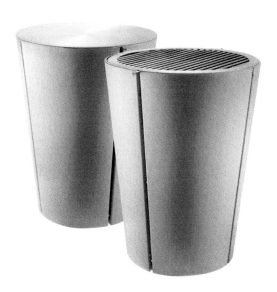

Cooking Lid, 2004 | **D** Tools Design | **M** Eva Denmark | **P** Tools Design

90

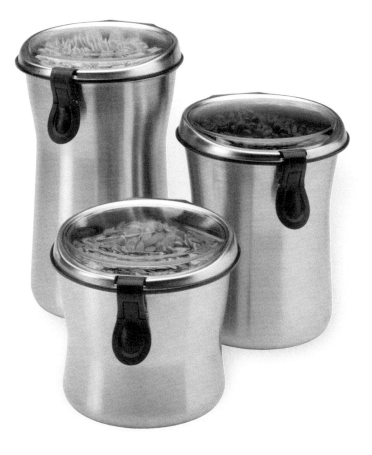

91

Garden, 1999 | **D** ALDO CIBIC | **P** SANTI CALECA

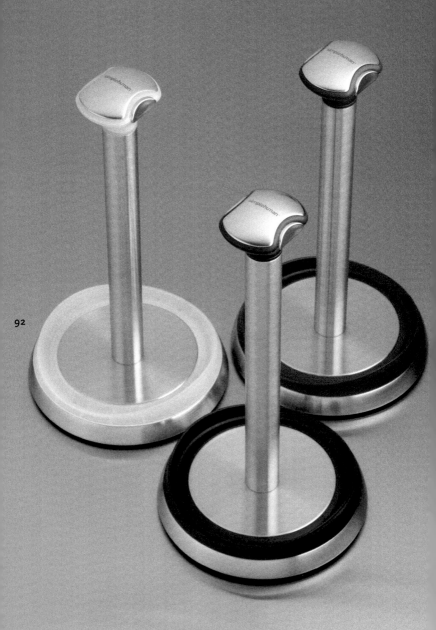

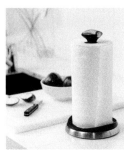
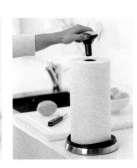

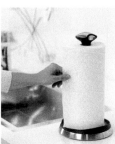
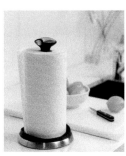

Quick Load Paper Towel Holder, 2004 | **D** Lum Design Associates | **M** Simplehuman | **P** Gregory Page

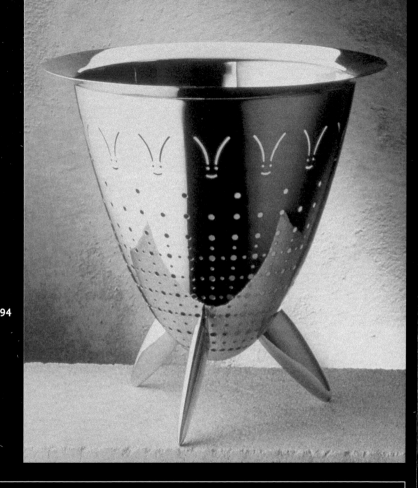

94

Max le Chinois, 1990 | D Philippe Starck | M Alessi | P Alessi

Nut Hammer, 2001 | **D** Tools Design | **M** Eva Denmark | **P** Tools Design

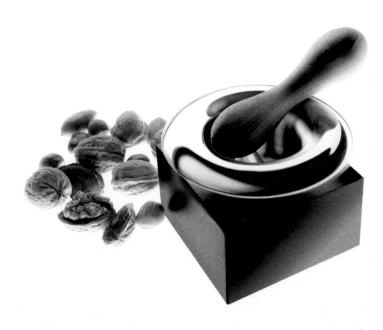

96

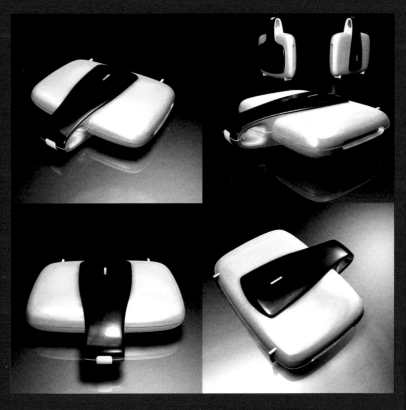

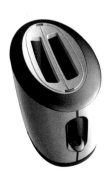

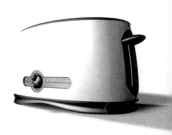

Aluminum Toaster, 2004 | **D** RALPH CHRISTIAN BREMENKAMP | **M** GALANZ ENTERPRISE

98

Polder Analog Cooking Thermometers, 2004 | **D** Stuart Harvey Lee, Robyn Kaminski | **M** Polder Inc.

Dishes Holder, 2001 | **D** Designers, Martin Necas | **M** Concept | **P** Digital Rendering

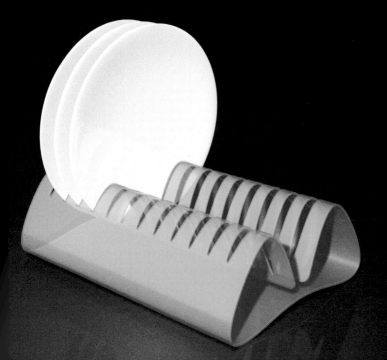

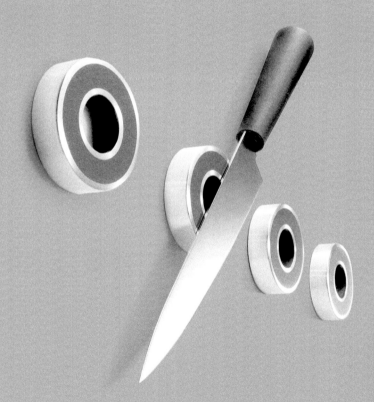

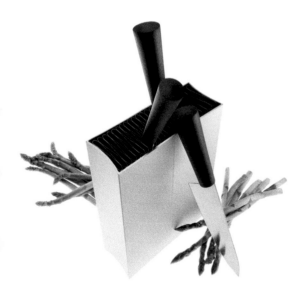

Knife Stand, 1999 | **D** TOOLS DESIGN | **M** EVA DENMARK | **P** TOOLS DESIGN

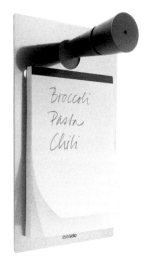

Memo Board, 1999 | **D** Tools Design | **M** Eva Denmark | **P** Tools Design

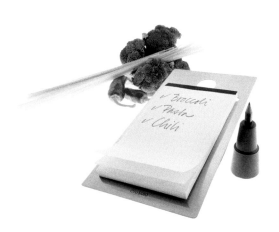

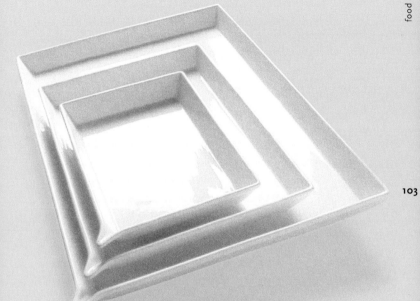

Drip, 1999 | **D** ALDO CIBIC | **P** SANTI CALECA

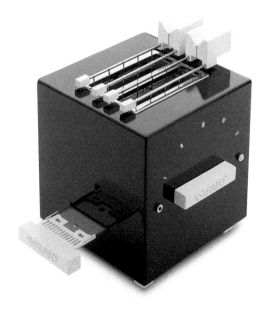

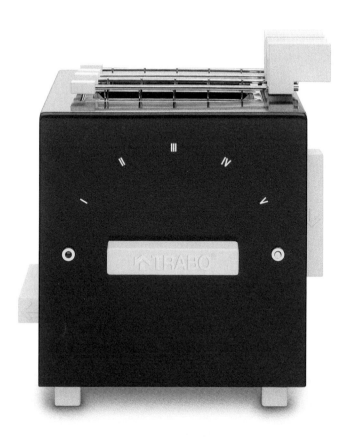

Block, 2004 | **D** Piero Russi | **M** Trabo | **P** G & G Global Milano

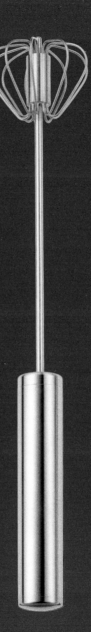

Kult Milk Frother, 2003 | **D** Metz & Kindler | **M** WMF AG | **P** WMF AG

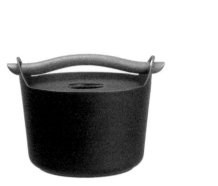

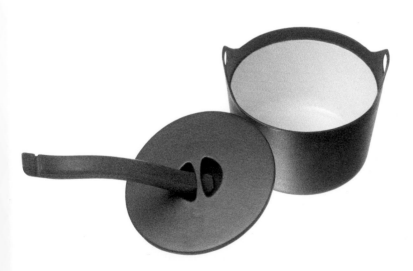

Sarpaneva, 1960 | **D** Timo Sarpaneva | **M** Iittala

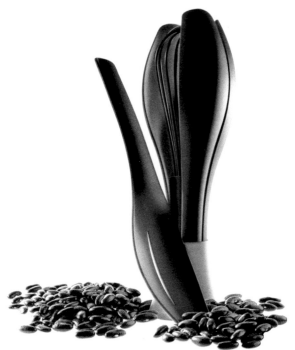

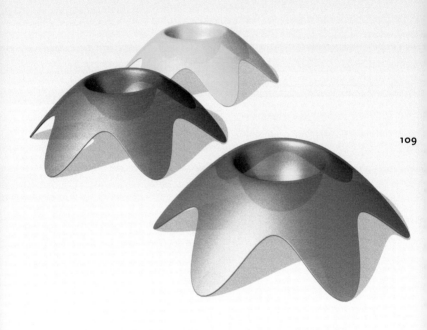

109

Egg Cup Flower, 2002 | **D** Martin Necas | **M** Concept | **P** Digital Rendering

110

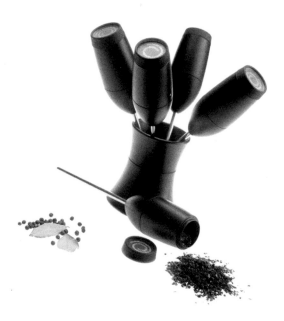

Digital Kitchen Timer, 2003 | **D** Lum Design Associates | **M** Concept | **P** Digital Rendering

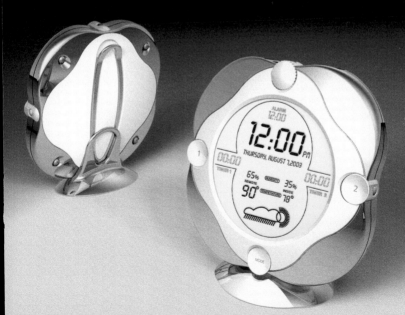

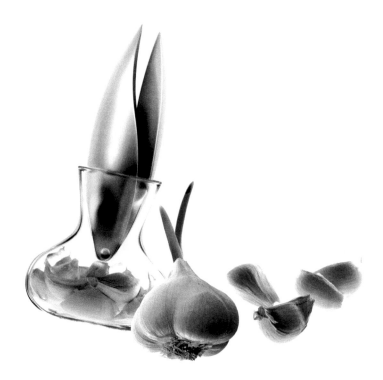

Royal, 2001 | **D** KELLY SANT | **P** SANTI CALECA

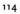

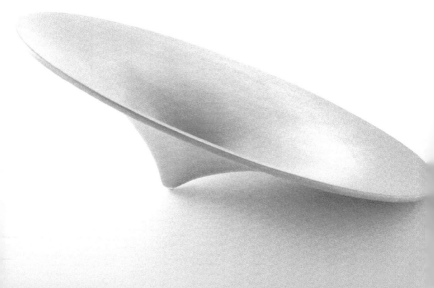

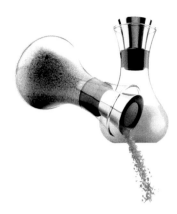

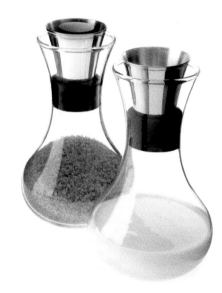

115

Milk and Sugar Set, 2004 | **D** Tools Design | **M** Eva Denmark | **P** Tools Design

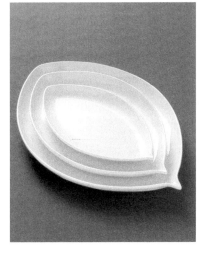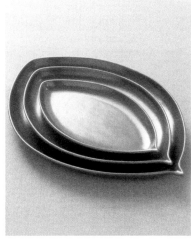

116

Foglia, 2000 | **D** Aldo Cibic | **P** Santi Caleca

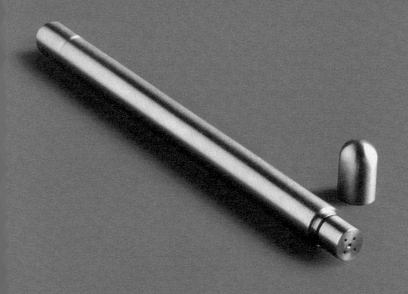

117

Asella Peeler, 2002 | **D** ADOLFO JOHNNY VENIDA | **M** INNOVAID ID INC. | **P** ADOLFO JOHNNY VENIDA

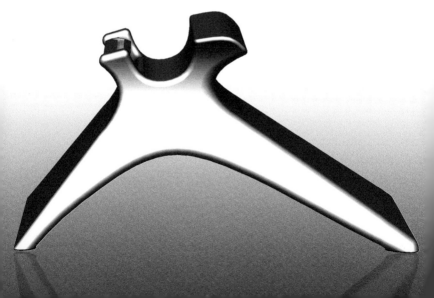

Fruit Peeler, 1997

Fruit Knife, 1997

119

Apple Corer, 1997

D Tools Design | **M** Eva Denmark | **P** Tools Design

120

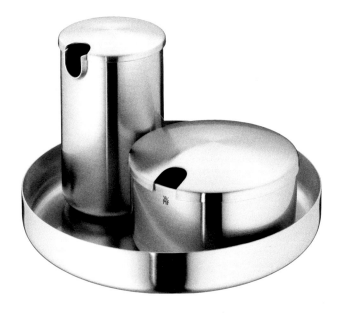

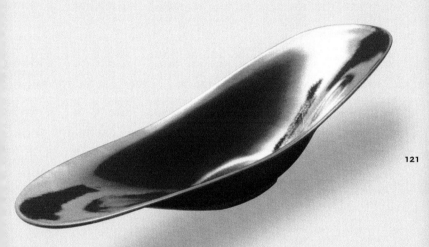

Gabbiano, 2000 | **D** ALDO CIBIC | **P** SANTI CALECA

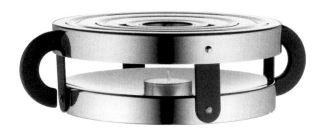

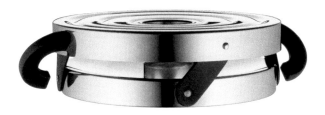

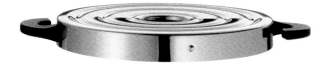

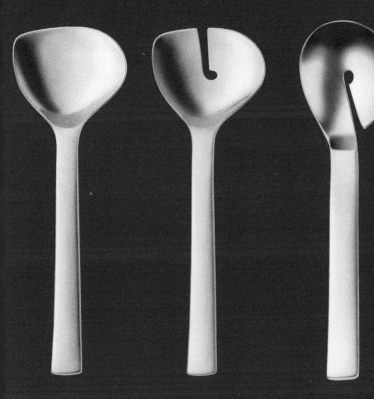

Salad Server *Salad Server* *Olive Server*

Style, 2004 | **D** Daniel Eltner | **M** WMF AG | **P** WMF AG

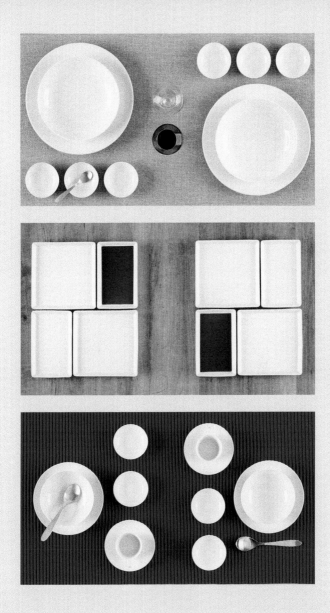

Convito, 2003 | **D** Pia Törnell | **M** Rörstrand | **P** Rörstrand

126

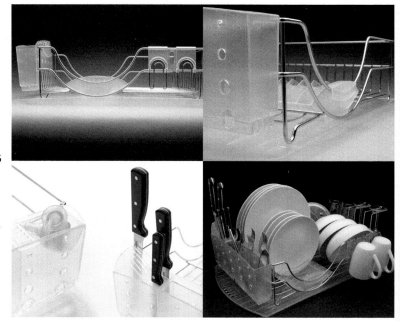

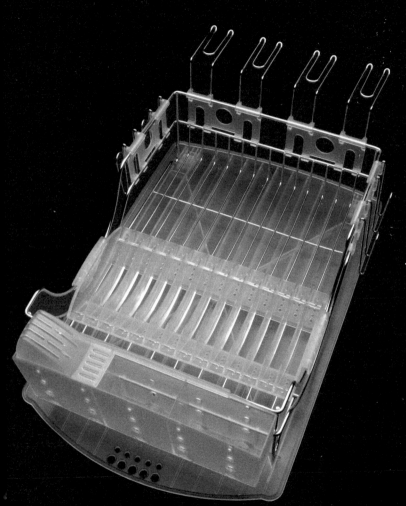

128

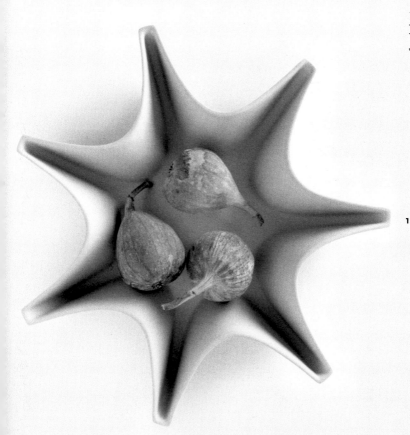

Asteria, 1996 | **D** Pia Törnell | **M** Rörstrand | **P** Rörstrand

Magnito Salt & Pepper, 2005 | **D** Josh Owen | **M** Kikkerland | **P** Julie Marquart

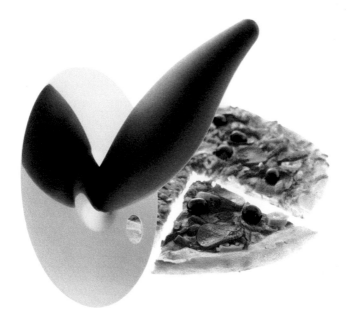

Pizza Cutter, 1999 | **D** Tools Design | **M** Eva Denmark | **P** Tools Design

132

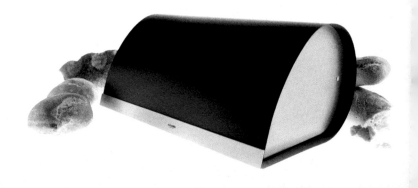

2-in-1 Milk and Sugar Set, 2003 | **D** Mario Taepper | **M** WMF AG | **P** WMF AG

134

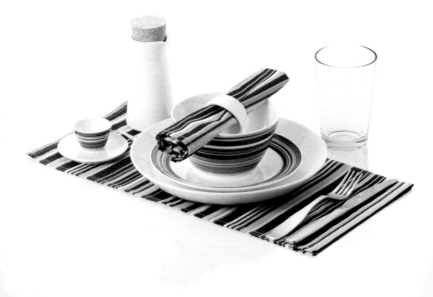

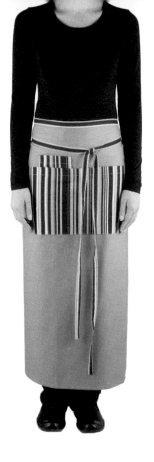
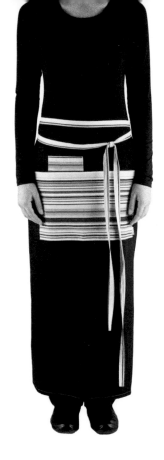

Origo Apron, 1999 | **D** ALFREDO HÄBERLI | **M** IITTALA

Origo Napkins and Kettle Gloves, 1999 | D ALFREDO HÄBERLI | M IITTALA

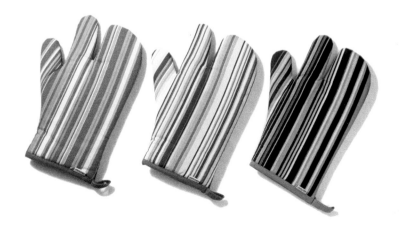

137

Origo Paper Napkins, 1999 | D ALFREDO HÄBERLI | M IITTALA

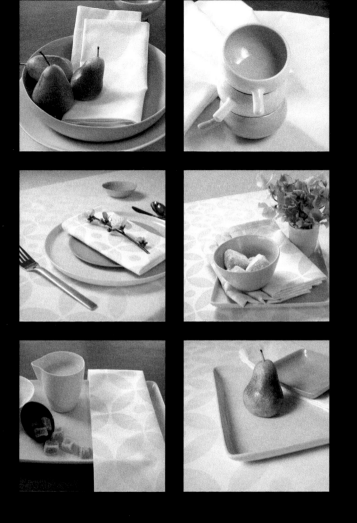

Geo Napkin and Tablecloth, 2004

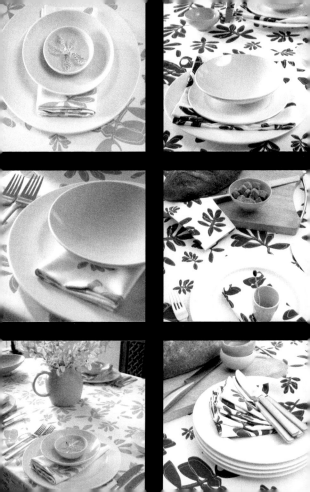

140

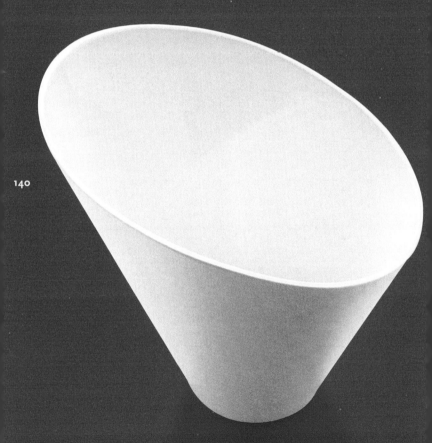

Emergency Sunglasses, 2003 | **D** MASSIMO FENATI | **M** MASSIMO FENATI | **P** MASSIMO FENATI

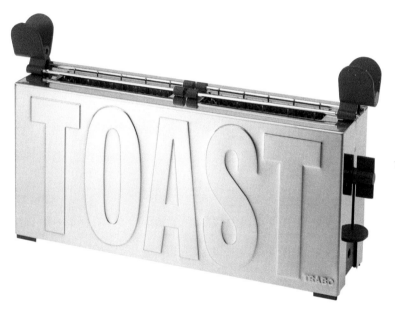

143

Toast, 1998 | **D** Gae Aulenti | **M** Trabo | **P** G & G Global Milano

144

Apron Olé, 2005

Apron Ñ, 2005

145

Ølé

Apron Capote, 2003

Apron Vino Tinto, 2004

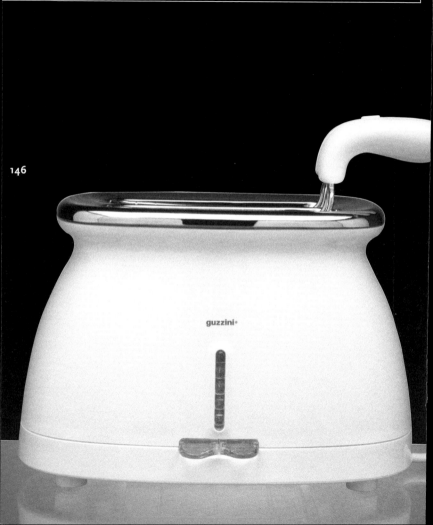

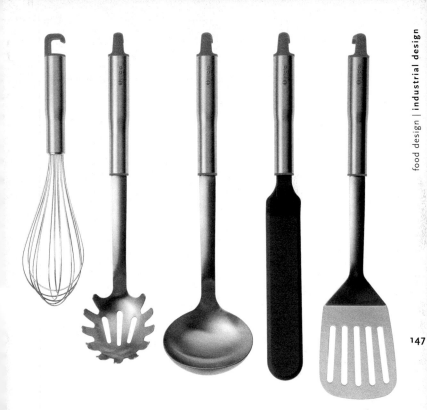

147

Kitchen Utensils, 2002 | **D** Harri Koskinen | **M** Iittala

148

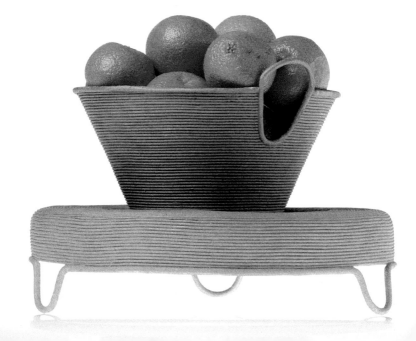

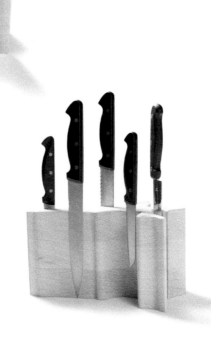

149

Throwzini, 2005 | **D** ADAM UND HARBORTH | **M** KONSTANTIN SLAWINSKI | **P** CHRISTOPHER LEDWIG

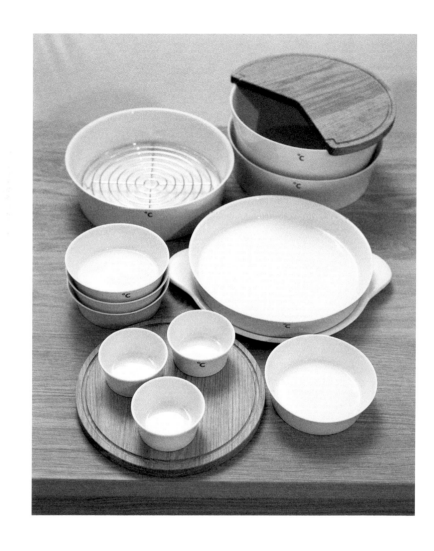

Grade, 2000 | **D** Pia Törnell | **M** Rörstrand | **P** Rörstrand

Kitchen Utensils, 2002 | D HARRI KOSKINEN | M IITTALA

151

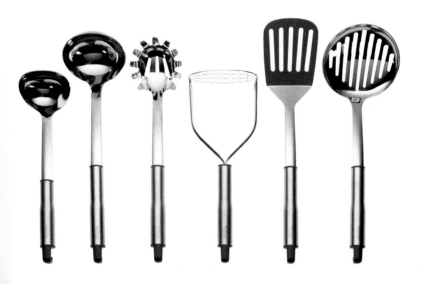

152

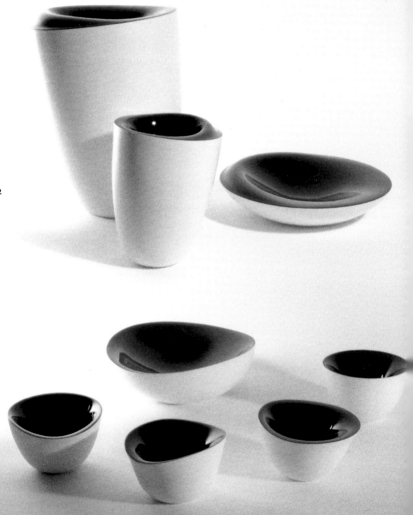

153

Complet Sugar Bowl, 1993 | **D** JØRGEN MØLLER | **M** GEORG JENSEN

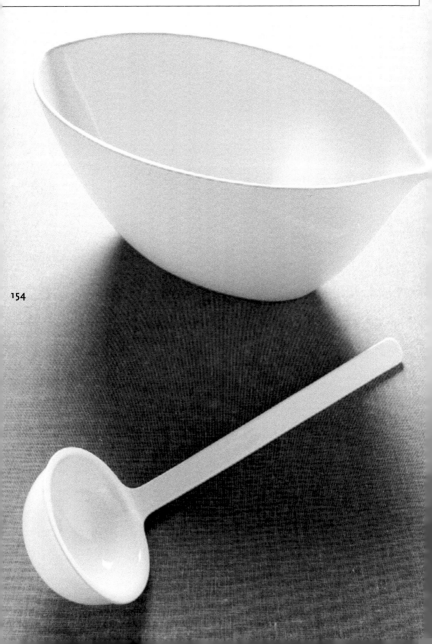

154

155

Cutting Boards, 1997 | **D** TOOLS DESIGN | **M** EVA DENMARK | **P** TOOLS DESIGN

Swedish Grace, 1999 | **D** Pia Törnell | **M** Rörstrand | **P** Rörstrand

158

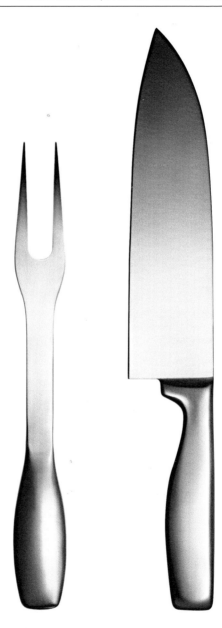

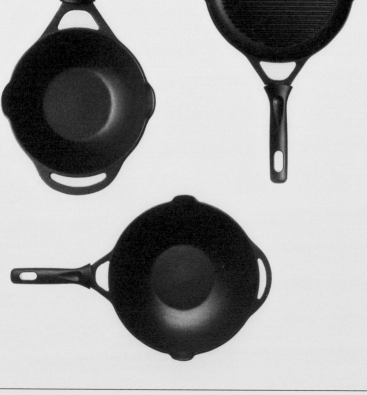

Panny, 1997 | **D** NANNY STILL | **M** IITTALA

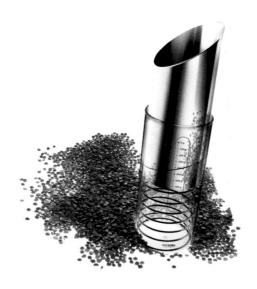

161

Kitchen Scales, 2001 | **D** Tools Design | **M** Eva Denmark | **P** Tools Design

162

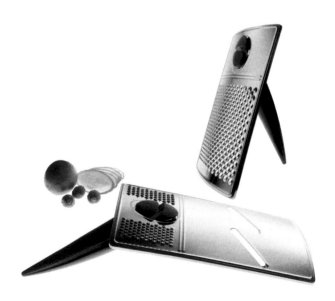

Nilo, 1999 | **D** ALDO CIBIC | **P** SANTI CALECA

p. 32
Hot Soup Cup

A perfect solution: ceramic bowl and saucer in one piece, very convenient for avoiding spillage. It is also ideal for hot desserts.

Die perfekte Lösung. Keramikteller und Schüssel in einem, was ein Verschütten vermeidet. Dient gleichzeitig für warmen Nachtisch.

La solution idéale : assiette en céramique et bol à soupe en un seul élément pour éviter les débordements. Sert aussi pour les desserts chauds.

La solución perfecta: plato de cerámica y bol en una sola pieza que evita derrames. Sirve también para postres calientes.

La soluzione perfetta: piatto di ceramica e scodella in un unico pezzo che evita versamenti. Utile anche per dolci caldi.

p. 33
Cheese Slicer

Tools Design has created this hybrid cheese slicer cum knife which allows the thickness of the slice of cheese to be graduated. Made of stainless steel.

Tools Design hat eine Mischung aus Käsereibe und Messer entworfen, mit der man die Dicke des Schnitts regulieren kann. Aus Edelstahl.

Tools Design a créé un mélange de râpe à fromage et de couteau permettant de régler l'épaisseur de la coupe. En acier inoxydable.

Tools Design ha creado un híbrido de laminador de queso y cuchillo que permite regular el grosor del corte. De acero inoxidable.

Tools Design ha creato un ibrido d'affetta formaggio e coltello che consente di regolare lo spessore del taglio. In acciaio inossidabile.

p. 34
Alex Cutlery

The extra-light prototypes designed by Jack Frederick merge the handle, stem and blade sections of the flatware.

Die Gestaltung dieser besonders leichten Prototypen von Jack Frederick lässt die Grenze zwischen dem Griff und dem Ende des Bestecks verschwinden.

Le design de ces prototypes ultra légers, signés Jack Frederick, fusionne le manche et la lame, gommant les limites.

El diseño de estos ligerísimos prototipos de Jack Frederick difumina el límite entre el mango del cubierto y su extremo.

Il design di questi leggerissimi prototipi di Jack Frederick sfuma il limite esistente tra il manico della posata e della sua estremità.

p. 35
Naji Cutlery

Naji plays on the liquid appearance of the metal used to create this set of "sculpted" cutlery.

Naji spielt mit dem fließenden Aussehen des benutzten Metalls, um dieses skulptural wirkende Besteck zu schaffen.

Naji joue avec l'apparence liquide du métal utilisé pour élaborer ces couverts d'aspect sculptural.

Naji juega con la apariencia líquida del metal utilizado para elaborar estos cubiertos de apariencia escultórica.

Naji gioca con l'apparenza liquida del metallo utilizzato per elaborare queste posate dall'apparenza scultorea.

pp. 36-37
Hi.link

Porcelain table china custom made for Hotel HI. The four-piece sets comprise dinner plate, bowl, a side dish and a glass.

Tischgeschirr aus Porzellan für das Hotel HI. Das Set aus vier Teilen enthält Teller, Glas, Schale und eine kleine Schale.

Vaisselle de table de porcelaine élaborée pour l'Hôtel HI. L'ensemble de quatre pièces comprend assiette, verre, bol et un petit récipient.

Vajilla de mesa de porcelana elaborada para el Hotel HI. La combinación de cuatro piezas incluye plato, copa, bol y un pequeño recipiente.

Servizio di patti in porcellana elaborato per l'Hotel HI. La combinazione di quattro pezzi include piatto, bicchiere, tazza grande ed un piccolo recipiente.

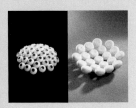

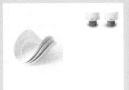

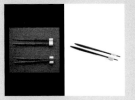

pp. 38-39
Kalpa

Multiple-use dishes in avant-garde designs from the collections of various museums, including the Stedelijk Museum in Amsterdam.

Vielzweckbehälter im Avantgardedesign, die zu den Sammlungen verschiedener Museen gehören, darunter das Stedelijk Museum in Amsterdam.

Récipients polyvalents au design avant-gardiste appartenant aux collections de divers musées, dont le Stedelijk Musée d'Amsterdam.

Recipientes multiuso de diseño vanguardista pertenecientes a las colecciones de varios museos, entre ellos el Museo Stedelijk de Amsterdam.

Recipienti multiuso di design avanguardista appartenenti alle collezioni di vari musei, tra i quali il Museo Stedelijk d'Amsterdam.

p. 40
Handful of Plates

A set of three ceramic dishes in the shape of a Mexican taco which facilitate eating with only one hand. Perfect for informal parties.

Ein Set aus drei Keramiktellern, die die Form eines mexikanischen Tacos haben und mit denen man mit nur einer Hand essen kann. Ideal für Feste.

Set de trois assiettes de céramique en forme de taco mexicain qui permet de manger d'une seule main. Idéales pour les fêtes.

Set de tres platos de cerámica con forma de taco mexicano que permiten comer con una sola mano. Ideales para fiestas.

Set di tre piatti in ceramica con forme di taco messicano che consente di mangiare con una sola mano. Ideali per le feste.

p. 41
Shake

Matching salt cellar and pepper pot made of white stoneware, easily told apart by their large, differentiated cork stoppers.

Set mit Salz- und Pfefferstreuer aus weißem Steingut, das von einem großen Korken gekrönt wird, durch den man sie perfekt unterscheidet.

Jeu de salière et poivrier en grès blanc couronnés d'un bouchon de liège permettant de bien les différencier.

Juego de salero y pimentero de gres blanco coronados con un gran tapón de corcho que permite distinguirlos claramente.

Sale e pepe in gres bianco rifiniti con un gran tappo di sughero che consente di distinguerli chiaramente.

p. 42-43
Chowbella

Joe Doucet's elegant porcelain rest keeps chopsticks tidily together.

Die eleganten Stäbchen von Joe Doucet ruhen auf einem Porzellanelement, das sie gleichzeitig vereint.

Les élégants baguettes de Joe Doucet reposent sur un élément en porcelaine qui sert à les réunir.

Los elegantes palillos de Joe Doucet descansan sobre una pieza de porcelana que sirve también para mantenerlos unidos.

Gli eleganti bastoncini di Joe Doucet riposano su di un pezzo di porcellana che serve anche per mantenerli uniti.

165

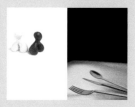

p. 44
Amoeba Condiment Set

Anthropomorphic salt and pepper set designed by Dominic Bromley in black (pepper pot) and white (salt cellar).

Ein Set aus einem anthropomorphen Salz- und Pfefferstreuer von Dominic Bromley in weiß (der Salzstreuer) und schwarz (der Pfefferstreuer).

Jeu de salière et poivrier anthropomorphiques de Dominic Bromley en blanc (la salière) et noir (le poivrier).

Juego de salero y pimentero antropomórficos de Dominic Bromley en colores blanco (el salero) y negro (el pimentero).

166

Sale e pepe antropomorfici di Dominic Bromley in colori bianco (la saliera) e nero (il porta pepe).

p. 45
Gourmet

A set of cutlery with a clean-cut, ergonomic design. Its main feature is the abrupt peg, separating the handle from the business end.

Besteckset mit klaren, ergonomischen Formen. Seine Ausdruckskraft ist auf die plötzliche Trennung des Griffs von dem funktionellen Ende zurückzuführen.

Jeu de couverts aux formes pures et ergonomiques. Leur point fort réside dans la séparation nette entre le manche et l'extrémité.

Juego de cubiertos de formas limpias y ergonómicas. Su fuerza reside en la abrupta separación entre el mango y el extremo funcional.

Servizio di posate dalle forme pulite ed ergonomiche. La sua forza radica nella secca separazione tra il manico e l'estremità funzionale.

p. 46
Bird Feeder

This bird feeder looks rather like an old-fashioned hourglass. The birdseed can be seen through the transparent sides of the container.

Futterplatz für Vögel, dessen Form an traditionelle Sanduhren erinnert. Der Behälter ist transparent und man sieht den Inhalt.

Mangeoire pour oiseaux dont la forme rappelle les sabliers traditionnels. Le contenant transparent permet de voir le contenu.

Comedor para pájaros cuya forma recuerda a los tradicionales relojes de arena. El depósito es transparente y permite ver su contenido.

Contenitore di cibo per uccelli cui forma ricorda i tradizionali orologi a sabbia. Il deposito è trasparente per consentire di vederne il contenuto.

p. 47
Duspaghi

The Duspaghi fork features a double stop to prevent spaghetti from becoming entangled on the fork's handle and spattering sauce.

Die Gabel Duspaghi hat einen doppelten Anschlag, der es vermeidet, dass sich die Spagetti um den Griff wickeln und die Sauce spritzt.

La fourchette Duspaghi comprend un double embout qui empêche les spaghettis de s'enrouler sur le manche et prévient les éclaboussures de sauce.

El tenedor Duspaghi incluye un doble tope que evita que los espaguetis se enrollen en el mango y que la salsa salpique.

La forchetta Duspaghi include un doppio fermo che evita che gli spaghetti si arrotolino sul manico, e che il sugo possa schizzare.

p. 48
Polar Ice Glass

These glasses have a compartment for ice cubes, so that they do not melt into the beverage.

Ein Set Gläser, zu dem ein kleiner Eisbehälter gehört, der verhindert, dass die Eiswürfel in dem Getränk schmelzen.

Jeu de verres avec un petit récipient intégré pour éviter que les cubes de glaces ne fondent dans le boisson.

Juego de vasos que incorpora un pequeño contenedor para los cubitos de hielo que evita que se derritan en la bebida.

Servizio di bicchieri dotato di un piccolo contenitore per i cubetti di ghiaccio per evitare che si sciolgano nella bibita.

p. 49
Homewear Collection

Toaster (vertical) and pizza oven (horizontal) designed by the renowned designer Matali Crasset.

Toaster (vertikal) und Fläche zum Aufwärmen von Pizzas (horizontal) von der bekannten Designerin Matali Crasset.

Toaster (vertical) et chauffe pizzas (horizontal) signé par l'illustre designer Matali Crasset.

Tostadora (vertical) y base para calentar pizzas (horizontal) de la reconocida diseñadora Matali Crasset.

Tostapane (verticale) e base per riscaldare pizze (orizzontale) della nota disegnatrice Matali Crasset.

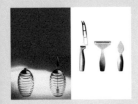 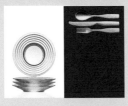

p. 50
Honey Pot & Sugar Jar

Matching jars for honey (with a spiral spoon to serve the honey) and sugar, with a beehive motif.

Set aus einem Honigtopf (mit einem spiralförmigen Löffel zum Servieren) und einem Zuckerbehälter in Form eines Bienenstocks.

Jeu de pot de miel (avec un bâtonnet en spirale qui permet de le servir) et de récipient à sucre en forme de ruche.

Juego de tarro para la miel (con un brazo en espiral que sirve para servirla) y recipiente para el azúcar con forma de colmena.

Set di barattolo per il miele (con un braccio a spirale per servirlo) e recipiente per lo zucchero a forma d'arnia.

p. 52
Aino Aalto

Traditional tableware by Aino Aalto. Equally perfect at formal dinner occasions or children's tea parties.

Geschirrset in traditionellen Linien von Aino Aalto, das sowohl für ein förmliches Abendessen als auch für einen Kindergeburtstag geeignet ist.

Jeu de vaisselle aux lignes traditionnelles de Aino Aalto. Peut servir pour un dîner formel ou pour des fêtes d'anniversaire d'enfant.

Juego de vajilla de líneas tradicionales de Aino Aalto; tanto para una cena formal como para la fiesta de cumpleaños de los niños.

Servizio di piatti dalle linee tradizionali d'Aino Aalto; tanto per una cena formale quanto per feste di compleanno per bambini.

p. 54
Mango

Nanny Still's naif Mango cutlery is still a favourite with designers all over the world.

Der kindliche Retrostil des Bestecks Mango von Nanny Still ist weiterhin einer der beliebtesten Stile von Designern auf der ganzen Welt.

La ligne rétro et infantile des couverts Mango de Nanny Still continue d'être la préférée de tous les designers du monde entier.

La línea retro e infantil de la cubertería Mango de Nanny Still continúa siendo una de las preferidas por los diseñadores de todo el mundo.

La linea retro ed infantile delle posate Mango di Nanny Still continua ad essere una delle preferite dei designer di tutto il mondo.

p. 51
Collective Tools

Complete set of kitchen utensils, including cheese knife, potato peeler, and kitchen knives. Everything you need to throw a successful party.

Set Küchenutensilien. Käsemesser, Schälmesser, Küchenmesser ... alles, was sich der Gastgeber eines Festes wünscht.

Jeu d'ustensiles pour la cuisine : couteau à fromage, éplucheur, couteaux de cuisine... tout pour plaire à l'amphitryon de la fête.

Juego de utensilios para la cocina: cuchillo de queso, pelador, cuchillos de cocina... todo lo que puede desear el anfitrión de la fiesta.

Set d'utensili per la cucina: coltello per il formaggio, pelatore, coltelli da cucina... tutto quanto necessario all'anfitrione della festa.

p. 53
Citterio

Cutlery from the Citterio collection. This bold, striking design has become a genuine modern classic.

Das gewagte und auffallende Design dieses Bestecks aus der Kollektion Citterio ist zu einem wahren modernen Klassiker geworden.

Le design osé et attrayant de ces couverts de la collection Citterio est devenu un véritable classique moderne.

El atrevido y llamativo diseño de esta cubertería de la colección Citterio la ha convertido en un auténtico clásico moderno.

L'ardito e vistoso design di questo servizio di posate della collezione Citterio lo ha reso un autentico classico moderno.

p. 55
Green Plates

Iittala has designed tableware in a range of sizes that nests together like a russian matryoshka.

Tellerset von Iittala mit Tellern verschiedener Größen, die sich wie Babuschkas ineinander schieben lassen.

Jeu d'assiettes de Iittala de formats différents qui s'imbriquent les unes dans les autres, à l'instar de poupées russes.

Juego de platos de Iittala de diferentes tamaños que se introducen unos dentro de otros como si se tratara de muñecas rusas.

Set di piatti d'Iittala di varie dimensioni che si introducono uno dentro gli altri come delle vere bamboline russe.

167

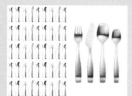

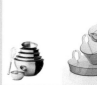

pp. 56-57
Kids Stuff

Alfredo Häberli has designed this cutlery for children to free them from struggling with knives and forks made for adults.

Kinderbesteck von Alfredo Häberli, das die Schwierigkeiten lösen soll, die Kinder bei der Benutzung von Utensilien für Erwachsene haben.

Couverts d'Alfredo Häberli exprès pour les enfants, qui ont du mal à utiliser les ustensiles pour adultes.

Cubertería de Alfredo Häberli diseñada para niños, que intenta resolver la dificultad que les supone utilizar utensilios para adultos.

168

Servizio di posate d'Alfredo Häberli disegnato per bambini, che cerca di risolvere la difficoltà che hanno nell'usare utensili per adulti.

p. 58
Kitchen Utensils

This range of kitchen utensils was designed by Harri Koskinen following minute recommendations from professional chefs.

Die Kollektion von Küchenutensilien von Harri Koskinen wurde bis ins kleinste Detail nach den Ratschlägen professioneller Küchenchefs gestaltet.

La collection d'ustensiles de cuisine de Harri Koskinen a été conçue jusque dans les moindres détails sur les conseils de chefs professionnels.

La colección de utensilios de cocina de Harri Koskinen ha sido diseñada hasta en los mínimos detalles, siguiendo los consejos de chefs profesionales.

La collezione d'utensili da cucina di Harri Koskinen è stata disegnata sino nei minimi dettagli seguendo i consigli di chef professionisti.

p. 59
Lindfors

Set of serving spoons guaranteed to be the centrepiece at any get-together.

Set aus Schöpflöffel und Schaumlöffel, die zum Zentrum der Aufmerksamkeit bei jeder Zusammenkunft werden.

Jeu de louches et écumoires pour devenir le point de mire de toute réunion.

Juego de cucharón y espumadera destinados a convertirse en el centro de atención de cualquier reunión.

Set di mestolo e schiumaiuolo destinati a diventare il centro d'attenzione di qualsiasi riunione.

p. 60
Steel Bowls

Set of stainless steel bowls in a range of sizes in which the contents can be gauged thanks to the measuring scale printed on the interior.

Set aus Edelstahlschalen in verschiedenen Größen, bei denen man den Inhalt mit der Skala im Inneren messen kann.

Jeu de bols en acier inoxydable de divers formats permettant de mesurer le contenu grâce aux mesures gravées à l'intérieur.

Juego de bols de acero inoxidable de varios tamaños que permiten medir el contenido gracias a la escala grabada en su interior.

Set di scodelle d'acciaio inossidabile di varie dimensioni che consentono di misurare il contenuto grazie alla scala incisa all'interno.

p. 61
Akasma

The designer Satyendra Pakhalé created these Akasma-glass objects inspired by the work of the Japanese designer Issey Miyake.

Der Designer Satyendra Pakhalé schuf diese Glasbehälter, inspiriert von Kreationen des japanischen Designers Issey Miyake.

Le designer Satyendra Pakhalé a créé ces récipients de verre en s'inspirant des créations du designer japonais Issey Miyake.

El diseñador Satyendra Pakhalé creó estos recipientes de cristal inspirándose en las creaciones del diseñador japonés Issey Miyake.

Il designer Satyendra Pakhalé ha creato questi recipienti di vetro ispirandosi alle creazioni del designer giapponese Issey Miyake.

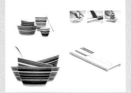

p. 62
Convito

According to Pia Törnell, design and functionality do not clash. Her tableware appeals to good taste everywhere.

Pia Törnell ist der Ansicht, dass Design und Funktionalität nicht unvereinbar sind. Ihre Teller und das Geschirr sind dem guten Geschmack verpflichtet.

D'après Pia Törnell, le design et la fonctionnalité ne sont pas incompatibles. Ses assiettes et vaisselles relèvent du bon goût.

Según Pia Törnell, el diseño y la funcionalidad no están reñidos. Sus platos y vajillas apelan al buen gusto.

Secondo Pia Törnell, il design e la funzionalità possono andare di pari passo. I suoi piatti e le sue stoviglie chiamano il buon gusto.

p. 63
Cutlery 01 Matt, 01, 02

Sinuous shapes and asymmetric design are the distinguishing features of this Tools Design range of cutlery.

Kurvige Formen und asymmetrisches Design sind die typischen Merkmale dieses Bestecks von Tools Design.

Formes sinueuses et designs asymétriques définissent ces couverts créés par Tools Design.

Formas sinuosas y diseños asimétricos son los rasgos distintivos de esta cubertería diseñada por Tools Design.

Forme sinuose e design asimmetrici sono gli elementi distintivi di questo servizio di posate disegnato da Tool Design.

p. 64
Origo

Alfredo Häberli's pieces are a festival of colors and forms, and they are dishwasher and microwave safe.

Die Schalen von Alfredo Häberli sind ein wahres Fest aus Farben und Formen. Geeignet für Mikrowellenherd und Geschirrspüler.

Les récipients d'Alfredo Häberli sont une véritable explosion de couleurs et de formes. Appropriés pour micro-ondes et lave-vaisselle.

Los recipientes de Alfredo Häberli son una auténtica fiesta de colores y formas. Adecuados para microondas y lavavajillas.

I recipienti d'Alfredo Häberli sono un'autentica festa di colori e forme. Adatto per microonde e lavastoviglie.

p. 65
Crack

Knife and grater in one. Designer: Julian Appelius. To use the grater, separate the knife from the base.

Raspel und Messer in einem von Julian Appelius. Um die Raspel zu benutzen, muss zuerst das Messer von seiner Basis getrennt werden.

Râpe et couteau d'une seule pièce de Julian Appelius. Pour utiliser la râpe, il faut d'abord séparer le couteau de sa base.

Rallador y cuchillo en una sola pieza de Julian Appelius. Para poder utilizar el rallador debe separarse primero el cuchillo de su base.

Grattugia e coltello in un solo pezzo di Julian Appelius. Per usare la grattugia bisogna prima spostare il coltello dalla sua base.

p. 66
Fruit Knife

Ergonomic fruit parer by Andreas Mikkelsen. The blade is cleverly and effectively hidden.

Rundes und ergonomisch geformtes Fruchtschälmesser von Andreas Mikkelsen. Die Klinge ist perfekt verborgen.

Eplucheur de fruits d'Andreas Mikkelsen de forme arrondie et ergonomique. La cuillère est parfaitement dissimulée.

Pelador de frutas de Andreas Mikkelsen de forma redondeada y ergonómica. La cuchilla queda perfectamente disimulada.

Sbuccia frutta d'Andreas Mikkelsen dalla forma arrotondata ed ergonomica. La lama resta perfettamente nascosta.

p. 67
Versatile

Versatile is an energy source for kitchen utensils powered by induction rather than electricity.

Versatile ist eine Energiequelle für Küchenutensilien, die durch Induktion statt durch elektrische Energie funktionieren.

Versatile est une source pour ustensiles de cuisine qui fonctionnent par induction au lieu d'énergie électrique.

Versatile es una fuente de energía para los utensilios de cocina que funcionan por inducción en vez de con energía eléctrica.

Versatile è una fonte d'energia per gli utensili da cucina che funzionano per induzione invece che con energia elettrica.

169

 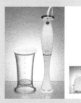

p. 68
Castors Salt and Pepper

These salt and pepper shakers from Castors have evolved from their initial 1970 form, and now recall the black and white mushroom design created in 1998.

Das Set aus Salz- und Pfefferstreuer von Castors hat sich seit dem Design 1970 bis zu den schwarz-weißen Champignons des Jahres 1998 weiterentwickelt.

Le jeu de salière et poivrier de Castors a évolué depuis le design de 1970 pour aboutir aux champignons blancs et noirs de 1998.

El juego de salero y pimentero de Castors ha evolucionado desde el diseño de 1970 y ha llegado a los champiñones blancos y negros de 1998.

La saliera e porta pepe di Castors si è evoluta dal design del 1970 arrivando ai funghi bianchi e neri del 1998.

p. 69
Complet Pepper Grinder

This set of salt and pepper pots are a part of the Complet collection by Jørgen Møller. They appear to be inspired on lipsticks.

Salz- und Pfefferstreuer, die zu dem Set Complet von Jørgen Møller gehören. Ihre Form erinnert an einen Lippenstift.

Salière et poivrier appartenant au set Complet, de Jørgen Møller. Sa forme rappelle vaguement un bâton de rouge à lèvres.

Salero y pimentero que pertenecen al set Complet, de Jørgen Møller. Su forma recuerda vagamente a un pintalabios.

Saliera e porta pepe del set Complet, opera di Jørgen Møller. La loro forma ricorda vagamente un rossetto.

p. 70
Nusskubus

Two wooden cubes for cracking nuts quickly and easily.

Zwei Holzwürfel zum einfachen und bequemen Knacken von Nüssen und anderen Trockenfrüchten mit Schale.

Deux cubes de bois permettent de casser noix et autres fruits secs à coquilles rapidement et facilement.

Dos cubos de madera permiten partir nueces y otros frutos secos con cáscara de forma rápida y cómoda.

Due cubi di legno che permettono di rompere le noci o altri frutti secchi con guscio in modo rapido e comodo.

p. 71
Pizza-pasta-plate

A specially designed platter for pizza and pasta shown at the Europe-Design Exhibition at the 2002 International Biennial of Young Art in Turin.

Dieser Teller für Pizza und Nudeln wurde auf der Ausstellung Europe-Design der Biennale Internazionale Arte Giovane in Turin 2002 gezeigt.

Cette assiette à pizza et pâtes fait partie de l'exposition Europe-Design de la Biennale Internazionale Arte Giovane de Turin de 2002.

Este plato para pizza y pasta formó parte de la exposición Europe-Design de la Biennale Internazionale Arte Giovane de Turín de 2002.

Questo piatto per pizza e pasta è stato esposto alla mostra Europe-Design della Biennale Internazionale Arte Giovane di Torino del 2002.

p. 72
Hand Blender

The work of designers Sowden and Ono for Guzzini. A trumpet-shaped blender.

Mixer der Designer Sowden und Ono der Marke Guzzini. Die Geräte haben die Form einer Trompete.

Batteur des designers Sowden et Ono pour la marque Guzzini. Les ustensiles sont en forme de trompette.

Batidora de los diseñadores Sowden y Ono para la marca Guzzini. Los utensilios tienen forma de trompeta.

Frullatore dei designer Sowden ed Ono per la casa Guzzini. Gli utensili hanno la forma di trombetta.

p. 73
Cheese Grater

Electronic cheese grater by Guzzini with a playful design. It may also be used to grate and chop other foods such as nuts and vegetables.

Elektrische Käseraspel mit verspielter Form der Marke Guzzini. Man kann damit auch andere Lebensmittel wie Nüsse und Gemüse reiben und hacken.

Râpe à fromage électrique de forme ludique de la marque Guzzini. Elle permet aussi de râper et hacher d'autres aliments comme des noix ou des légumes.

Rallador de queso eléctrico de forma juguetona de la marca Guzzini. También permite rallar y picar otros alimentos como nueces y verduras.

Grattugia elettrica per formaggio dalla forma divertente della casa Guzzini. Consente anche di grattugiare e tritare altri elementi come noci e verdure.

p. 74
Potholders in Silicone

Silicone protective pads for holding hot saucepans and dishes. Unlike cloth pot-holders, these provide total insulation from the heat.

Silikontopflappen zum Halten heißer Töpfe und Schüsseln. Im Gegensatz zu Stofftopflappen schützen diese vollständig vor der Hitze.

Maniques de silicone pour soutenir des récipients chauds : à l'inverse des maniques en tissus, celles-ci isolent totalement de la chaleur.

Manoplas de silicona para sostener recipientes calientes: al contrario de las manoplas de tela, éstas aíslan completamente del calor.

Presine di silicone per reggere recipienti caldi: al contrario delle presine in tela, isolano completamente dal calore.

p. 75
Amoeba Long Dish

An exceptionally large vessel in a sculpted shape suitable for a display of fruit, as a bread basket or to serve vegetables.

Sehr großer Behälter mit skulpturaler Form, der als Tablett für Früchte, Brot oder gekochtes Gemüse dienen kann.

Récipient de forme sculpturale et de grand format qui peut servir de coupe de fruits, pour le pain ou pour les légumes cuits.

Recipiente de forma escultórica y de gran tamaño que puede servir como bandeja para la fruta, para el pan o para las verduras cocidas.

Recipienti dalla forma scultorea e gran dimensione che può servire come vassoio per la frutta, per il pane o per verdure cotte.

pp. 76-77
Aalto

A classic from the '30s. Alvar Aalto's vase continues to be one of the most versatile icons of all time.

Ein Klassiker der Dreißigerjahre. Die Vase von Alvar Aalto wird immer noch als eine der vielseitigsten Designikonen aller Zeiten betrachtet.

Un classique des années 30, le vase d'Alvar Aalto reste toujours une des icônes les plus polyvalentes du design intemporel.

Un clásico de los años 30. El vaso de Alvar Aalto sigue considerándose uno de los iconos más versatiles del diseño de todos los tiempos.

Un classico degli anni 30. Il vaso di Alvar Aalto continua ad essere considerato una delle icone più versatili del design di tutti tempi.

p. 78
Teema

Minimalist chinaware by designer Kaj Franck. Each different type of plate is differentiated by its size and color.

Minimalistisches Geschirr von Kaj Franck. Die verschiedenen Teller unterscheiden sich durch Farbe und Größe.

Vaisselle de Kaj Franck au design minimaliste. Les différentes assiettes se différencient par leur couleur et leur format.

Vajilla de Kaj Franck de diseño minimalista. Los diferentes platos se distinguen por su color y su tamaño.

Stoviglia di Kaj Franck dal design minimalista. I vari piatti si contraddistinguono per il loro colore e dimensione.

p. 79
Had Salad Service

Salad servers with long, slim stems that handle like Chinese chopsticks.

Salatbesteck bestehend aus Gabel und Löffel. Die langen und dünnen Stiele ermöglichen eine Handhabung, so als ob es Essstäbchen wären.

Jeu de fourchette et cuillère pour servir la salade. Les longs manches tout en minceur se manipulent à l'instar de baguettes chinoises.

Juego de tenedor y cuchara para servir ensalada. Los mangos largos y delgados permiten manipularlos como si fueran palillos chinos.

Set di forchetta e cucchiaio per servire insalata. I manici larghi e slanciati permettono di manipolarli come se fossero dei bastoncini cinesi.

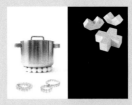

p. 80
Convito

Stainless steel bowl with lid. Minimalist Nordic-style design, Convito goes for usability over empty beauty.

Schale aus Edelstahl mit Deckel. Minimalistisch und im nordischen Stil, Convito zieht die Bequemlichkeit der leeren Schönheit vor.

Bol d'acier inoxydable avec couvercle. Minimaliste et sur la ligne du design nordique. Convito préfère le côté pratique à la vaine beauté.

Bol de acero inoxidable con tapa. Minimalista y en la línea del diseño nórdico; Convito prefiere la comodidad a la belleza hueca.

Recipiente d'acciaio inossidabile con coperchio. Minimalista ed in linea con il design nordico; Convito preferisce la comodità alla bellezza vuota.

172

p. 81
Piano

Renzo Piano's flatware items seem to fit naturally into the user's hand. The serving utensils have wooden handles.

Das Besteck von Renzo Piano ist fast eine Verlängerung der Hand des Benutzers. Das Besteck, das zum Servieren dient, hat einen Holzgriff.

Les couverts de Renzo Piano sont presque la prolongation de la main de l'utilisateur. Les ustensiles de service sont parés de manches en bois.

Los cubiertos de Renzo Piano son casi una extensión de la mano del usuario. Los utensilios que se usan para servir tienen mango de madera.

Le posate di Renzo Piano sono quasi un'estensione della mano dell'utente. Le posate da servizio hanno il manico di legno.

p. 82
Perle

Tablemats with an original design simulating pearls on a necklace which can be linked up in a variety of ways.

Untersetzer in originellem Design, die die Form der Perlen einer Kette imitieren und auf verschiedene Weisen verknüpft werden können.

Dessous de plat au design original : à l'instar des perles d'un collier, il peut prendre des formes différentes.

Salvamanteles de diseño original que imitan la forma de las cuentas de un collar y que pueden enlazarse de distintas formas.

Sottopiatti da portata dal design originale che imitano la forma dei fili di una collana e che possono allacciare in vari modi.

p. 83
Spice

Enamelled porcelain salt and pepper shakers in basic geometrical shapes which, combined together, symbolise the Cross.

Salz- und Pfefferstreuer aus glasiertem Porzellan mit einfachen geometrischen Formen, die in ihrer Kombination ein Kreuz ergeben.

Salière et poivrier de porcelaine émaillée de formes géométriques simples qui en se combinant, rappellent le symbole de la croix.

Salero y pimentero de porcelana esmaltada de formas geométricas básicas que, al combinarse, remiten al simbolismo de la cruz.

Saliera e porta pepe in porcella smaltata dalle forme geometriche di base che, abbinate, ricordano il simbolismo della croce.

p. 84
Golden Spoon

Matteo Thun dreamed of a lucky charm and when he woke up, he designed this spoon and called it "a talisman for living in happiness".

Matteo Thun träumte einmal von einem Glückssymbol und als er aufwachte, entwarf er diesen Löffel, den er als „ein Maskottchen für das glückliche Leben" bezeichnet.

Matteo Thun rêva un jour du symbole de la chance et au réveil, dessina cette cuillère qu'il appelle « une mascotte qui aide à vivre heureux ».

Matteo Thun soñó un día con un símbolo de la buena suerte y al despertar diseñó esta cuchara que llama "una mascota que ayuda a vivir feliz".

Matteo Thun sognò un giorno un simbolo della fortuna ed al risveglio disegnò un cucchiaio che chiama "una mascotte che aiuta a vivere felice".

p. 85
Tiny Follies Tray
Snack Supports

Tiny individual trays as whimsical and unexpected as the appetizers served on them.

Kleine Tabletts: Sie haben fantasievolle und überraschende Formen, ebenso wie die Vorspeisen, die darauf serviert werden.

Mini plateaux aux formes capricieuses et insolites, comme les apéritifs qu'on y sert.

Mini-bandejas de formas caprichosas y sorprendentes, como los aperitivos que se sirven en ellas.

Mini-vassoi disegnati dalle forme capricciose e sorprendenti, come gli aperitivi che vi sono serviti.

p. 86
Prawns Pipette

The traditional laboratory pipette is recreated here for serving prawns for aperitifs. The liquid in the interior is drunk as if the pipette were a straw.

Traditionelle Pipette aus der Medizin, die zu einem Spieß für Vorspeisen wurde. Die Flüssigkeit im Inneren wird aufgesaugt, so als ob es sich um einen Strohhalm handeln würde.

Pipette médicale traditionnelle reconvertie en pince pour apéritifs. Le liquide qu'elle contient s'aspire à l'instar d'une paille.

Pipeta médica tradicional reconvertida en pincho para aperitivos. El líquido contenido en su interior se sorbe como si la pipeta fuera una pajita.

Pipetta medica tradizionale riconvertita in bastoncino per aperitivi. Il liquido contenuto al suo interno è aspirato come se la pipetta fosse una cannuccia.

p. 87
Knife Block

Each slot is marked with the size of the corresponding knife and allows easy removal of the knives from the block.

Die Rillen geben Aufschluss über die Größe des Messers. Außerdem helfen sie dabei, das Messer aus dem Holzblock zu nehmen, der als Stütze dient.

Les rainures indiquent le format du couteau, et facilite son extraction du bloc qui lui sert de support.

Las ranuras informan del tamaño del cuchillo, además de facilitar su extracción del bloque que le sirve de soporte.

Le scanalature forniscono informazioni sulla dimensione del coltello, oltre ad agevolarne l'estrazione dal blocco che gli serve da supporto.

p. 88-89
Cooking Lid

Portable stainless steel grill for barbecue fans in search of a practical and uncomplicated cooking system.

Tragbarer Grill für BBQ-Fans, die sich das Leben nicht unnötig mit technischen Erfordernissen erschweren wollen. Aus rostfreiem Stahl.

Grill portable pour fans de barbecue qui ne souhaitent pas se compliquer la vie avec des techniques et méthodes de cuisson alternatives. En acier inoxydable.

Parrilla portátil para fans de la barbacoa que no quieren complicarse la vida con técnicas y métodos de cocción alternativos. De acero inoxidable.

Griglia portatile per i fan del barbecue che non vogliono complicarsi la vita con tecniche e metodi di cottura alternativi. In acciaio inossidabile.

p. 90
Clear Lid Canisters

The contents of these ergonomic jars are visible through their transparent lids, which are easily opened and closed.

Durch den durchsichtigen Deckel dieser ergonomisch geformten Behälter sieht man den Inhalt. Das Verschlusssystem ist bequem.

Le couvercle transparent de ces pots de forme ergonomique permet de voir leur contenu : le système de fermeture est pratique.

La tapa transparente de estos tarros de forma ergonómica permite ver su contenido; el sistema de cierre es cómodo.

Il coperchio trasparente di questi barattoli di forma ergonomica consente di vedere il suo contenuto; il sistema di chiusura è comodo.

173

p. 91
Garden

White trays with square and vertical ridges on their surface to prevent cutlery and dishes from slipping and sliding.

Weiße Tabletts mit vertikalen und quadratischen Rillen, die verhindern, dass die Bestecke und das Geschirr auf der Fläche rutschen.

Plateaux blancs aux rainures verticales et carrées empêchant les couverts et la vaisselle de glisser.

Bandejas de color blanco con ranuras verticales y cuadradas que impiden que los cubiertos y la vajilla resbalen por su superficie.

Vassoio di color bianco con scanalature verticali e quadrate che impediscono alle posate ed alle stoviglie di scivolare sulla superficie.

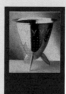

p. 92-93
Quick Load Paper Towel Holder

Kitchen paper holder designed to make changing the roll as simple as possible. A stop prevents the roll from unravelling.

Küchenrollenhalter, der so gestaltet ist, dass das Papier leicht ersetzt werden kann. Eine Vorrichtung verhindert, dass das Papier sich entrollt.

Support de papier de cuisine désigné pour faciliter le remplacement du rouleau. Un embout sur la base empêche le papier de se dérouler.

Soporte para papel de cocina diseñado para que cambiar el rollo resulte lo más fácil posible. Un tope en la base evita que el papel se desenrolle.

Supporto per carta da cucina disegnato per rendere il più facile possibile la sostituzione del rotolo. Un fermo sulla base evita che la carta si srotoli.

p. 94
Max le Chinois

Kitchen colander with an unusual semi-oval design, with holes in amusing shapes. It stands on a tripod.

Küchensieb mit außergewöhnlichem Design und einer halbovalen Form mit Löchern, die lustige Muster bilden. Ein Dreifuß dient als Stütze.

Passoire de cuisine au design surprenant et de forme semi ovale avec des ouvertures formant des motifs amusants. Un tripode lui sert de base.

Colador de cocina de sorprendente diseño y forma semioval con agujeros que forman divertidos dibujos. Un tripode le sirve de base.

Passino da cucina dal sorprendente design e forma semi ovale con fori che compongono divertenti disegni, con un tripode di base.

p. 95
Nut Hammer

A sophisticated nutcracker. A square stand supports a metal funnel in which nuts are placed to be cracked.

Nussknacker mit elegantem Design. Eine quadratische Stütze dient als Halter für einen Trichter aus Metall, in den die Nüsse eingefüllt werden.

Casse-noisettes au design élégant. Une base carrée sert de support à un embout de métal dans lequel on introduit le fruit sec.

Cascanueces de elegante diseño. Una base cuadrada sirve de soporte a un embudo de metal en el que se introduce el fruto seco.

Schiaccianoci d'elegante design. Una base quadrata serve da supporto ad un imbuto di metallo in cui s'introduce il frutto secco.

p. 96
Belmondo Sandwich Maker

A sandwich toaster that looks like a laptop computer. This design did not progress past the prototype phase.

Sandwichmaker mit einer Form, die an ein Laptop erinnert. Dieses Teil blieb immer ein Prototyp und wurde nie hergestellt.

Machine à sandwich dont la forme ressemble à un ordinateur portable. Le design, resté à la phase de prototype, n'a jamais été concrétisé.

Sandwichera de forma similar a un ordenador portátil. El diseño nunca pasó de la fase de prototipo y no llegó a fabricarse.

La Sandwichera dalla forma simile a un computer portatile. Il design non ha mai superato la fase di prototipo, e non è mai stato fabbricato.

p. 97
Aluminum Toaster

This toaster is part of a set of kitchen appliances with a fun, informal but sophisticated design.

Dieser Toaster gehört zu einem Set Küchengeräte mit einem lustigen, sympathischen und durchdachten Design.

Ce toaster fait partie d'un ensemble d'appareils électriques de cuisine amusants, sympathiques au design sophistiqué.

Este tostador forma parte de un set de electrodomésticos de cocina divertidos, simpáticos y de diseño sofisticado.

Questo tostapane fa parte di un set d'elettrodomestici da cucina divertenti, simpatici e dal design sofisticato.

174

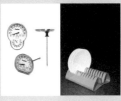

p. 98
Polder Analog Cooking Thermometers

Stainless steel kitchen thermometers with easy-to-read displays and original designs.

Küchenthermometer, die einfach abzulesen sind, in originellen Formen und aus Edelstahl.

Thermomètres de cuisine facile à lire, aux formes originales, fabriqués en acier inoxydable.

Termómetros de cocina fáciles de leer, de formas originales y fabricados en acero inoxidable.

Termometri da cucina di facile lettura, dalle forme originali, realizzati in acciaio inossidabile.

p. 99
Dishes Holder

Rack for draining dishes made from brightly colored plastic. Water drains to the edges instead of running into the centre.

Geschirrhalter zum Abtropfen in kräftigen Farben. Das Wasser läuft auf beiden Seiten ab, statt sich in der Mitte zu sammeln.

Egouttoirs à assiette en plastique et de couleurs vives. L'eau s'égoutte sur les côtés au lieu de s'accumuler au centre.

Escurreplatos fabricado en plástico de vivos colores. El agua escurre hacia los lados en vez de acumularse en el centro.

Scolapiatti fabbricati in plastica dai colori vivaci. L'acqua scorre verso i lati invece di accumularsi al centro.

p. 100
Knife Magnets

Wall magnets for keeping knives handy in the kitchen. Their design is reminiscent of a dartboard.

Wandmagneten, damit man beim Kochen immer die Messer zur Hand hat. Die Form erinnert an eine Zielscheibe.

Aimants muraux pour avoir les couteaux toujours à portée de main lorsque l'on cuisine. Leur forme rappelle celle d'une diane.

Imanes de pared para tener siempre a mano los cuchillos cuando se cocina. Su forma recuerda a la de una diana.

Calamite da parete per tenere sempre a mano i coltelli quando si cucina. La loro forma ricorda un bersaglio.

p. 101
Knife Stand

Kitchen knife stand. As many knives can be stored as the thickness of their handles allows.

Halter für Küchenmesser. Es können soviel Messer gehalten werden, wie dies die Dicke ihrer Griffe zulässt.

Support de couteaux de cuisine. Peut en recueillir un certain nombre en fonction de la taille des manches.

Soporte para cuchillos de cocina. Es posible almacenar tantos como permita el grosor de sus mangos.

Supporto per coltelli da cucina. Se ne possono ordinari vari secondo lo spessore dei loro manici.

p. 102
Memo Board

Memo pad holder. A pointed element allows the holder to be attached to the wall.

Halterung für Notizblocks. Ein Element mit einer spitzen Form ermöglicht die Befestigung an der Wand.

Support de cahier. Un élément en forme de pointe permet de fixer le support sur le mur.

Soporte para libreta. Un elemento en forma de punta permite fijar el soporte en la pared.

Supporto per bloc-notes. Un elemento a punta consente di fissare il supporto sulla parete.

p. 103
Drip

Set of three white ceramic dishes with a run-off channel at one corner to facilitate pouring liquids from one into another.

Set aus drei flachen Schalen aus weißer Keramik mit einem Abfluss an einer Ecke zum Umfüllen des Inhalts in einen anderen Behälter.

Set de trois plateaux de céramique blanche, dotés d'une cannelure à l'un des angles pour transvaser facilement le contenu vers un autre récipient.

Set de tres bandejas de cerámica blanca dotadas de un canalillo en una de las esquinas para facilitar el transvase del contenido a otro recipiente.

Set di tre vassoi in ceramica bianca dotati di una scanalatura su uno degli angoli, per agevolare il travaso del contenuto in un altro recipiente.

175

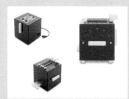
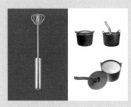

pp. 104-105

Block

Cubic toaster by architect Piero Russi. The electrical lead can be removed for safety.

Toaster in Würfelform von dem Architekten Piero Russi. Das Kabel kann vom Toaster getrennt werden, um Unfälle zu vermeiden.

Toaster de forme cubique de l'architecte Piero Russi. Le câble peut se déconnecter du toaster pour prévenir les accidents.

Tostadora de forma cúbica del arquitecto Piero Russi. El cable puede desconectarse de la tostadora para prevenir accidentes.

Tostapane a forma di cubo dell'architetto Piero Russi. Il cavo può essere staccato dal tostapane per evitare incidenti.

p. 106
Kult Milk Frother

Hand operated device for whipping cream by turning a handle.

Manueller Mixer zum bequemen Sahneschlagen durch Drehen des Griffs.

Batteur manuel qui permet de fouetter la crème facilement en faisant tourner le manche.

Batidora manual que permite montar la nata cómodamente haciendo girar el mango.

Frullatore manuale che consente di montare la panna comodamente facendo girare il manico.

p. 107
Sarpaneva

Stainless steel saucepan, a Finnish design classic. The ingenious handle allows the pan lid or the saucepan itself to be lifted without using a kitchen glove.

Edelstahltopf, ein Klassiker des finnischen Designs. Die geniale Form des Griffes ermöglicht das Heben des Deckels oder des ganzen Topfes ohne Topflappen.

Casserole en acier inoxydable, un classique du design finlandais. La forme géniale de son manche permet de lever le couvercle ou la louche entière sans utiliser de maniques.

Cazo de acero inoxidable, un clásico del diseño finlandés. La genial forma de su mango permite levantar la tapa o el cazo entero sin utilizar manoplas.

Casseruola d'acciaio inossidabile, un classico del design finlandese. La geniale forma del manico consente di alzare il coperchio o la casseruola intera senza usare le presine.

p. 108
Set of Spoons & Spatula

Set of spoons and spatula that fit together in the form of a flower on a specially designed stand.

Set aus Schöpflöffeln, die ineinander greifen und dabei aufgrund der Stütze, die sie vereint, eine Blumenform bilden.

Set de cuillères à spatule qui s'imbriquent l'une dans l'autre pour épouser la forme d'une fleur grâce au support qui les maintient ensemble.

Set de cucharas con espátula que encajan entre ellas adoptando la forma de una flor gracias a su soporte, que las mantiene unidas.

Set di cucchiai con spatola che si incastrano tra di loro adottando la forma di un fiore grazie al supporto, che li mantiene uniti.

p. 109
Egg Cup Flower

Colorful egg cups, simple and lightweight, to brighten up any table.

Eierbecher in lustigen Farben, einfach und leicht, die jeden Tisch fröhlich wirken lassen.

Coquetiers aux couleurs gaies, simples et légers, ajoutant une touche joyeuse à toute table qui les accueille.

Hueveras de colores divertidos, sencillas y ligeras, que le darán un toque de alegría a cualquier mesa.

Porta uova dai colori divertenti, semplici e leggeri, che porteranno un tocco d'allegria su qualsiasi tavolo.

p. 110
Spice Jars

A spice rack to keep spice jars in a single unit.

Gewürzständer, auf dem die Gewürze auf einem einzigen Ständer stehen.

Support à épices de cuisine qui permet de les grouper dans un seul récipient.

Especieros de cocina que permiten agrupar las especias en un único contenedor.

Porta spezie da cucina che consente di riunire le spezie in un solo contenitore.

p. 111
Digital Kitchen Timer

This kitchen timer has several different functions in one, including, of course, a clock.

Küchenuhr mit verschiedenen Funktionen in einer kompakten Einheit, darunter natürlich auch die des Chronometers.

Horloge de cuisine réunissant diverses fonctions dans une seule unité compacte dont entre autres, celle de chronomètre.

Reloj de cocina que integra diversas funciones en una sola unidad compacta; entre ellas, obviamente, la de cronómetro.

Orologi da cucina che integrano diverse funzioni in una sola unità compatta; tra cui, ovviamente, quella del cronometro.

p. 112
Garlic Press

Easy-to-clean garlic press that looks just like a head of garlic.

Leicht zu reinigende Knoblauchpresse in Form einer Knoblauchknolle.

Presse-ail facile à nettoyer, en forme de tête d'ail.

Prensador de ajos fácil de limpiar y cuya forma se parece, precisamente, a la de una cabeza de ajos.

Spremi aglio di facile pulizia, dalla forma che rassomiglia proprio a quella di una testa d'aglio.

p. 113
Royal

White ceramic fruit salver. Rounded pits in the bottom prevent the fruit from moving.

Weißes Keramiktablett für Früchte. Die abgerundeten Kerben halten die Früchte auf dem Tablett.

Plat pour fruit en céramique blanche. Les fentes arrondies retiennent les fruits sur le plateau.

Bandeja de cerámica blanca para la fruta. Las hendiduras redondeadas sujetan la fruta a la bandeja.

Vassoio per la frutta di ceramica bianca. Le spaccature arrotondate reggono la frutta sul vassoio.

p. 114
Chinese Hat

Orange ceramic fruit salver in the shape of a Chinese peasant's hat.

Obsttablett aus orangefarbener Keramik in Form eines chinesischen Bauernhutes.

Plateau de céramique orange en forme de chapeau de paysan chinois.

Bandeja para la fruta de cerámica naranja con forma de sombrero de campesino chino.

Vassoio da frutta in ceramica arancione con forma di cappello da contadino cinese.

p. 115
Milk and Sugar Set

Sugar pot and creamer with a sealed lid to prevent milk from spilling.

Zuckerdose und kleiner Milchkrug. Der hermetische Deckel verhindert ein Verschütten des Inhalts.

Sucrier et petit pot à lait. Le couvercle hermétique empêche de renverser le contenu.

Azucarero y pequeña jarra para la leche. El tapón hermético impide que el contenido se derrame.

Zuccheriera e piccolo bricco per il latte. Il tappo ermetico impedisce al contenuto di versarsi.

177

178

p. 116
Foglia

Two three-piece sets of oval dishes with a pouring spout for serving. The dish shown on the left is made of white ceramic and the dish shown on the right is finished in anthracite.

Zwei Sets mit drei ovalen Tellern mit Rillen zum Servieren. Das linke ist aus weißer Keramik, das rechte anthrazitfarben.

Deux jeux de trois plats ovales dotés d'une petite ouverture pour servir. Celui de gauche est en céramique blanche, celui de droite, de couleur anthracite.

Dos sets de tres platos ovalados con canalillo para servir. El de la izquierda es de cerámica blanca; el de la derecha, de color antracita.

Due set di tre piatti ovali con impugnatura da servizio. Quello di sinistra è di ceramica bianca; quello di destra, antracite.

p. 117
PS

Salt and pepper dispenser made of polished stainless steel. Salt is shaken from one end and pepper from the other.

Salz- und Pfefferstreuer aus poliertem Edelstahl. Das Salz wird aus dem einen Ende gestreut, der Pfeffer aus dem anderen.

Salière et poivrier fabriqués en acier inoxydable verni. Le sel sort par une extrémité et le poivre de l'autre.

Dispensador de sal y pimienta fabricado en acero inoxidable pulido. La sal se dispensa por un extremo y la pimienta por el extremo opuesto.

Saliera e porta pepe fabbricato in acciaio inossidabile lucidato. Il sale esce da un'estremità ed il pepe da quella opposta.

p. 118
Asella Peeler

This fruit and vegetable peeler stands on a flat surface and can be used with just one hand.

Schälmesser, das sich auf eine glatte Fläche stützt und mit dem man Früchte und Gemüse mit nur einer Hand schälen kann.

Eplucheur qui s'appuie sur une superficie plane et permet d'éplucher fruits et légumes d'une seule main.

Pelador que se apoya en una superficie plana y permite pelar frutas y verduras con una sola mano.

Pela frutta che si appoggia su di una superficie piatta e permette di pelare frutta e verdura con una sola mano.

p. 119
Fruit Peeler, Fruit Knife, Apple Corer

Set comprising fruit parer, fruit knife and apple corer designed by Tools Design. Useful and compact.

Set aus Schälmesser, Obstmesser und Apfelentkerner, entworfen von Tools Design. Praktisch und kompakt.

Set de couteaux économes, couteau pour les fruits et pour ôter le cœur des pommes, désigné par Tools Design. Utile et compact.

Set de pelador, cuchillo para las frutas y descorazonador de manzanas, diseñado por Tools Design. Útil y compacto.

Set di pela frutta, coltello per la frutta e utensile per togliere il cuore delle mele, disegnato da Tools Design. Utile e compatto.

p. 120
Kult Sugar and Milk Set

Sugar bowl and milk jug. Sold separately or as a pair, in different sizes.

Zuckerdose und Milchkrug. Sie können zusammen oder getrennt erworben werden. Es gibt außerdem verschiedene Größen.

Sucrier et pot à lait. Il est possible de les acquérir ensemble ou séparés. Disponibles en diverses tailles au gré des besoins du client.

Azucarero y jarra para la leche. Se pueden adquirir juntos o por separado. Existen diferentes tamaños a disposición del usuario.

Zuccheriera e bricco per il latte. Si possono comprare insieme o per separato. Esistono anche diverse grandezze a disposizione dell'acquirente.

p. 121
Gabbiano

Red ceramic table decoration which can be used as a fruit bowl.

Tischdekoration aus Keramik, die als Obstschale dienen kann.

Centre de table de céramique rouge pour poser les fruits ou comme simple objet de décoration.

Centro de mesa de cerámica roja. Sirve como frutero o como simple objeto decorativo.

Centro tavola in ceramica rossa. Serve come cestino per la frutta o come semplice oggetto decorativo.

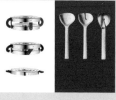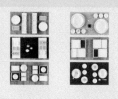

p. 122
Twist Pot Coaster/Walmer

Folded, it is a table coaster. Unfolded, light the tea candle inside and it is a pot warmer.

Accessoire mit doppelter Verwendung. Zusammengelegt dient es als Untersetzer. Wenn man es auseinander nimmt und die Kerze im Inneren anzündet, ist es ein Stövchen.

Ustensile à double usage. Plié sert de dessous de plat. Déplié, une bougie allumée à l'intérieur, il sert de chauffe-plats.

Utensilio de doble uso. Plegado sirve como salvamanteles. Desplegado, y una vez encendida la vela de su interior, como calentador de platos.

Utensile a doppio uso. Piegato, serve come sottopiatto da portata. Aperto, ed una volta accesa la candela interna, come riscalda piatti.

p. 123
Style

Salad and olive servers in the Style collection, a hybrid between western and eastern eating utensils.

Salat- und Olivenbesteck der Linie Style, das wie eine Mischung aus östlichem und westlichem Besteck gestaltet ist.

Plats à salade et à olives de la ligne Style, conçus comme un mélange entre les couverts occidentaux et orientaux.

Servidores de ensalada y de olivas de la línea Style, concebidos como un híbrido de la cubertería occidental y la oriental.

Posate per l'insalata e le olive della linea Style, concepiti come un ibrido delle posate occidentali e di quelle orientali.

p. 124-125
Convito

A range of dishes, bowls, salvers and sauceboats in Pia Törnell's Convito collection.

Verschiedene Sets mit Tellern, Schalen, Vorspeisentabletts und Saucieren aus der Kollektion Convito von Pia Törnell.

Différents sets d'assiettes, bols, plateaux pour apéritif et saucières de la collection Convito de Pia Törnell.

Diferentes sets de platos, boles, bandejas para el aperitivo y salseras de la colección Convito de Pia Törnell.

Diversi set di piatti, recipienti, vassoio per l'aperitivo e salsiere della collezione Convito de Pia Törnell.

p. 126-127
System Dishrack

A modular system of racks for tableware and cutlery that adapts to any requirements.

Modulares System, das als Stütze für Besteck und Geschirr dient, und das auf verschiedene Weise an die Bedürfnisse des Benutzers angepasst werden kann.

Système modulaire qui sert de support à couverts et vaisselle, pouvant être utilisé de différentes manières au gré des besoins de l'usager.

Sistema modular que sirve de soporte para cubertería y vajilla, y que puede personalizarse de diferentes maneras para adaptarlo a las necesidades del usuario.

Sistema modulare che serve da supporto per le posate e le stoviglie, personalizzabile in vari modi per adattarsi alle necessità dell'utente.

179

p. 128
Macinapepe

Pepper mill made of two different types of wood. A must on any Italian table serving Mediterranean fare.

Pfeffermühle aus zwei verschiedenen Holzarton. Ein typisch italienisches Gerät für die mediterrane Küche.

Moulin à poivre fabriqué à partir de deux essences de bois différentes. Un ustensile typiquement italien pour la cuisine méditerranéenne.

Molinillo de pimienta fabricado con dos tipos distintos de madera. Un típico utensilio italiano para la cocina mediterránea.

Macinapepe fabbricato con due tipi diversi di legno. Un tipico utensile italiano per la cucina mediterranea.

p. 129
Asteria

Blue star-shaped fruit bowl to add a touch of fantasy to color-loving kitchens.

Sternförmige blaue Obstschale. Etwas Fantasie für bunte Küchen.

Bol de fruits en forme d'étoile et de couleur bleue. Une touche de fantaisie pour les cuisines plus coloristes.

Bol de frutas en forma de estrella y de color azul. Un toque de fantasía para las cocinas más coloristas.

Recipiente per la frutta a forma di stella e di color blu. Un tocco di fantasia per le cucine più coloriste.

p. 130
Magnito Salt & Pepper

Magnetic salt and pepper set that stands together as one piece while not in use.

Set aus Salz- und Pfefferstreuer, das magnetisch zusammenhält, wenn man es nicht benutzt.

Jeu de salière et de poivrier aimantés, collés ensemble lorsqu'ils ne sont pas utilisés.

Set de salero y pimentero que se mantienen unidos magnéticamente cuando no se usan.

Set di saliera e porta pepe che si mantengono uniti magneticamente quando non si usano.

p. 131
Pizza Cutter

This pizza wheel cuts portions safely, with its specially designed handle which prevents the blade from accidentally coming into contact with the fingers.

Pizzaschneider. Die Form des Griffs vermeidet, dass die Hand versehentlich die Klinge berührt.

Découpe pizza. La forme du manche évite que la main entre accidentellement en contact avec le couteau.

Cortador de porciones de pizza. La forma del mango evita que la mano entre en contacto accidentalmente con la cuchilla.

Taglia porzioni di pizza. La forma del manico evita che la mano possa entrare in contatto accidentalmente con la lama.

p. 132
Bread Bin

Minimalist bread bin to keep bread and buns in perfect condition.

Minimalistischer Brotkasten, in dem Brot und Backwaren perfekt gelagert werden.

Panière au design minimaliste qui assure la conservation parfaite du pain et des viennoiseries.

Panera de diseño minimalista que asegura la perfecta conservación del pan y la bollería en su interior.

Porta pane dal design minimalista che assicura la perfetta conservazione del pane e dei lieviti al suo interno.

p. 133
2-in-1 Milk and Sugar Set

Easy-to-clean sugar and creamer set. A salt and pepper set in the same design is also available.

Set aus Zuckerdose und Milchkännchen, das sehr einfach zu reinigen ist. Es gibt auch einen Salz- und Pfefferstreuer im gleichen Design.

Jeu de sucrier et pot à lait très faciles à nettoyer. La salière et le poivrier sont disponibles dans le même design.

Set de azucarero y jarra para la leche de muy fácil limpieza. También disponible salero y pimentero con el mismo diseño.

Set di zuccheriera e bricco per il latte di facilissima pulizia. Disponibile anche la saliera e il porta pepe con lo stesso design.

180

p. 134
Origo Blue Textile

Place-mat and napkin in colorful striped material, to match the aprons on the following page.

Serviette und Tischset mit feinen bunten Streifen, die zu den Schürzen auf der folgenden Seite passen.

Ensemble de serviettes et de sets de table individuels imprimés de fines rayures colorées, assortis aux tabliers de la page suivante.

Set de servilleta y mantel individual estampado con finas rayas de colores, a juego con los delantales de la página siguiente.

Set di tovagliolo e table mate individuale stampato con fini righe colorate, coordinato con i grembiuli della pagina seguente.

p. 135
Origo Apron

Bright aprons in a bold black and sky-blue design from Alfredo Häberli's Origo collection for Iittala.

Auffallende Küchenschürzen in schwarz und himmelblau aus der Kollektion Origo von Alfredo Häberli für Iittala.

Tabliers de cuisine, attrayants, aux coloris noir et bleu ciel de la collection Origo de Alfredo Häberli pour Iittala.

Llamativos delantales de cocina en color negro y azul cielo de la colección Origo de Alfredo Häberli para Iittala.

Sgargianti grembiuli da cucina in nero e blu cielo della collezione Origo d'Alfredo Häberli per Iittala.

p. 136
Origo Napkins and Kettle Gloves

Paper napkins and oven gloves in the characteristic Origo print.

Papierservietten und Küchenhandschuhe mit dem typischen Druck der Serie Origo.

Serviettes en papier et maniques de cuisine imprimées du design caractéristique de la série Origo.

Servilletas de papel y manoplas de cocina estampadas con el característico diseño de la serie Origo.

Tovaglioli di carta e manopole da cucina stampate con il caratteristico disegno della serie Origo.

p. 137
Origo Paper Napkins

Paper napkins in the Origo collection.

Papierservietten aus der Serie Origo.

Serviettes en papier de la série Origo.

Servilletas de papel de la serie Origo.

Tovaglioli di carta della serie Origo.

p. 138
Geo Napkin and Tablecloth

Dandi's extra large napkins are perfect for dinner parties as well as for more informal occasions.

Die großen Servietten der Marke Dandi sind perfekt für formelle Abendessen und ungezwungenere Anlässe geeignet.

Les serviettes et la nappe de grand taille, de la marque Dandi sont parfaites, tant pour les dîners formels que pour les occasions plus informelles.

Las servilletas de gran tamaño de la marca Dandi son perfectas tanto para cenas formales como para ocasiones más informales.

I tovaglioli di gran dimensione della casa Dandi sono perfetti tanto per cene formali quanto per occasioni più informali.

p. 139
Olive Branch Napkin and Tablecloth

Tablecloth and napkins in different colors from Dandi, printed in the brand's characteristic patterns.

Set aus Servietten und Tischdecke in verschiedenen Farben der Marke Dandi. Typisch für diese Marke ist der auffallende Druck.

Set de serviettes et de nappe de différentes couleurs de la marque Dandi, aux superbes impressions caractéristiques de sa marque.

Set de servilletas y mantel en diferentes colores de la marca Dandi. Su marca de fábrica es su llamativo estampado.

Set di tovaglioli e tovaglia in vari colori della casa Dandi. Nota per i suoi sgargianti stampati.

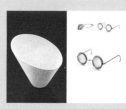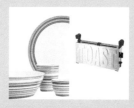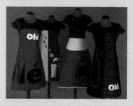

p. 140
Cono

Conical kitchen vase in dazzling white ceramic.

Kegelförmiger Krug aus weißer, glänzender Keramik.

Cruche pour la cuisine de forma conique, en céramique blanche brillante.

Jarrón para la cocina de forma cónica y fabricado en cerámica blanca brillante.

Vaso da cucina conico realizzato in ceramica bianca brillante.

p. 141
Emergency Sunglasses

Tea strainer in the form of a pair of sunglasses, as a tribute on behalf of the designer to Italy (his fatherland) and England (his adopted home).

Teesieb in Form einer Sonnenbrille, mit der der Designer eine Hommage an Italien, sein Geburtsland, und England, das Land, in dem er lebt, erbringen wollte.

Passoire à thé en forme de lunettes de soleil avec lesquels le designer a voulu rendre hommage à l'Italie (son pays d'origine) et à l'Angleterre (pays d'adoption).

Colador de té en forma de gafas de sol con el que el diseñador ha querido rendir homenaje a Italia (su país de origen) e Inglaterra (el de adopción).

Colino per il tè a forma d'occhiali da sole con cui il designer ha voluto rendere omaggio all'Italia (suo paese d'origine) e l'Inghilterra (quello d'adozione).

p. 142
Origo

A treat for the eyes. A big cup and bowls in a range of different sizes to accommodate breakfast cereals, coffee, desserts or even boiled eggs.

Ein Augenschmaus. Eine Riesentasse und fünf Schalen in verschiedenen Größen für Zerealien, den Kaffee, den Nachtisch oder sogar für hartgekochte Eier.

Un festin pour les yeux. Grande tasse et cinq bols de différents formats pour les céréales, le café, les desserts et même un œuf dur.

Un festín para los ojos. Tazón y cinco boles de diferentes tamaños para los cereales, el café, los postres o incluso un huevo duro.

Una festa per gli occhi. Tazza e cinque recipienti di varie dimensioni per i cereali, il caffè, i dolci o addirittura un uovo sodo.

p. 143
Toast

Italian design has made its way into kitchens all over the world thanks to designs like this original, minimalist toaster.

Das italienische Design hat mit Entwürfen wie diesem originellen und minimalistischen Toaster die Küchen der ganzen Welt erobert.

Le design italien est entré dans toutes les cuisines grâce à certains objets, à l'instar de cet original toaster minimaliste.

El diseño italiano ha entrado en las cocinas de todo el mundo gracias a diseños como el de este original y minimalista tostador de pan.

Il design italiano è entrato nelle cucine di tutto il mondo grazie a disegni come questo tostapane originale e minimalista.

p. 144-145
Aprons Olé, Ñ, Capote, and Vino Tinto

Aprons with themes taken from Spanish folklore, like these bulls, the letter ñ or the exclamation olé!

Spanisch inspirierte Schürzen, die mit volkstümlichen Symbolen wie dem Stier, dem Buchstaben ñ und den Olé-Rufen spielen.

Tabliers d'inspiration hispanique jouant avec des symboles folkloriques, à l'instar du taureau, de la lettre ñ et des olé.

Delantales de inspiración hispánica que juegan con símbolos folclóricos como el toro, la letra ñ y los gritos de olé.

Grembiuli d'ispirazione ispanica che giocano con i simboli folcloristici come il toro, la lettera ñ o i gridi di olé.

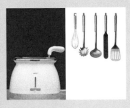

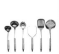

p. 146
Toaster

Rounded toaster from Guzzini. Functional, discreet and easy to use.

Toaster mit runden Formen der Marke Guzzini. Funktionell, diskret und sehr bequem in der Handhabung.

Toaster à pain aux formes rondes de la marque Guzzini. Fonctionnel, discret et très facile à manipuler.

Tostador de pan de formas redondeadas de la marca Guzzini. Funcional, discreto y muy cómodo de manejar.

Tosta pane dalle forme arrotondate della casa Guzzini. Funzionale, discreto e molto facile da maneggiare.

p. 147
Kitchen Utensils

Kitchen utensils made to the specifications given by a number of professional chefs.

Küchenutensilien, bei deren Herstellung den Empfehlungen verschiedener professioneller Küchenchefs gefolgt wurde.

Instruments de cuisine fabriqués en fonction des conseils donnés par les chefs cuisiniers.

Instrumentos de cocina para cuya fabricación se han seguido las recomendaciones de varios chefs de cocina profesionales.

Strumenti da cucina realizzati grazie alle raccomandazioni di vari chef professionisti.

p. 148
B.M. Fruit Bowl

Rustic-style fruit bowl which doubles as an attractive table decoration.

Rustikaler Obstkorb, der auch als Tischdekoration dient.

Corbeille à fruits d'inspiration rustique à fonction décorative comme centre de table.

Cesto para la fruta de inspiración rústica que sirve también como decorativo centro de mesa.

Cesto per la frutta d'ispirazione rustica che serve anche come decorativo centro tavola.

p. 149
Throwzini

Wooden block with a magnet in its interior for storing kitchen knives. Can be mounted on the wall.

Holzblock, in dessen Innerem ein Magnet sitzt, der die Küchenmesser festhält. Er kann auch an die Wand gehängt werden.

Bloc de bois contenant un aimant intérieur qui permet de garder les couteaux de cuisine. Il peut également s'accrocher au mur.

Bloque de madera en cuyo interior se ha introducido un imán y que permite guardar los cuchillos de cocina. También puede colgarse en la pared.

Blocco di legno con dentro una calamita che consente di ordinare i coltelli da cucina. Può anche essere appeso al muro.

p. 150
Grade

A collection of casseroles and dishes in different shapes and sizes, suitable for table or oven.

Set aus Schalen und Tabletts zum Servieren in verschiedenen Größen und Formen, sowohl für den Backofen als auch als Tischgeschirr geeignet.

Set de bols et de plateaux de service de différentes formes et tailles, allant du four à la table.

Set de boles y bandejas para servir en diferentes tamaños y formas, aptos tanto para el horno como para la mesa.

Set di recipienti e vassoi per servire in varie dimensioni e forme, da usare in forno e in tavola.

p. 151
Kitchen Utensils

Kitchen utensils (skimming spoons, turners, ladles, etc.) by Harri Koskinen, suitable for induction hobs.

Küchenutensilien (Schaumlöffel, Schöpflöffel, Kellen ...) von Harri Koskinen, die für Induktionsherde geeignet sind.

Ustensiles de cuisine (raseras, écumoires, louches...) de Harri Koskinen, adaptés à la cuisine par induction.

Utensilios de cocina (raseras, espumaderas, cucharones...) de Harri Koskinen, aptos para cocinas de inducción.

Utensili da cucina (palette, schiumaiole, mestoli...) di Harri Koskinen, adatti per piani cottura ad induzione.

183

p. 152
Still & Slow Motion

The secret behind the Still series is the soft clay used by the designer and his deep knowledge of its hardening properties.

Das Geheimnis der Serie Still liegt in dem Fließen des Tons, mit dem der Designer arbeitet, und dem exakten Punkt, an dem dieser Ton sich festigt.

Le secret de la série Still vient de la finesse de l'argile utilisée par son designer et du point précis où elle se solidifie.

El secreto de la serie Still es la fluidez de la arcilla con la que trabaja su diseñador y el punto exacto en el que aquella se solidifica.

Il segreto della serie Still è la fluidità dell'argilla con cui lavora il designer, ed il suo punto esatto di solidificazione.

p. 153
Complet Sugar Bowl

Extremely simple but elegant sugar bowl by Jørgen Møller.

Zuckerdose von Jørgen Møller mit einem außerordentlich einfachen und eleganten Design.

Sucrier de Jørgen Møller de design extraordinairement simple et très élégant.

Azucarero de Jørgen Møller de diseño extraordinariamente sencillo y muy elegante.

Zuccheriera di Jørgen Møller dal design straordinariamente semplice e molto elegante.

p. 154
Paola

Soup tureen and matching ladle in white ceramic.

Suppenschüssel und dazu passende Kelle aus weißer Keramik.

Récipient pour la soupe et louche assortie fabriquée en céramique blanche.

Recipiente para la sopa y cucharón a juego fabricados en cerámica blanca.

Recipiente per la minestra e mestolo abbinato prodotti in ceramica bianca.

p. 155
Cutting Boards

Set of three boards for three different kinds of food: raw meat, raw vegetables and cooked products.

Set aus drei Schneidebrettern für drei verschiedene Arten von Lebensmitteln: Fleisch, Gemüse und bereits gekochte Speisen.

Set de trois planches à couper pour trois différents types de nourriture: viande, légumes et aliments déjà cuits.

Set de tres tablas de corte para tres tipos de comida diferente: carne, verduras y alimentos ya cocidos.

Set di tre taglierini per tipi diversi di cibo: carne, verdura ed alimenti già cotti.

p. 156-157
Swedish Grace

Individual placemats and napkins by Pia Törnell in a simple blue striped pattern.

Tischsets und Servietten von Pia Törnell, die mit einfachen, blauen Streifen dekoriert sind.

Ensemble de sets de tables individuels et serviettes assorties de Pia Törnell, décorés de simples rayures bleues.

Juego de manteles individuales y servilletas de Pia Törnell decorado con sencillas rayas azules.

Set di table mate individuali e tovaglioli di Pia Törnell decorato con semplici righe blu.

184

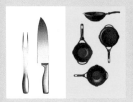
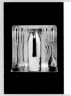

p. 158
Collective Tools

Stainless steel kitchen cutlery with long, practical handles.

Diese Messer und Gabeln aus Edelstahl haben bequeme Griffe, die leicht zu handhaben sind.

En acier inoxydable, les manches pratiques de ces couteaux et fourchettes de table plaisent immédiatement.

Fabricados en acero inoxidable, los cómodos mangos de estos cuchillos y tenedores de corte harán que te familiarices con ellos en un instante.

Realizzati in acciaio inossidabile, i comodi manici di questi coltelli e forchette da taglio ti permetteranno di prenderci la mano in un solo istante.

p. 159
Panny

A set of wok-like frying pans in assorted sizes. Lightweight and easy to handle.

Set aus Pfannen in verschiedenen Größen, die einem Wok gleichen. Sie sind sehr leicht und einfach zu handhaben.

Jeu de poêles de différents formats en forme de wok. Leur point fort : leur légèreté et facilité de manipulation.

Juego de sartenes de diferentes tamaños y de forma similar a la de un wok. Su punto fuerte es su ligereza y la comodidad con la que se manejan.

Servizio di padelle di varie dimensioni dalla forma simile ad un wok giapponese. Il suo punto forte è la leggerezza e comodità con cui si possono manipolare.

p. 160
Compleat Bartender

Full kit for the cocktail bar in stainless steel.

Edelstahlzubehör für Bar und Cocktailbar.

Jeu d'ustensiles de bar et de cocktails en acier inoxydable.

Set de herramientas de bar y de coctelería en acero inoxidable.

Set di utensili da bar e da cocktail in acciaio inossidabile.

p. 161
Kitchen Scales

Food scale (metric and Imperial) comprising three stainless steel and glass components.

Küchenwaage (in Gramm und Unzen). Sie besteht nur aus drei Edelstahlteilen und Glas.

Verre mesureur de cuisine (en grammes et onces). Trois pièces en acier inoxydable et verre.

Medidor de cocina (en gramos y onzas). Consta únicamente de tres piezas fabricadas en acero inoxidable y cristal.

Misuratore da cucina (in grammi e onze). Composto di tre pezzi realizzati in acciaio inossidabile e vetro.

p. 162
Grater

Rectangular kitchen grater on a stand. It can be set up horizontally or vertically on the work surface.

Rechteckige, stehende Reibe. Sie kann horizontal oder vertikal auf den Tisch gestellt werden.

Râpe de cuisine rectangulaire sur socle. Utilisable sur la table à l'horizontale ou à la verticale.

Rayador de cocina rectangular con pie. Permite ser apoyado en la mesa horizontal o verticalmente.

Grattugia da cucina rettangolare con piede. Può essere appoggiata sul tavolo in orizzontale o in verticale.

p. 163
Nilo

Set of three triangular extra-large white ceramic bowls.

Set aus drei dreieckigen Schalen aus weißer Keramik, in die sehr viel hineinpasst.

Sets de trois bols triangulaires de céramique blanche, intéressants pour leur grande contenance.

Set de tres boles triangulares de cerámica blanca que destacan por su gran capacidad.

Set di tre recipienti triangolari in ceramica bianca che spiccano per la loro gran capienza.

185

Name, year | D DESIGNER | A ARCHITECT | P PHOTOGRAPHER

Industrial Kitchens From the vast, computer-assisted kitchens at the world's leading restaurants, to the compact all-in-one domestic kitchen space, through the gastronomical research laboratories fitted with the latest in technological gadgetry: what would become of the cook—whether a professional chef or not—, without a comfortable, versatile and above all, functional space in which to let loose his creativity? The kitchens at the top international restaurants of the day are chefs' workshops where they chisel away, like sculptors, at their recipes.

Industrieküchen Angefangen bei den computergesteuerten und riesigen Herden der besten Restaurants der Welt bis zu den gastronomischen Forschungslaboren, die mit der neusten Technologie ausgestattet sind, oder den kompakten Küchen, bei denen alles in einem einzigen Block vorhanden ist: Was wäre der Koch, egal ob Hobby- oder Berufskoch, ohne einen bequemen, anpassungsfähigen und vor allem funktionellen Arbeitsplatz, an dem er seine Speisen zubereiten kann? Die Küchen der berühmtesten internationalen Restaurants der heutigen Zeit sind die Räume, in denen die Chefs ihre beinahe skulpturalen Speisen kreieren.

Cuisines industrielles Des gigantesques cuisines électroniques des meilleurs restaurants du monde aux ateliers de recherche gastronomique à la pointe de la technologie où aux cuisines compactes tout en un à usage domestique, que deviendrait le cuisinier, professionnel ou amateurs chevronnés, sans un espace pratique, adaptable et surtout fonctionnel pour y réaliser ses créations? A l'heure actuelle, les cuisines des restaurants les plus célèbres représentent l'univers dans lequel les chefs, à l'instar de sculpteurs, façonnent leurs créations.

Cocinas industriales De las computerizadas y gigantescas cocinas de los mejores restaurantes del mundo a los talleres de investigación gastronómica dotados de los últimos avances tecnológicos o las cocinas compactas todo-en-uno para uso doméstico. ¿Qué sería del cocinero, profesional o aficionado, sin un espacio cómodo, adaptable y, sobre todo, funcional en el que llevar a cabo sus creaciones? Las cocinas de los más renombrados restaurantes internacionales del momento son el espacio en el que los chefs llevan a cabo sus creaciones cuasi escultóricas.

Cucine industriali Dalle cucine computerizzate e giganteschi dei migliori ristoranti del mondo, ai laboratori d'investigazione gastronomica dotati delle ultime novità tecnologiche o le cucine compatte tutto-in-uno per uso domestico. Cosa sarebbe il cuoco, professionista o dilettante, senza uno spazio comodo, adattabile e, soprattutto, funzionale ove portare a buon fine le sue creazioni? Le cucine dei più famosi ristoranti internazionali del momento sono lo spazio in cui i chef realizzano le loro creazioni quasi-scultoree.

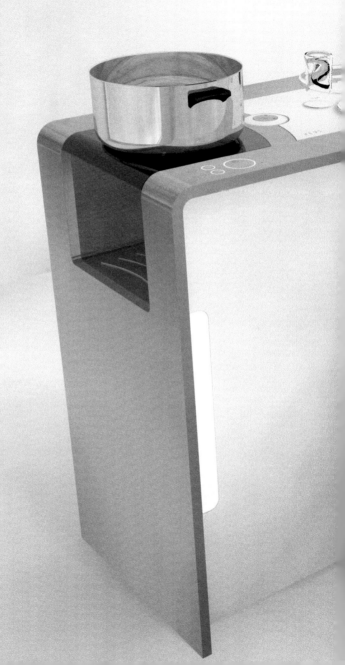

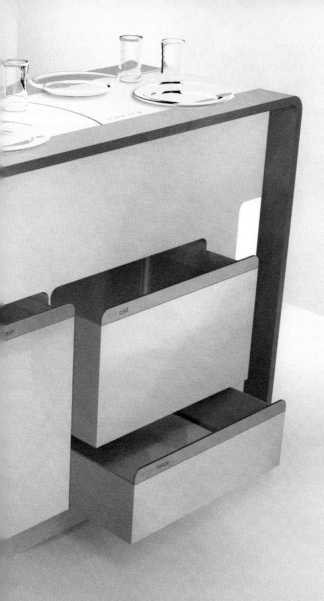

Cucina, 2004 | **D** Franco Marino Cagnina | **P** Franco Marino Cagnina

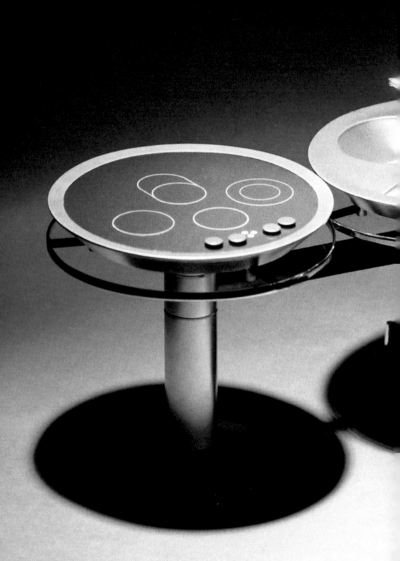

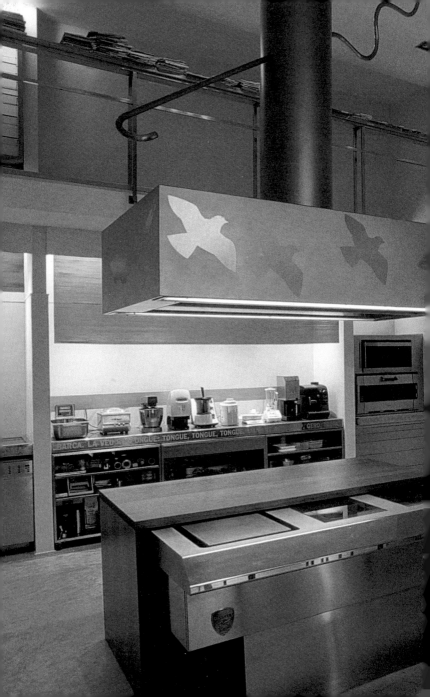

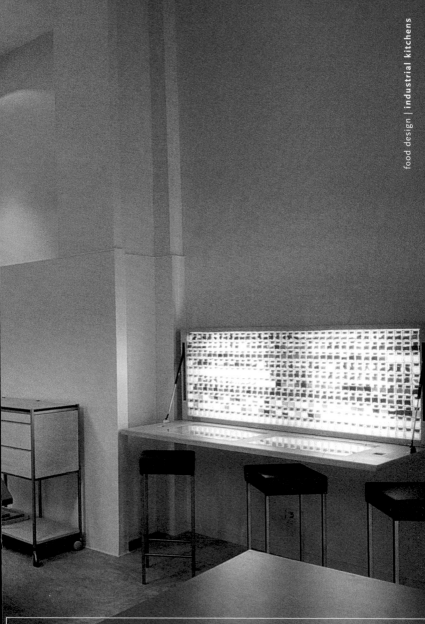

El Bulli Taller, 2003 | A Claudia Schneider

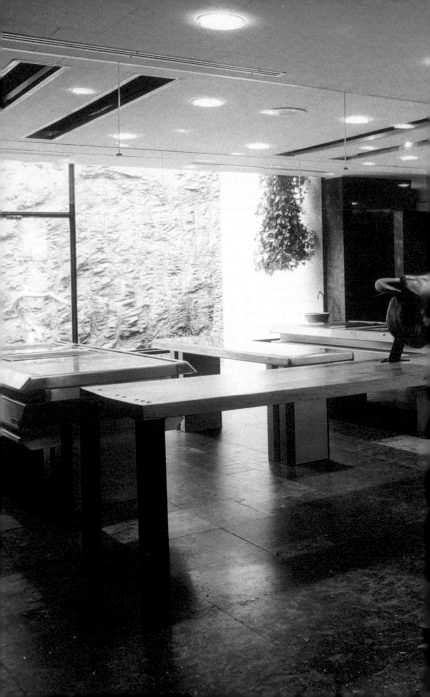

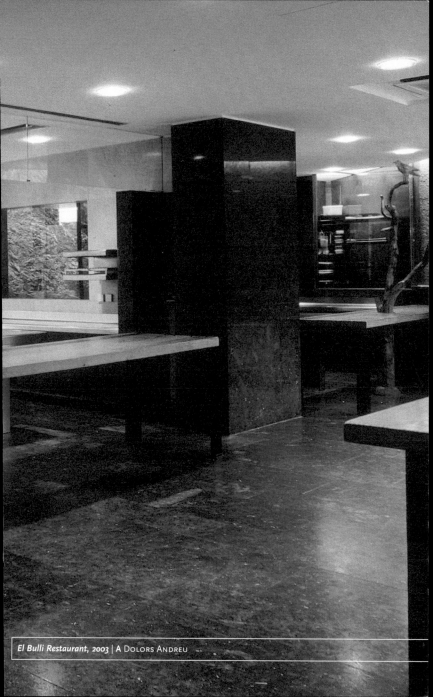

El Bulli Restaurant, 2003 | A Dolors Andreu

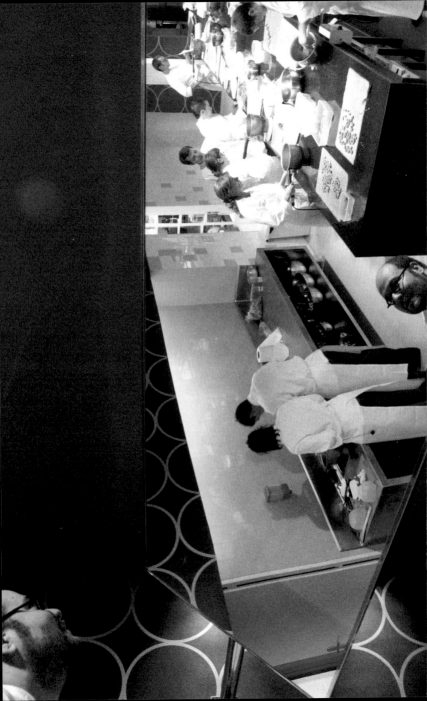

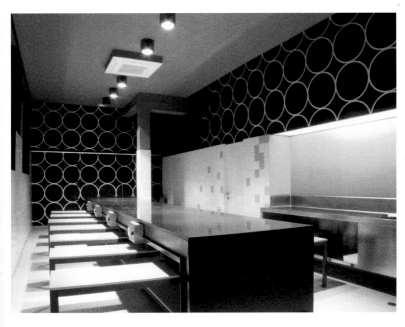

Espai Sucre | **A** Accions – Alfons Tost | **P** Lola, Toti Ferrer

198

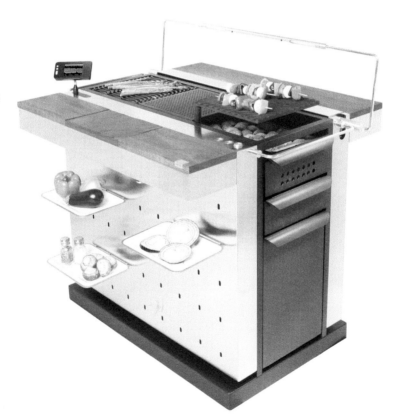

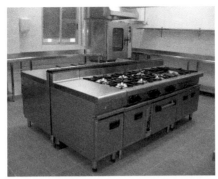

Model 4014

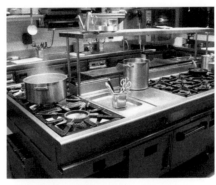

Model 4005

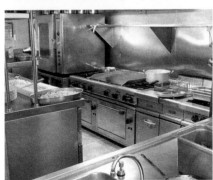

Model 3106

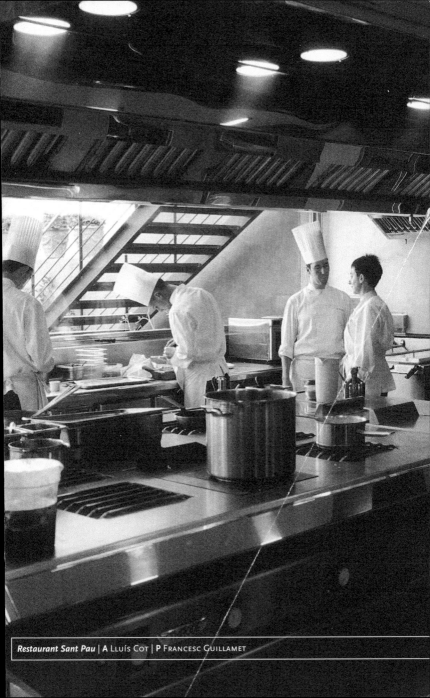

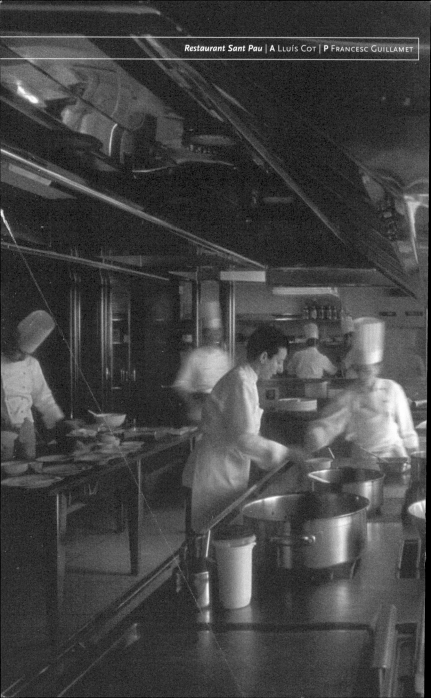

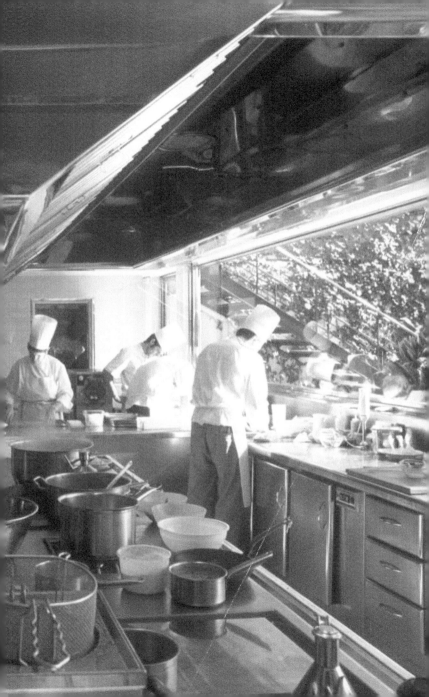

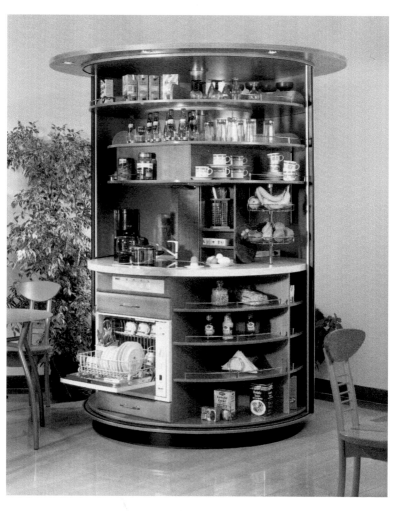

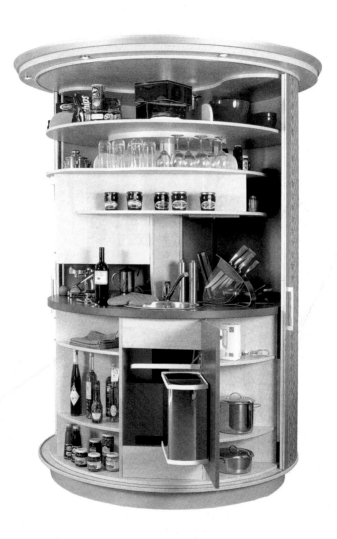

Circular Kitchen, 2004 | **D** ALFRED AVERBECK

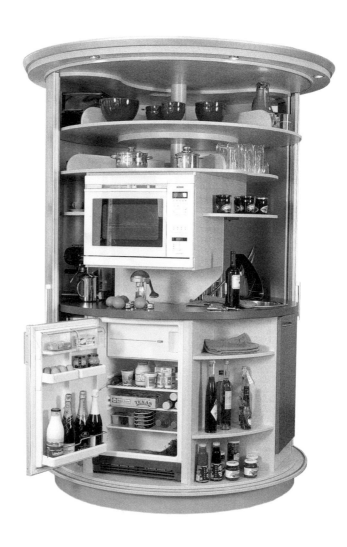

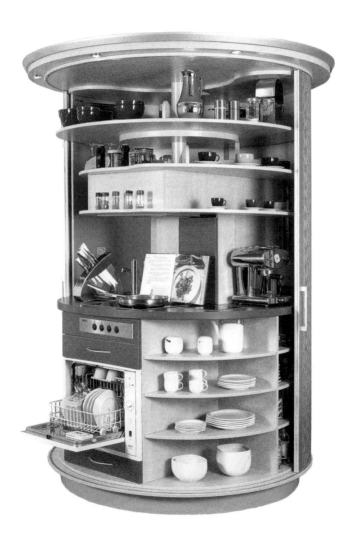

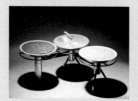

pp. 188-189
Cucina

Compact kitchen space with an old-fashioned air. Drawers of all sizes are at hand to store the kitchen utensils. A practical work surface is also available.

Kompakte Küche im Retrostil mit Schubladen verschiedener Größen, in denen man Küchenutensilien aufbewahren kann. Dient auch als Arbeitsfläche.

Cuisine compacte aux allures rétro, dotée de tiroirs de différentes tailles pour ranger les ustensiles de cuisine. Sert aussi comme plan de travail.

Cocina compacta de aire retro y con cajones de diferentes tamaños para guardar los utensilios de cocina. Sirve también como mesa de trabajo.

Cucina compatta d'aspetto retro e con cassetti di diverse dimensioni per conservare gli strumenti da cucina. Serve anche come tavolo da lavoro.

pp. 190-191
Kitchen Trio

The user can move around this three-fold work surface on a single stand instead of being limited to a static position in the kitchen.

Der Benutzer kann sich um diese dreifache, auf einem Fuß stehende Arbeitsfläche bewegen, anstatt auf einen Ort in der Küche limitiert zu sein.

L'utilisateur peut circuler autour de cette surface de travail en trois parties.

Trio de plataformas de trabajo unidas por su base. El usuario puede moverse a su alrededor en vez de situarse siempre en la misma posición.

Trio di piattaforme da lavoro unite alla base. L'utente può spostarsi intorno invece di situarsi sempre nella stessa posizione.

pp. 192-193
El Bulli Taller

The workshop at the El Bulli restaurant. Here the different textures and flavours destined for the restaurant menu are tested.

Werkstatt des Restaurants El Bulli. Hier wird mit den Texturen und dem Geschmack der Gerichte experimentiert, die später auf der Speisekarte des Restaurants zu finden sind.

Atelier du restaurant El Bulli. On y expérimente les textures et les saveurs qui figureront ensuite sur la carte du restaurant.

Taller del restaurante El Bulli. En él se experimenta con las texturas y los sabores que posteriormente pasarán a la carta del restaurante.

Laboratorio del ristorante El Bulli. Qui si fanno gli esperimenti con le consistenze ed i sapori che appariranno in seguito sul menù del ristorante.

pp. 194-195
El Bulli Restaurant

The dining room at the El Bulli restaurant. Minimalist design is chosen, in order not to detract any importance from the real protagonist: the cuisine of Ferran Adrià.

Speiseraum des Restaurants El Bulli. Die Gestaltung ist minimalistisch, damit dem, was hier wirklich wichtig ist, nicht die Show gestohlen wird, nämlich den Gerichten von Ferran Adrià.

Salle à manger du restaurant El Bulli. Le minimalisme du design veut faire la part belle à ce qui compte vraiment : les plats de Ferran Adrià.

Comedor del restaurante El Bulli. El minimalismo del diseño pretende no quitarle protagonismo a lo que verdaderamente importa: los platos de Ferran Adrià.

Sala da pranzo del ristorante El Bulli. Il minimalismo del design non vuole togliere protagonismo a quanto veramente importante: i piatti di Ferran Adrià.

pp. 196-197
Espai Sucre

Another view of the kitchens of the Espai Sucre restaurant. Elegant austerity is the note on these premises.

Ein anderer Blick auf die Küche des Espai Sucre und ein Foto der Tische im Lokal, schlicht und elegant.

Une vue différente sur la cuisine de l'Espai Sucre et une vue des tables du local, au design austère et élégant.

Una vista diferente de la cocina del Espai Sucre y una imagen de las mesas del local, de diseño austero y elegante.

Una visione diversa della cucina dell'Espai Sucre ed un'immagine dei tavoli del locale, dal design austero ed elegante.

p. 198
Fuego

Compact kitchen space with a system of multiple-use trays that take up a minimum of space once they are pulled out.

Kompakter Herd mit verschiedenen multifunktionellen Fächern, die, wenn sie geöffnet werden, sehr wenig Platz brauchen.

Cuisine compacte dotée de plateaux à usages multiples occupant, une fois dépliés, un espace minime.

Cocina compacta con diferentes bandejas multiusos que ocupan, una vez desplegadas, un espacio mínimo.

Cucina compatta con vari vassoi multiuso che occupano, una volta aperti, un minimo spazio.

p. 199 *Macfrin*

Modular equipment system that allows different layout combinations for industrial kitchens.

Industrielle, modulare Herde in verschiedenen Kombinationen.

Cuisines industrielles modulaires aux agencements multiples.

Cocinas industriales modulares en distintas combinaciones.

Cucine industriali modulari in varie combinazioni.

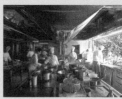

pp. **200-201**
Restaurant Sant Pau
Work area at Sant Pau restaurant. Each chef has the necessary space to keep out of the way of colleagues.

Arbeitsbereiche im Restaurant Sant Pau. Jeder Koch hat genug Arbeitsraum, um nicht mit seinen Mitarbeitern zusammenzustoßen.

Zones de travail du restaurant Sant Pau. Chaque cuisinier dispose de suffisamment d'espace pour ne pas gêner ses collègues.

Areas de trabajo del restaurante Sant Pau. Cada cocinero trabaja con el espacio suficiente necesario para no chocar con sus compañeros.

Aree di lavoro del ristorante Sant Pau. Ogni cuoco lavora con lo spazio sufficiente necessario per non urtarsi con i colleghi.

pp. **202-203**
Restaurant Sant Pau
General view of the kitchens at Sant Pau restaurant. Here, the generous spaces allowed each chef can be appreciated.

Blick in die Küche des Restaurants Sant Pau. Man sieht, wie groß die Arbeitsbereiche sind.

Vue générale de la cuisine du restaurant Sant Pau. L'aire de travail y est très spacieuse.

Vista general de la cocina del restaurante Sant Pau. En ella se puede apreciar la amplitud del área de trabajo.

Visione generale della cucina del ristorante Sant Pau. Spicca lo spazio della zona da lavoro.

pp. **204-205**

Circular Kitchen

Alfred Averbeck's circular kitchens. Fully integrated shelves, cabinets, dishwasher, bottle racks, waste bins, sink, etc. A sliding door closes it off when not in use.

Runde Küchen von Alfred Averbeck. Sie sind mit Regalen, Schränken, Geschirrspüler, Flaschenständer, Mülleimer, Spülbecken usw. ausgestattet. Durch die Schiebetür können sie geschlossen werden, wenn sie nicht benutzt werden.

Cuisines circulaires d'Alfred Averbeck. Elles intègrent armoires, lave-vaisselle, porte-bouteilles, poubelles, frigidaires... Une porte coulissante permet de la fermer lorsqu'elle n'est pas utilisée.

Cocinas circulares de Alfred Averbeck. Integran estanterías, armarios, lavaplatos, botelleros, cubos para la basura, fregadero... Su puerta corredera permite cerrarla cuando no se está utilizando.

Cucine circolari d'Alfred Averbeck. Integrano scaffalature, armadi, lavastoviglie, portabottiglie, secchi per la spazzatura, lavello... La porta scorrevole permette di chiuderla quando non si usa.

pp. **206-207**

Circular Kitchen

Different combinations for Alfred Averbeck's circular kitchen design. One comprises a microwave oven and a reduced size refrigerator.

Verschiedene Kombinationen der runden Küche von Alfred Averbeck. Eine davon ist mit einem Mikrowellenherd und einem kleinen Kühlschrank ausgestattet.

Différentes combinaisons modules de la cuisine circulaire d'Alfred Averbeck. Une d'elles possède même un micro-onde intégré et un petit frigidaire.

Diferentes combinaciones de la cocina circular de Alfred Averbeck. Una de ellas integra incluso microondas y una pequeña nevera.

Varie combinazioni della cucina circolare d'Alfred Averbeck. Una comprende addirittura un microonde ed un minifrigo.

212 *Name, year* | D DESIGNER | M MANUFACTURER | P PHOTOGRAPHER

Packaging Food packaging must ensure the product's nutritional qualities remain intact and in perfect condition, must offer clear information regarding the contents and bring their distinguishing features to the consumer's attention. It must also provide relevant data regarding the manufacturer, ingredients, best-before date, and instructions for use. In addition to all this, packaging must be pleasing to the eye and always open to innovation. Thus, it is clearly one of the most complex challenges faced by designers today.

Verpackung Die Verpackung eines Lebensmittel-Produktes soll es schützen und im bestmöglichen Zustand konservieren. Außerdem sollte sie vermitteln, was darin ist und sich von anderen Verpackungen unterscheiden, um die Aufmerksamkeit des Verbrauchers auf sich zu ziehen. Auch alle wichtigen Informationen wie die Daten des Herstellers, Inhaltsstoffe, Verfallsdatum und Anweisungen sollten auf der Verpackung enthalten sein. Wenn sie dann auch noch ästhetisch anziehend und innovativ sein soll, wird uns klar, dass es sich wahrscheinlich um eine der komplexesten Aufgaben handelt, die sich dem Designer der heutigen Zeit stellen.

Packaging Le packaging d'un produit gastronomique est conçu pour maintenir l'aliment intact, dans les meilleures conditions de conservation possible. Il doit inclure tous les renseignements sur le contenu et ses différentes caractéristiques pour attirer l'attention du consommateur et comprendre toutes les informations utiles (données du fabricant, ingrédients, date de péremption, instructions...). Tout cela sans oublier le côté esthétique, attrayant et innovateur de l'emballage! Le packaging est donc, de nos jours, une des tâches les plus complexes du designer.

213

Packaging El packaging de un producto gastronómico ha de mantener el alimento intacto y en las mejores condiciones de conservación posibles, ha de comunicar perfectamente cuál es el contenido y sus características distintivas para captar la atención del consumidor y ha de incluir obligatoriamente todo tipo de información útil (datos del fabricante, ingredientes, fecha de caducidad, instrucciones en algunos casos...). Si a eso se añade el requisito de resultar estéticamente atractivo e innovador nos daremos cuenta de que este es posiblemente uno de los trabajos más complejos que puede llevar a cabo un diseñador hoy en día.

Packaging Il packaging di un prodotto gastronomico deve mantenere l'alimento intatto e nelle migliori condizioni di conservazione possibili, deve comunicare perfettamente qual è il contenuto e le caratteristiche distintive per captare l'attenzione del consumatore e deve includere obbligatoriamente tutte le informazioni utili (dati del fabbricante, ingredienti, la scadenza, istruzioni in alcuni casi...). Se a ciò, si aggiunge il requisito di essere esteticamente attraente ed innovatore ci si renderà conto che questo è forse uno dei lavori più complessi oggi come oggi per un designer.

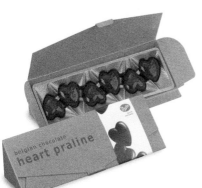

Trefin Heart Praline, 2005

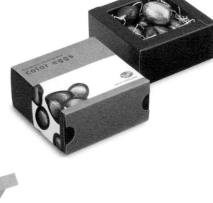

Trefin Color Eggs, 2005

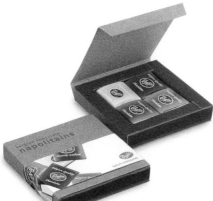

Trefin Napolitains, 2005

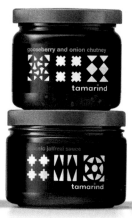
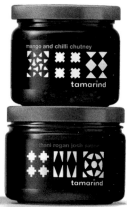

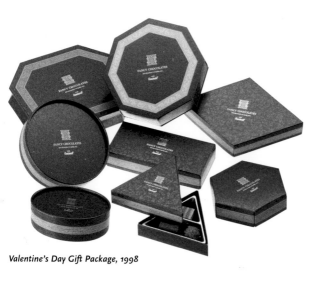

Valentine's Day Gift Package, 1998

217

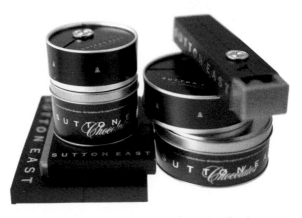

Sutton East Chocolates, 2005

218

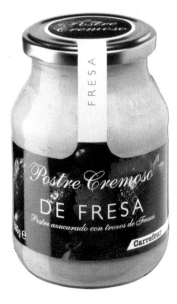

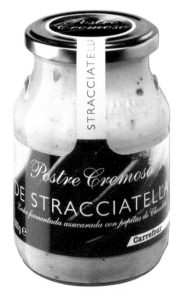

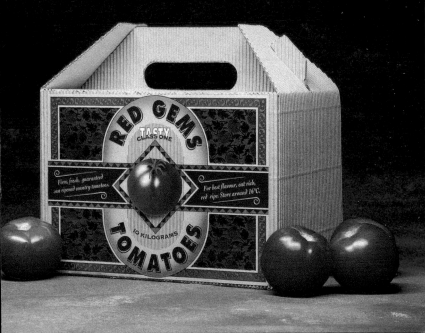

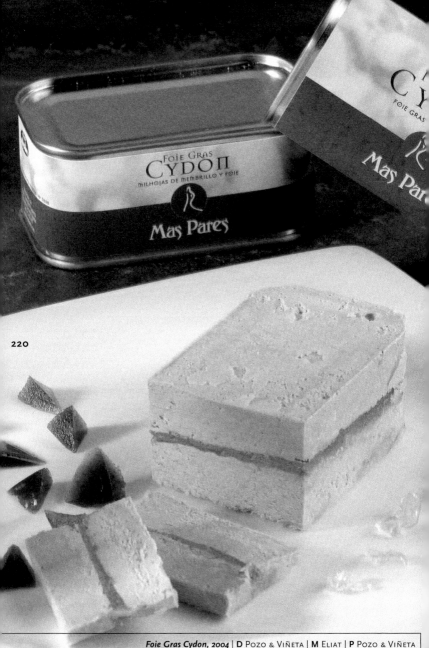

220

Foie Gras Cydon, 2004 | **D** Pozo & Viñeta | **M** Eliat | **P** Pozo & Viñeta

El Foie Gras de los Faraones, 2002 | **D** Sonia Bermúdez | **M** Eliat | **P** Txús Sartorio

Las Estaciones del Foie Gras, 2004 | **D** Pozo & Viñeta | **M** Eliat | **P** Pozo & Viñeta

222

Mayonnaise Series, 2001 | **D** KENTARO KAJI, EMIKO SHIBASAKI | **M** AJINOMOTO CO.

224

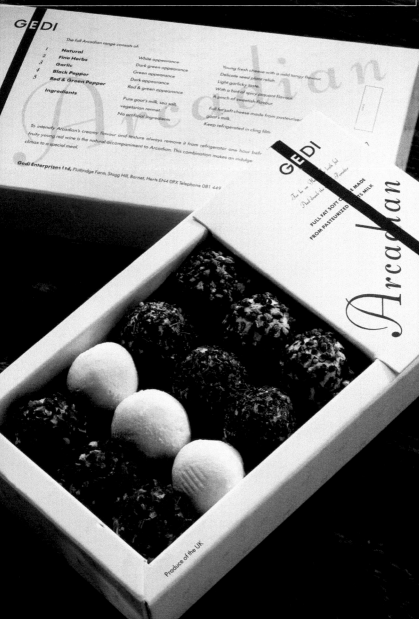

GEDI

The full Arcadian range consists of:

1 **Natural**
2 **Fine Herbs**
3 **Garlic**
4 **Black Pepper**
5 **Red & Green Pepper**

Ingredients

White appearance
Dark green appearance
Green appearance
Dark appearance
Red & green appearance

Pure goat's milk, sea salt,
vegetarian rennet
No artificial ingredients

Young fresh cheese with a mild tangy flavour
Delicate seed plant relish
Light garlicky taste.
With a hint of spicy piquant flavour
A pinch of sweetish flavour

Full fat soft cheese made from pasteurise
goat's milk.
Keep refrigerated in cling film

To intensify Arcadian's creamy flavour and texture always remove it from refrigerator one hour befr
fruity young red wine is the natural accompaniment to Arcadian. This combination makes an indulge
climax to a special meal.

Gedi Enterprises Ltd, Flutridge Farm, Stagg Hill, Barnet, Herts EN4 0PX Telephone 081 449

GEDI

**FULL FAT SOFT CHEESE MADE
FROM PASTEURIZED GOATS MILK**

Arcadian

Produce of the UK

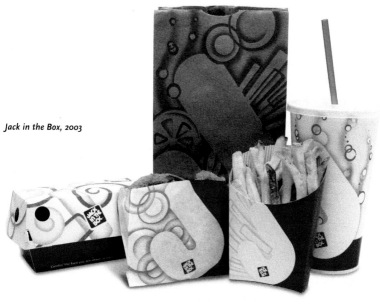

Jack in the Box, 2003

227

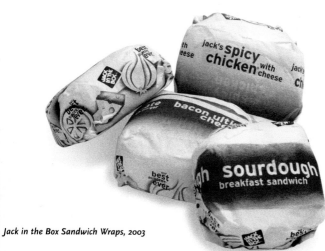

Jack in the Box Sandwich Wraps, 2003

D J. ANDERSON, J. TEE, G. COOK, E. DE LA CRUZ, A. WICKLUND | **M** JACK IN THE BOX | **P** N/A

228

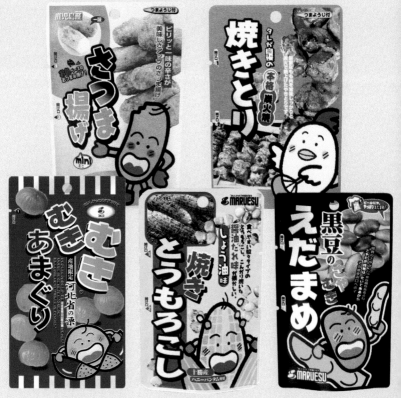

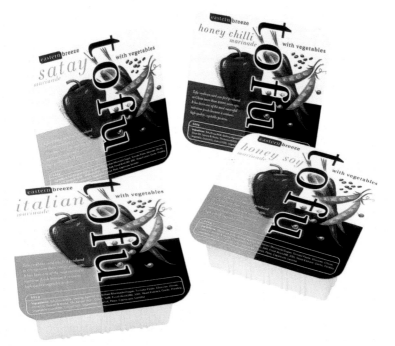

229

Eastern Breeze Tofu, 2002 | **D** DAVID FRY | **M** TIXANA

La Vuelta al Mundo en Chocolate, 1999 | **D** Enric Rovira | **M** Enric Rovira SL | **P** Enric Rovira

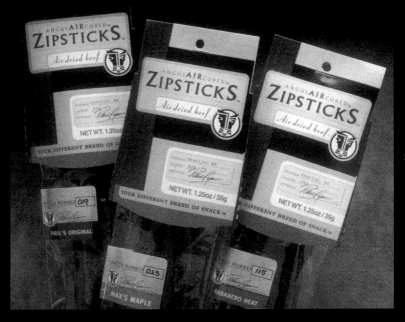

231

Zipsticks, 2002 | **D** Mary Hermes, Andrew Smith, John Anderle | **M** Paul Suzman | **P** N/A

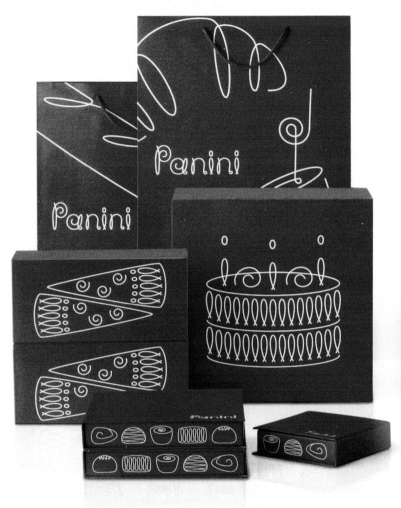

232

Panini Packaging, 2004 | **D** Hideo Akiba, Fiona Verdon-Smith | **M** Grand Hyatt

Nine Bonbons Box, 2001 | **D** Exit de Disseny | **M** Enric Rovira SL | **P** Enric Rovira

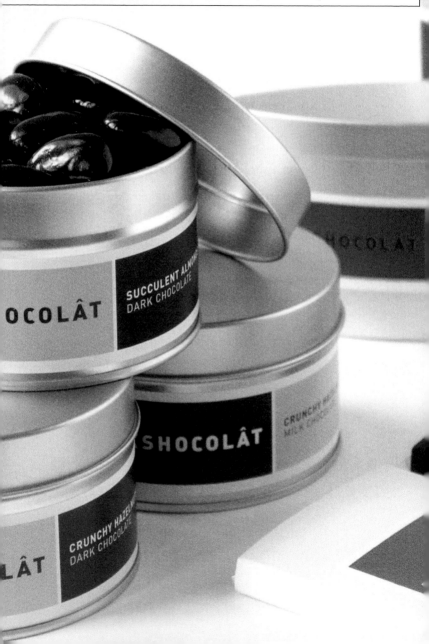

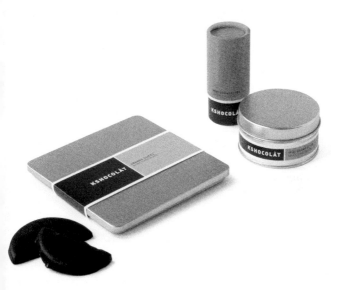

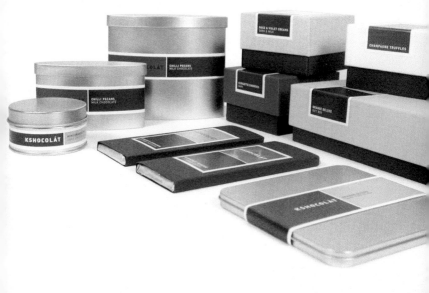

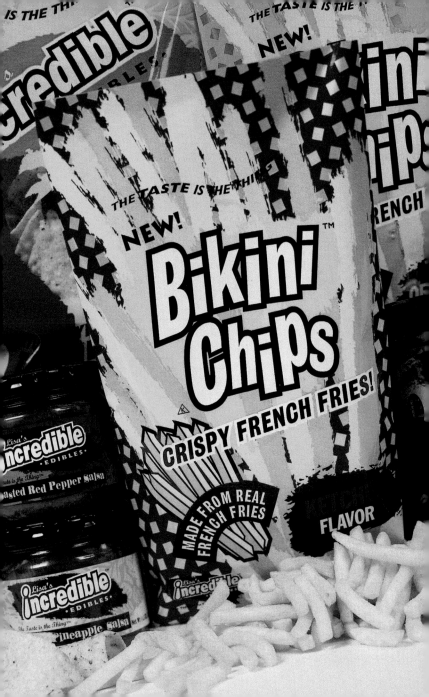

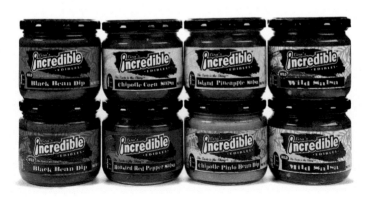

237

Bikini Chips, 1997 | **D** MARK GREENE | **M** LISA'S GOURMET SNACKS | **P** SCOTT VAN OSDOL

Lisa's Incredible, 1997 | **D** MARK GREENE | **M** LISA'S GOURMET SNACKS | **P** SCOTT VAN OSDOL

Tesco Finest Yogurts, 2004 | **D** John Ward, Simon Pemberton | **M** Tesco | **P** James Murphy

Finest **TESCO**

WHOLE THAI SPICES

A special blend of cumin seed, coriander seed, ginger, lemongrass and other spices, essential for any Thai curry dish.

Recipe
suggestion
on back of pack

2x15g ℮

Finest **TESCO**

WHOLE CURRY SPICES

A delicious blend of coriander seed, cumin seed, fennel seed and other spices, perfect for all curry dishes.

Recipe
suggestion
on back of pack

2x30g ℮

239

Finest **TESCO**

MIXED
HERB
SEASONING RUB
Delicious with lamb or pork.

Finest **TESCO**

TUSCAN STYLE
HERB BLEND
WITH FENNEL
Delicious in risotto.

Finest **TESCO**

HOT
SPICED
SEASONING RUB
Delicious with beef.

Tesco Finest Herbs & Rubs, 2004 | **D** John Ward, Simon Pemberton | **M** Tesco | **P** James Murphy

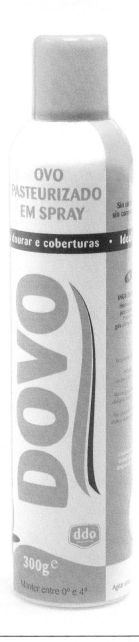

Dovo Spray, 2004 | **D** Pedro Oliveira, Sistema4 | **M** DDO, Ovoprodutos | **P** Sistema4

242

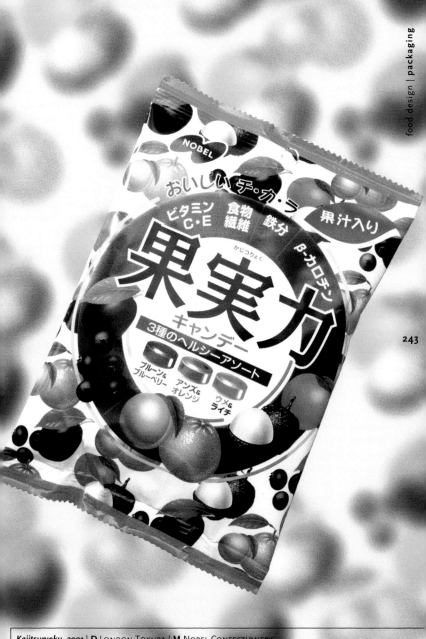

243

NOBEL

おいしい チ・カ・ラ

ビタミン
C・E

食物
繊維

鉄分

β-カロチン

果汁入り

かじつりょく
果実力

キャンデー

3種のヘルシーアソート

プルーン&
ブルーベリー

アンズ&
オレンジ

ウメ&
ライチ

Kajitsuryoku, 2001 | **D** London Tokura | **M** Nobel Confectionery

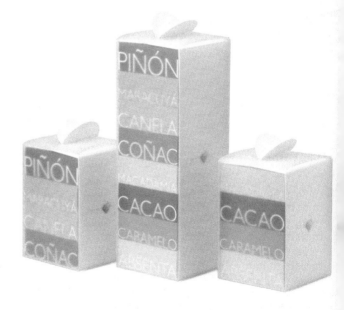

Vertical, 2003 | **D** Enric Rovira | **M** Enric Rovira SL | **P** Enric Rovira

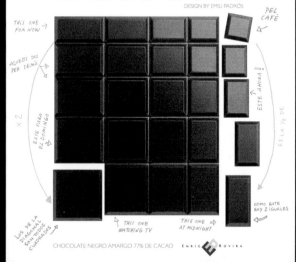

CHOCO DOSIS

DESIGN BY EMILI PADRÓS

THIS ONE FOR NOW →

PEL CAFÈ

AQUESTI DOS PER DEMA

ESTE AHREA

X 2

ESTE PARA EL DOMINGO

ES LA ½ DE

COMO ESTE HAY 2 IGUALES

LOS DE LA DIAGONAL SON TODOS CUADRADOS

THIS ONE WATCHING TV

THIS ONE AT MIDNIGHT

CHOCOLATE NEGRO AMARGO 77% DE CACAO

ENRIC ROVIRA

Choco Dosis, 2004 | D EMILI PADRÓS | M ENRIC ROVIRA SL | P ENRIC ROVIRA

246

Half Made, 2001

Dressing Series, 2001

Potato Salad Series, 2001

Lisa's Incredible, 1997 | **D** Mark Greene, Pecos design.com | **M** Lisa's Gourmet Snacks

250

251

Ol'Mera Olive Oil, 2005 | **D** Peter Watts | **M** Ol'Mera

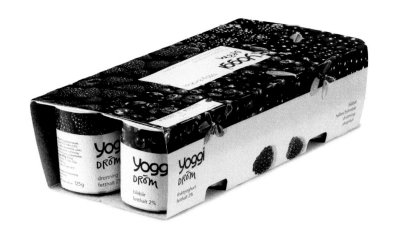

Yoggi Dream, 2004 | **D** Lina Elfstrand | **M** Arla Foods, Yoggi | **P** Lasse Kärkkäinen

Mixed Snack, 2004 | **D** Kou Umetani | **M** Maruesu | **P** Taro Hirai

255

Leggos Stir Through, 1995 | **D** HELEN WATTS | **M** LEGGOS | **P** JAMES VLAHOGIANNIS

256

Request Cookee, 2003 | **D** Yasuo Tanaka | **M** Cisco Co.

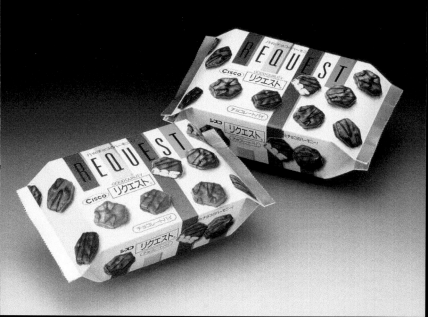

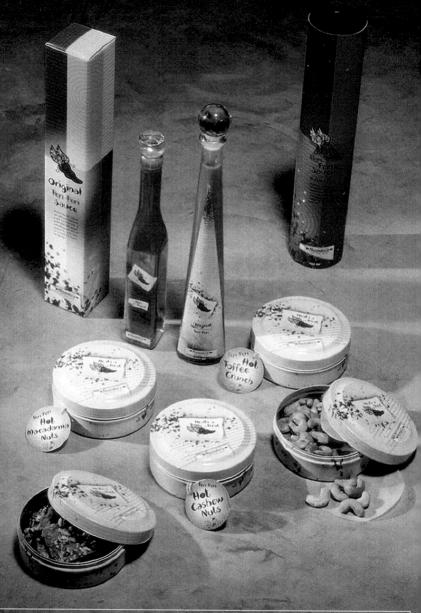

Nando's Signatura Range, 2002 | **D** CARINA COMRIE | **M** NANDO'S CHICKENLAND | **P** DAVID PASTOLL

Planetarium, 2000 | **D** ENRIC ROVIRA | **M** ENRIC ROVIRA SL | **P** ENRIC ROVIRA

Nando's Salad Dressings, 2002 | **D** Shona Danckwerts | **M** Nando's Chickenland | **P** David Pastoll

Baby, 2003 | **D** ENRIC ROVIRA | **M** ENRIC ROVIRA SL | **P** ENRIC ROVIRA

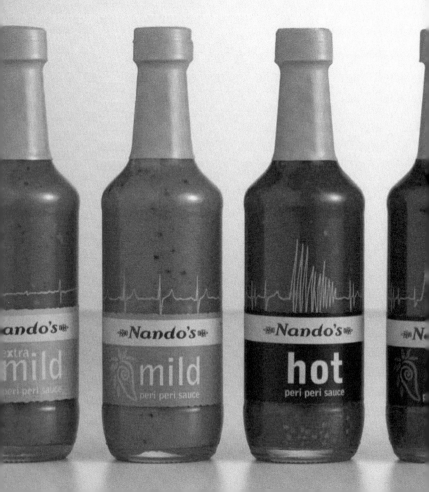

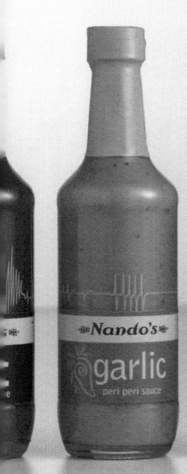

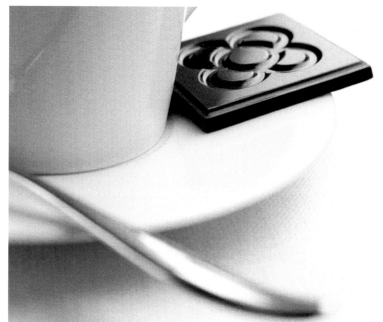

Mini Rajoles Box, 1997 | **D** Exit de Disseny | **M** Enric Rovira SL | **P** Enric Rovira

ANA

ANA'S DINING

FIRST CLASS

CHICKEN CURRY

地鶏とマッシュルームのカリー

With its careful preparation to bring out the best in its stringently selected ingredient, this is the curry for those who want only the best. Enjoy its first-class flavor.

総料理長

1人分 205g
中辛

Chicken Curry, 1999 | **D** YOSHINORI SHIOZAWA | **M** ALL NIPPON AIRWAYS TRADING | **P** MICHIHARU BABA

266

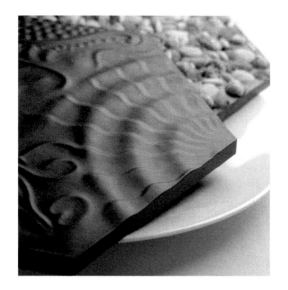

268

Hexàgon Gaudí, 1997 | **D** ENRIC ROVIRA | **M** ENRIC ROVIRA SL | **P** ENRIC ROVIRA

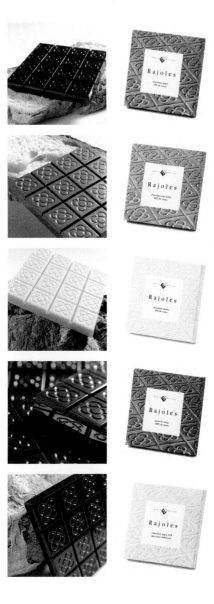

269

Rajola, 1995 | **D** Exit de Disseny | **M** Enric Rovira SL | **P** Enric Rovira

270

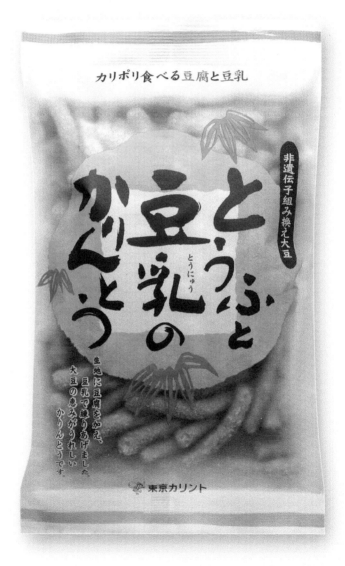

271

Accents, 2000 | **D** ANA MIR | **M** ENRIC ROVIRA SL | **P** ENRIC ROVIRA

Chocolate a la Taza, 1995 | **D** Exit de Disseny | **M** Enric Rovira SL | **P** Enric Rovira

274

275

Kodomono Puti-Zeri, 2002 | **D** Izumi Kidoshi | **M** Morinaga Milk Industry | **P** Adcon

276

"Soleil" gift consisting of sweet bean paste and local tea, 1998

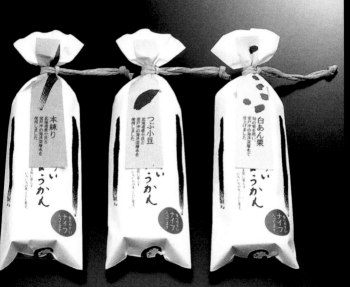

277

278

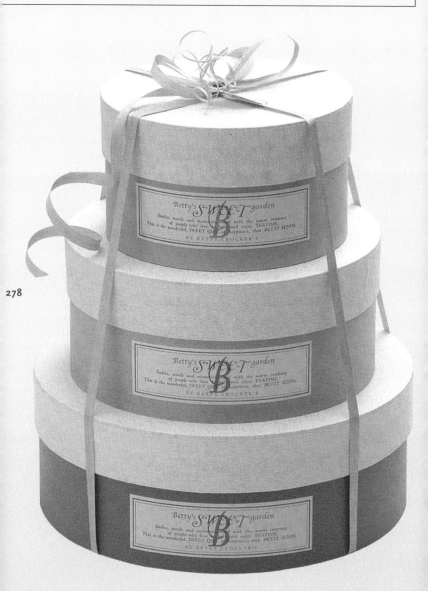

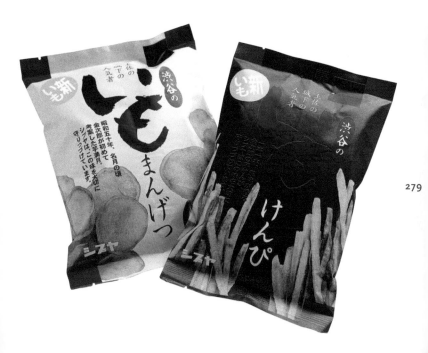

Potato Confectionery Bag, 1999 | **D** Mihoko Hachiuma | **M** Shibuya | **P** Kenzo Nakajima

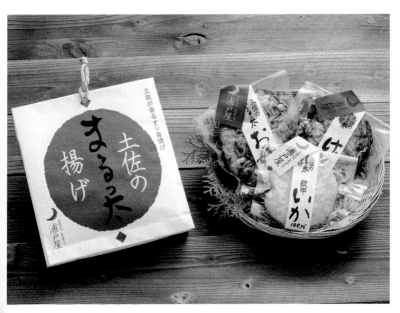

Assortment of Tempura for Souvenir, 1998 | **D** Mihoko Hachiuma | **M** Uradoya | **P** Kenzo Nakajima

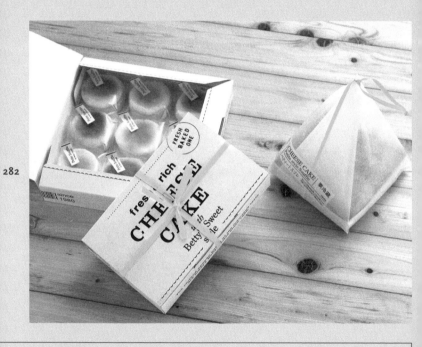

Gift Package for Cheese Cake, 2002 | **D** Mihoko Hachiuma | **M** Betty's Sweet | **P** Kenzo Nakajima

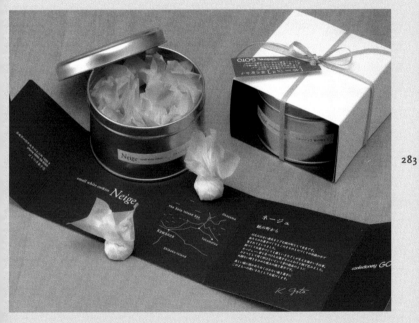

283

Cookie Gift Neige, 2004 | **D** MIHOKO HACHIUMA | **M** CONFECTIONERY GOTO | **P** KENZO NAKAJIMA

284

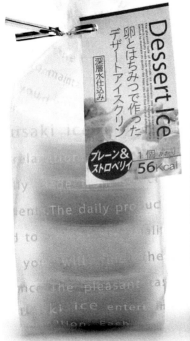
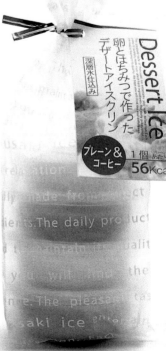

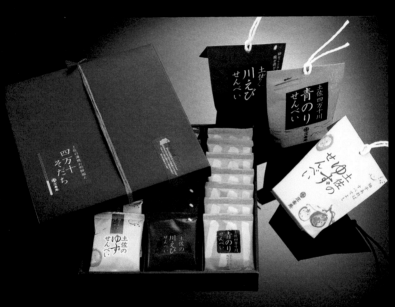

Shimannto Sodachi, 1999 | **D** Mihoko Hachiuma | **M** Shoju-an | **P** Kenzo Nakajima

286

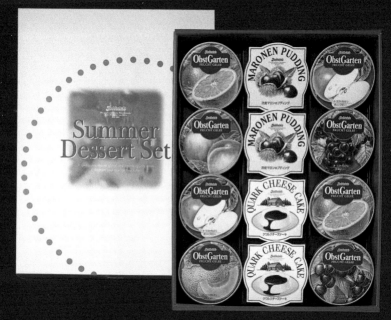

D'Lush, 2003 | **D** PETER WATTS | **M** NATURALLY GOOD | **P** JAMES VLAHOGIANNIS

Kome Roman, 2003 | **D** Takatugu Yazawa, Hiroyuki Sakai | **M** Kitoku Shinryo

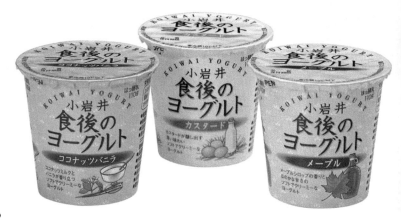

Syokugono Yogurt, 2000 | **D** Takatugu Yazawa | **M** Koiwai Dairy Products

292

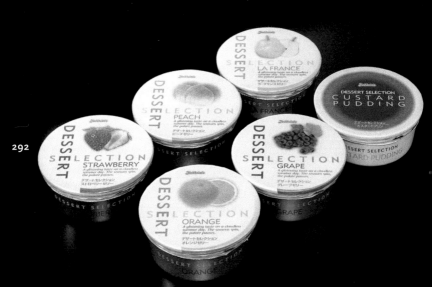

Crefer, 2004 | **D** SATOSHI TAMAGAKI | **M** YAMAZAKI-NABISCO | **P** FORWARD

294

Koiwai Ice Cream, 2000 | **D** Hiroyuki Sakai | **M** Koiwai Dairy Products

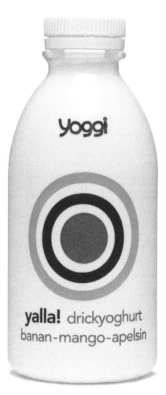

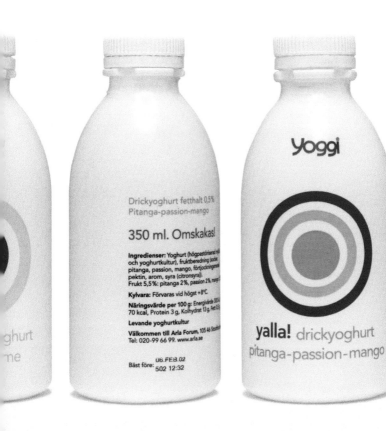

Drickyoghurt fetthalt 0,5%
Pitanga-passion-mango

350 ml. Omskakas!

Ingredienser: Yoghurt (högpastöriserad mjölk
och yoghurtkultur), fruktberedning (socker,
pitanga, passion, mango, förtjockningsmedel
pektin, arom, syra (citronsyra).
Frukt 5,5 %: pitanga 2%, passion 2%, mango 1,5%.

Kylvara: Förvaras vid högst +8°C.

Näringsvärde per 100 g: Energivärde 300 kJ
70 kcal, Protein 3 g, Kolhydrat 13 g, Fett 0,5 g.

Levande yoghurtkultur

Välkommen till Arla Forum, 105 46 Stockholm
Tel: 020-99 66 99. www.arla.se

Bäst före: 06.FEB.02
 502 12:32

yoggi

yalla! drickyoghurt
pitanga-passion-mango

p. 214
OAO

Packaging designed by Philippe Starck for different kinds of organic foods (rice, chocolate, sea salt, müsli, biscuits).

Verpackung von Philippe Starck für verschiedene Arten von Bio-Lebensmitteln (Reis, Schokolade, Meersalz, Müsli, Kekse ...)

Emballages de Philippe Starck pour différents types d'aliments biologiques (riz, chocolat, sel marin, muesli, biscuits...).

Envases de Philippe Starck para diferentes tipos de alimentos orgánicos (arroz, chocolate, sal marina, muesli, galletas...).

298

Contenitori di Philippe Starck per vari tipi d'alimenti organici (riso, cioccolato, sale marino, muesli, biscotti...).

p. 215
Trefin Heart Praline, Color Eggs, Napolitains

Boxes designed by Cadbury Japan to hold chocolates: bonbons, colored eggs, or Napolitains.

Kisten von Cadbury Japan für verschiedene Schokoladenprodukte: Pralinen, Schokoladeneier, Napolitainer ...

Boîtes de Cadbury Japan pour différents produits de chocolat: chocolats, œufs de couleur, napolitains...

Cajas de Cadbury Japan para diferentes productos de chocolate: bombones, huevos de colores, napolitanas...

Scatole di Cadbury Japan per vari prodotti di cioccolato: praline, uova colorate, napoletane...

p. 216
Tamarind Indian Cuisine

Encouraged by its booming success, the Tamarind restaurant has launched a line of sauces, seasonings and spices with its own brand.

Der Erfolg des bekannten Restaurants Tamarind brachte die Linie von Saucen und Gewürzen mit gleichem Namen hervor.

Fort de son succès, le restaurant Tamarind a lancé une ligne de sauces, condiments et épices portant son nom.

El éxito del reconocido restaurante Tamarind ha provocado el lanzamiento de una línea de salsas, condimentos y especias con su nombre.

Il successo del noto ristorante Tamarind ha portato al lancio di una linea di salse, condimenti e spezie dall'omonimo nome.

p. 217
Valentine's Day Gift Package, Sutton East Chocolates

Chocolate boxes designed specially for Saint Valentine's day, and packaging for chocolate bars and other chocolate items.

Pralinenschachteln, die speziell für den Valentinstag entworfen wurden, und Verpackungen für Schokoladentafeln und andere Schokoladenprodukte.

Boites de chocolats créées spécialement pour la saint Valentin et packaging pour tablettes et autres produits chocolatés.

Cajas de bombones diseñadas especialmente para el día de San Valentín y packaging para tabletas y otros productos de chocolate.

Scatole di cioccolatini disegnate in modo specifico per il giorno di San Valentino ed un packaging per tavolette ed altri prodotti di cioccolato.

p. 218
Postre Cremoso

Transparent glass containers and classy labelling for Carrefour's cream desserts.

Verpackungen aus durchsichtigem Glas mit eleganten Etiketten für die cremigen Nachspeisen der Supermarktkette Carrefour.

Emballages de verre transparent et élégant étiqueté pour les desserts onctueux de la chaîne de supermarché Carrefour.

Envases de vidrio transparente y elegante etiquetado para los postres cremosos de la cadena de supermercados Carrefour.

Recipienti in vetro trasparente ed elegante etichettato per i dolci cremosi della catena di supermercati Carrefour.

p. 219
Red Gems Tomatoes

Peter Watts was asked to create packaging for Water Wheel's tomatoes. A boutique box and label design was in keeping with the high standards of this company's produce.

Peter Watts wurde mit dem Entwurf dieser originellen Kiste für die hochwertigen Tomaten des Unternehmens Water Wheel beauftragt.

Peter Watts a été chargé de faire le design original de cette boite de tomates (choisies pour leur qualité) pour la compagnie Water Wheel.

Peter Watts ha sido el encargado de diseñar esta original caja de tomates (seleccionados por su excelencia) para la compañía Water Wheel.

Peter Watts ha ricevuto l'incarico di disegnare queste originali scatole di pomodori (selezionati per essere eccellenti) dalla ditta Water Wheel.

p. 220
Foie Gras Cydon

Cydon merges culture, history and gastronomy all into one. One block of foie gras with a slice of quince.

Cydon vereint Kultur, Geschichte und Gastronomie. Ein Block Leberpastete mit einer Schicht Quittenkonfitüre.

Cydon unie culture, histoire et gastronomie. Un bloc de foie gras avec une couche de coing.

Cydon aúna cultura, historia y gastronomía. Un bloque de foie gras con una capa de membrillo.

Cydon abbina cultura, storia e gastronomia. Un blocco di foie gras con uno strato di mela cotogna.

p. 221
El Foie Gras de los Faraones; Las estaciones del Foie Gras

Two suggestions for presenting foie-gras: an arrangement of four different-flavored portions, and in a pyramid.

Zwei Arten, um Leberpastete zu präsentieren: in vier Portionen mit verschiedenem Geschmack und in Form einer Pyramide.

Deux façons de présenter le foie gras: en quatre portions aux saveurs distinctes et en forme de pyramide.

Dos formas de presentar el foie gras: en cuatro porciones de sabores distintos y en forma de pirámide.

Due modi di presentare il foie gras: in quattro porzioni di sapori diversi ed a forma di piramide.

p. 222
Miyako Kombu

Colorful, baroque packaging for Nakano Bussan snacks.

Bunte und barocke Verpackungen für die Snacks der Marke Nakano Bussan.

Emballages coloristes et baroques pour les snacks de la marque Nakano Bussan.

Envases coloristas y barrocos para los snacks de la marca Nakano Bussan.

Recipienti coloristi e barocchi per gli snack della casa Nakano Bussan.

p. 223
Mayonnaise Series

Different jars for each different mayonnaise type from Ajinomoto. Each flavor is assigned a different number.

Verpackungen für Majonäsen verschiedener Geschmacksrichtungen der Marke Ajinomoto. Jede Geschmacksrichtung entspricht einer anderen Nummer.

Emballages de mayonnaise aux différentes saveurs de la marque Ajinomoto. A chaque parfum correspond un numéro différent.

Envases de mayonesas de diferentes sabores de la marca Ajinomoto. Cada sabor se corresponde con un número distinto.

Recipienti per maionese dai vari sapori della casa Ajinomoto. Ogni sapore corrisponde ad un diverso numero.

pp. 224-225
Knorr Sauce

Packaging for Knorr sauces. Ergonomic design, rather like a pot-bellied mineral water bottle.

Verpackungen für Knorr-Saucen. Das Design ist ergonomisch und gleicht einer Mineralwasserflasche, ist aber etwas rundlicher.

Emballages pour les sauces Knorr. Le design est ergonomique et semblable à une petite bouteille d'eau minérale, un peu plus recherchée.

Envases para las salsas Knorr. El diseño es ergonómico y parecido al de un botellín de agua mineral, aunque algo más rechoncho.

Recipienti per le salse Knorr. Il design è ergonomico, simile a quello di una bottiglietta d'acqua minerale, benché un po' più tozzo.

p. 226
Arcadian 12 Cheese Pack

Minimalist design and a slightly old-fashioned look for these cheese-portion boxes for Gedi. The brand's distinctive logo is the red stripe.

Minimalistisches Design und ein leichter Rotrostil für diese Käseschächteln der Marke Gedi. Der rote Streifen ist das Erkennungszeichen.

Design minimaliste et allures légèrement rétro pour cette boîte de petits fromages de la marque Gedi. La frange rouge en est la marque distinctive.

Diseño minimalista y de aire ligeramente retro para estas cajas de quesitos de la marca Gedi. La franja roja es su elemento distintivo.

Design minimalista, dall'aria leggermente retro per queste scatole di formaggini della casa Gedi. La striscia rossa è il suo elemento distintivo.

p. 227
Jack in the Box, Sandwich Wraps

Jack in the Box hamburger restaurants have set this example of how a product's visual appeal can be re-designed.

Ein Beispiel für die Neugestaltung eines Designs, das die visuelle Attraktivität des Produktes erhöhen soll, in diesem Fall des Schnellimbisses Jack in the Box.

Exemple de nouveau design qui vise à exalter l'attrait visuel d'un produit, dans ce cas celui des hamburgers Jack in the Box.

Ejemplo de rediseño que pretende potenciar el atractivo visual de un producto, en este caso los de las hamburgueserías Jack in the Box.

Esempio di redesign che vuole rafforzare la bellezza visiva di un prodotto, in questo caso quello della casa di hamburger Jack in the Box.

p. 228
Retort Oyatsu Packs

Maruesu brand packaged snacks (maize, beans, hazelnuts). Each different variety is identified through a different character.

Verpackungen für Snacks (aus Mais, Bohnen, Haselnüssen) der Marke Maruesu. Jeder Snack wird durch eine andere Figur charakterisiert.

Emballages de snacks (mais, haricots, noisettes) de la marque Maruesu. Chaque snack a un personnage différent pour le distinguer des autres.

Envases de snacks (maíz, judías, avellanas) de la marca Maruesu. Cada snack se identifica con un personaje diferente.

Recipienti di snack (mais, fagioli, nocciola) della casa Maruesu. Ogni snack s'identifica con un diverso personaggio.

p. 229
Eastern Breeze Tofu

Tixana created these organic tofu products in an attempt to include them in the Australian diet.

Die Produkte aus Bio-Tofu der Marke Tixana wurden geschaffen, um dieses Lebensmittel in der australischen Ernährung zu etablieren.

Les produits de tofu biologique de la marque Tixana ont été créés pour aider à introduire ce produit dans le régime alimentaire australienne.

Los productos de tofu orgánico de la marca Tixana fueron creados para ayudar a introducir este alimento en la dieta australiana.

I prodotti di tofu organico della casa Tixana sono stati creati per aiutare ad introdurre quest'alimento nella dieta australiana.

p. 230
La Vuelta al Mundo en Chocolate

A five-box set representing the five continents. Each box contains chocolates manufactured with ingredients from its represented continent.

Behälter mit fünf Schachteln, die die fünf Kontinente repräsentieren. Jede Schachtel enthält Schokolade, die mit Zutaten des jeweiligen Kontinents hergestellt ist.

Etui de cinq boites représentent les cinq continents. Chacune boite contient du chocolat fabriqué avec des ingrédients issus de ces continents.

Estuche de cinco cajas que representan los cinco continentes. Cada caja contiene chocolate fabricado con ingredientes de esos continentes.

Astuccio di cinque scatole che rappresentano i cinque continenti. Ogni scatola contiene del cioccolato realizzato con gli ingredienti di questi continenti.

p. 231
Zipsticks

These meat snacks are packaged to stand out from competitors.

Durch die Gestaltung der Verpackung dieser Fleischsnacks soll dieses Produkt von seiner Konkurrenz unterschieden werden.

Le design de l'emballage de ces snacks de viande vise à différencier ce produit de la concurrence, transmettant une idée de qualité.

El diseño del envase de estos snacks de carne pretende diferenciar este producto de los de su competencia.

Il design dei recipienti di questi snack di carne vuole differenziare questo prodotto da quelli dei suoi concorrenti.

p. 232
Panini Packaging

Charming bags and boxes for Panini, the café and patisserie at the luxurious Dubai Grand Hyatt Hotel.

Lustig gestaltete Tüten und Schachteln für Panini, Café und Konditorei des luxuriösen Grand Hyatt in Dubai.

Design amusant de paquets et de boites pour Panini, le café pâtisserie du luxueux hôtel Grand Hyatt de Dubaï.

Divertido diseño de bolsas y cajas para Panini, el café-pastelería del lujoso hotel Grand Hyatt de Dubai.

Divertente design di buste e scatole per Panini, il caffè-pasticceria del lussuoso hotel Grand Hyatt di Dubai.

p. 233
Nine Bonbons Box

Nine-pack boxes for chocolates in unconventional flavors such as vinegar or saffron.

Schachtel mit neun Pralinen mit ungewöhnlichen Geschmacksrichtungen wie Essig oder Safran.

Boite de neuf chocolats aux saveurs insolites comme vinaigre ou safran.

Cajas de nueve bombones de sabores no convencionales como vinagre o azafrán.

Scatole di nove cioccolatini dai sapori poco convenzionali come aceto o zafferano.

pp. 234-235
Kshocolât

A global solution for over 50 different product types: metal, plastic and cardboard boxes in assorted sizes.

Umfassende Lösung für 50 verschiedene Produkttypen: Metallschachteln, Kunststoffschachteln und Kartons in verschiedenen Größen.

Solution globale pour plus de 50 types différents de produits : boites de métal, de plastique et en carton de tailles différentes.

Solución global para más de 50 tipos diferentes de productos: cajas de metal, de plástico y de cartón en distintos tamaños.

Soluzione globale per più di 50 tipi diversi di prodotti: scatole in metallo, plastica e di cartone di varie dimensioni.

p. 236
Bikini Chips

Lisa's Gourmet Snacks potato crisps in a bag. The use of the color yellow is the only feature uniting this range of designs.

Tüte für Chips der Marke Lisa's Gourmet Snacks. Die gelbe Farbe ist das einzige vereinheitlichende Element der gesamten Designlinie.

Sachet de chips de la marque Lisa's Gourmet Snacks. Le jaune est ce qui unifie tous les designs de la gamme.

Bolsa de patatas fritas de la marca Lisa's Gourmet Snacks. El color amarillo es el único punto unificador de todos los diseños de la gama.

Sacchetto di patatine fritte della casa Lisa's Gourmet Snacks. Il giallo è l'unico punto comune a tutti i design della gamma.

p. 237
Lisa's Incredible

Snack sauces presented in jars with different color schemes on the label to identify the different varieties.

Dosen mit Sauce für Snacks. Die verschiedenen Farben der Etiketten entsprechen den verschiedenen Geschmacksrichtungen der Saucen.

Pots de sauces pour snacks. Les diférentes couleurs de l'étiquette correspondent aux différentes saveurs des sauces.

Tarros de salsas para snacks. Los diferentes colores del etiquetado se corresponden con los diferentes sabores de las salsas.

Barattoli di salse per snack. I diversi colori delle etichette corrispondono ai vari delle salse.

p. 238

Tesco Finest Yogurts

Top-of-the-range yogurt cartons designed for Tesco, the largest grocery retailer in the United Kingdom.

Becher für hochwertigen Joghurt der Supermarktkette Tesco, die größte in Großbritannien.

Emballage de yaourt haut de gamme pour la chaîne de supermarché Tesco, la plus importante en le Royaume-Uni.

Envases de yogur de gama alta para la cadena de supermercados Tesco, la mayor del Reino Unido.

Recipienti per yogurt di gamma alta per la catena di supermercati Tesco, la più importante del Regno Unito.

p. 239

Tesco Finest Herbs & Rubs

Spice containers for Tesco's Fine Foods section. The transparent plastic circle allows the contents to be viewed.

Verpackungen für hochwertige Gewürze der Kette Tesco. Durch den Kreis aus transparentem Kunststoff sieht man den Inhalt.

Emballages d'épices haut de gamme pour la chaîne Tesco. Le cercle de plastique transparent permet de contrôler le contenu.

Envases de especias de gama alta para la cadena Tesco. El círculo de plástico transparente permite inspeccionar su contenido.

Recipienti per spezie d'alta gamma per la catena Tesco. L'anello di plastica trasparente consente d'ispezionare il contenuto.

p. 240

Fullprotein

High-protein beverage in two flavors (strawberry and vanilla) in one-litre bottles or 250 ml pots.

Proteinreiches Getränk in zwei Geschmacksrichtungen (Erdbeere und Vanille), das in Verpackungen mit einem Liter oder 250 ml angeboten wird.

Boisson riche en protéines aux deux parfums (fraise et vanille) disponible en emballage d'un litre et de 250 ml.

Bebida rica en proteínas de dos sabores (fresa y vainilla) disponible en envases de un litro y de 250 ml.

Bevanda ricca in proteine a due gusti (fragola e vaniglia) disponibile in recipienti da un litro e da 250 ml.

p. 241

Dovo Spray

Pasteurised egg in a spray bottle is a hygienic alternative to the traditional basting brush. It comes in 300 g bottles.

Pasteurisiertes Ei in Sprayform ist eine hygienische Alternative zum traditionellen Pinsel für Lebensmittel. Verpackungen mit 300 g.

L'œuf pasteurisé en spray est une alternative hygiénique au traditionnel pinceau pour aliments. Disponible en emballages de 300 g.

El huevo pasteurizado en spray es una alternativa higiénica al tradicional pincel para alimentos. Disponible en envases de 300 g.

L'uovo pastorizzato spray è un'alternativa igienica al tradizionale pennello per alimenti. Disponibile in confezioni da 300 g.

p. 242

Yoggi

Tetrabrik cartons of drinkable yogurt for the Swedish brand Arla. Its powerful, personal logo separates this product from its competitors.

Tetrabrik-Verpackung für Trinkjoghurt der schwedischen Marke Arla. Das starke und typische Logo unterscheidet das Produkt von der Konkurrenz.

Emballages tétrabrique de yaourt liquide pour la marque suédoise Arla. La personnalité de leur puissant logo les différencie de la concurrence.

Envases de tetrabrik de yogur líquido para la marca sueca Arla. La personalidad de su potente logo los diferencia de la competencia.

Tetrabrik di yogurt liquido per la casa svedese Arla. La personalità del suo potente logo li differenzia rispetto alla concorrenza.

p. 243

Kajitsuryoku

These fruit-flavored sweets are packaged to suggest their beneficial effects on the buyer's health.

Verpackung für Fruchtbonbons. Dem Käufer soll die Idee der gesundheitsfördernden Wirkung dieser Bonbons vermittelt werden.

Emballage pour bonbons aux fruits. L'objectif et de persuader l'acheteur des bienfaits des bonbons pour sa santé.

Envase para caramelos de fruta. Su objetivo es transmitir al comprador la idea de los efectos beneficiosos de los caramelos para la salud.

Recipiente per caramelle di frutta. L'obiettivo è quello di trasmettere all'acquirente l'idea degli effetti positivi delle caramelle sulla salute.

p. 244
Vertical

A case in which little upright trays hold chocolates with different flavors.

Kästchen, in dem man kleine Pralinentabletts mit verschiedenen Geschmacksrichtungen übereinander anordnen kann.

Etui qui permet de disposer verticalement des petits plateaux de chocolats aux différentes saveurs.

Estuche que permite disponer verticalmente pequeñas bandejas de bombones de diferentes sabores.

Astuccio che consente di disporre verticalmente piccoli vassoi di caramelle dai vari sapori.

p. 245
Choco Dosis

As a variation on the traditional chocolate bar, the Choco Dosis design allows different sized portions to be broken off.

Dieses Design von Choco Dosis, das auf der traditionellen Schokoladentafel beruht, ermöglicht das Aufteilen der Schokolade in Portionen verschiedener Größe.

Basé sur le design traditionnel d'une tablette de chocolat, Choco Dosis permet de prendre des morceaux de différentes tailles.

Basado en el diseño tradicional de una tableta de chocolate, Choco Dosis permite quebrar porciones de diferentes tamaños.

Basato sul design tradizionale di una tavoletta di cioccolato, Choco Dosis permette di rompere le porzioni in varie grandezze.

pp. 246-247
Ajinomoto Catering

Top-of-the-range food packaging from Ajinomoto, including a variety of salad dressings and different kinds of potato salads.

Verpackung für hochwertige Lebensmittel (darunter Salatsaucen und verschiedene Arten von Kartoffelsalat) der Marke Ajinomoto.

Emballages pour aliments de haut de gamme (parmi eux sauces pour salades et différents types de salades de pommes de terre) de la marque Ajinomoto.

Envases para alimentos de gama alta (entre ellos salsa para ensaladas y diferentes tipos de ensalada de patata) de la marca Ajinomoto.

Recipienti per alimenti d'alta gamma (tra i quali le salse per insalata e vari tipi d'insalati di patata) della casa Ajinomoto.

p. 248
Snap!

Espresso coffee capsules covered in different varieties of chocolate, e.g. milk chocolate or almond chocolate, are presented in these sachets.

Beutel für Bonbons mit Espressogeschmack mit verschiedenen Arten von Schokolade überzogen, Milchschokolade, Mandelschokolade ...

Petits sachets pour grains de café expresso recouverts de différents types de chocolats : au lait, aux amendes...

Bolsitas para píldoras de café espresso recubiertas de diferentes tipos de chocolate: con leche, con almendras...

Sacchetti per cialde di caffè espresso ricoperte di vari tipi di cioccolato: con latte, mandorle...

p. 249
Lisa's Incredible

Bags for maize snacks in assorted flavors. A transparent window lets the consumer see the product inside.

Beutel für Mais-Snacks verschiedener Geschmacksrichtungen. Das transparente Sichtfenster ermöglicht es, den Zustand des darin enthaltenen Produktes zu überprüfen.

Sachets de snacks de maïs aux différentes saveurs. La petite fenêtre transparente permet de vérifier l'état de fraicheur du produit à l'intérieur.

Bolsas de snacks de maíz de diferentes sabores. La ventana transparente permite comprobar el estado del producto en su interior.

Sacchetti di snack di mais di vari sapori. La finestrella trasparente consente di verificare lo stato interno del prodotto.

303

p. **250**

Fowlers Vacola Preserving Range

An old-fashioned feel in this design identifies the product with bygone times when preserving was an important occupation in every household.

Das Retro-Design dieser Verpackungen identifiziert das Produkt mit einer Epoche, in der man mehr Aufmerksamkeit auf die Aufbewahrung des Produktes richtete.

Le design rétro de ces emballages identifie le produit à une époque où l'on accordait plus d'importance à la conservation du produit.

El diseño retro de estos envases identifica el producto con una época en la que se prestaba más atención a la preservación del producto.

Il design retro di questi recipienti identifica il prodotto con un'epoca in cui si faceva maggior attenzione alla salvaguardia del prodotto.

p. **251**

Ol'Mera Olive Oil

High quality olive oil containers, hand-made and competitively priced, from Ol'Mera.

Verpackungen für hochwertige, preisgünstige und von Hand hergestellte Öle der Marke Ol'Mera.

Emballages pour huile de qualité supérieure, de prix compétitif et de production artisanale de la marque Ol'Mera.

Envases para el aceite de alta calidad, de precio competitivo y producción manual de la marca Ol'Mera.

Recipienti per olio d'alta qualità, dal prezzo competitivo e di produzione manuale della casa Ol'Mera.

pp. **252-253**

Yoggi Dream

Individual yogurt pots and flavor-combination packs for Yoggi. This traditional design has been successfully redrawn with a quiet, elegant air.

Individuelle Verpackung für Joghurts und Packungen mit mehreren Geschmacksrichtungen der Marke Yoggi. Ein traditionelles Design, das elegant und zurückhaltend erneuert wurde.

Emballages de yaourt individuels et packs de diverses saveurs de la marque Yoggi. Un design traditionnel rénové, tout en élégance et discrétion.

Envases de yogur individuales y packs de varios sabores de la marca Yoggi. Un diseño tradicional renovado elegantemente y sin estridencias.

Recipienti per yogurt singoli e pack di vari sapori della casa Yoggi. Un design tradizionale rinnovato elegantemente e senza essere stridente.

p. **254**

Mixed Snack

These plastic packets for assorted snacks are printed over 80 % of the front surface.

Plastikbeutel für verschiedene Snacks mit Aufdrucken, die fast 80 % der vorderen Fläche der Verpackung bedecken.

Sachets de plastique pour snacks variés et de typographies couvrant pratiquement les 80 % du devant de l'emballage.

Bolsas de plástico para snacks variados y con tipografías que ocupan prácticamente el 80 % de la superficie frontal del envase.

Sacchetti di plastica per diversi snack e con presenza tipografica che occupa in pratica l'80 % della loro superficie frontale.

p. **255**

Leggos Stir Through

The objective in designing these glass jars was to highlight the idea of freshness and quality of the select products they contain.

Mit der Gestaltung dieser Gläser wollte man die Idee von Frische und Qualität der ausgewählten Zutaten vermitteln.

Le design de ces pots de verre a été conçu pour rehausser l'idée de fraîcheur et la qualité des ingrédients sélectionnés.

El objetivo al diseñar estos tarros de vidrio ha sido enfatizar la idea de frescura y calidad de los ingredientes seleccionados.

L'obiettivo nel disegnare questi barattoli di vetro è stato quello di sottolineare l'idea di freschezza e di qualità degli ingredienti selezionati.

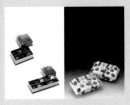
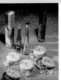

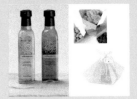

p. 256
Grand Place Chocolate

Six and ten piece trays in which each chocolate has its own individual compartment.

Schachtel mit sechs und zehn Pralinen, in der jede Praline ihr eigenes Fach hat.

Boites de six et dix chocolats séparés les uns des autres par des petits compartiments individuels.

Cajas de seis y diez bombones en la que cada pieza cuenta con su compartimiento individual.

Scatola da sei e dieci cioccolatini in cui ogni pezzo ha un suo compartimento individuale.

p. 257
Request Cookee

Chocolate snack package with a play of colors on the front.

Verpackung für Schokoladensnacks, die mit verschiedenen Farben auf der Vorderseite spielt.

Emballage pour snacks chocolatés jouant avec plusieurs couleurs sur le devant.

Envase para snacks de chocolate que juega con varios colores en su parte frontal.

Recipiente per snack di cioccolato che gioca con vari colori sulla parte frontale.

p. 258
Nando's Signatura Range

One of the star products of the Nando brand is its range of gift sauces. Its packaging is designed to spotlight this idea.

Eines der Vorzeigeprodukte der Marke Nando ist die Saucenserie zum Verschenken. Das Verpackungsdesign unterstreicht dieses Konzept.

Un des produits phare de la marque Nando est la gamme de sauces pour offrir. Le design du packaging est conçu pour souligner cette idée.

Uno de los productos estrella de la marca Nando es su gama de salsas para regalo. El diseño del packaging pretende subrayar esa idea.

Uno dei prodotti stella della casa Nando è la sua gamma di salse da regalo. Il design del packaging vuole mettere in evidenza quest'idea.

p. 259
Planetarium

A case for spherical chocolates. Each chocolate represents a different planet in the solar system.

Schachtel für kugelförmige Pralinen. Jede Praline stellt einen anderen Planeten des Sonnensystems dar.

Etuis pour chocolats sphériques. Chaque chocolat représente une planète différente du système solaire.

Estuche para bombones esféricos. Cada bombón representa un planeta diferente del sistema solar.

Astuccio per cioccolatini sferici. Ogni cioccolatino rappresenta un diverso pianeta del sistema solare.

p. 260
Nando's Salad Dressings

Nando's range of salad dressings. The hand drawings accentuate the natural and traditional qualities of the ingredients.

Salatsaucen der Marke Nando. Die Zeichnungen vermitteln die natürliche und traditionelle Linie des Produktes.

Sauces pour salades de la marque Nando. Les dessins transmettent une idée naturelle et traditionnelle du produit.

Salsas para ensalada de la marca Nando. Los dibujos transmiten una idea natural y tradicional del producto.

Salse per insalata della casa Nando. I disegni trasmettono un'idea naturale e tradizionale del prodotto.

p. 261
Baby

A product intended as a present for first-time parents. The exclusive array of confectionery in the interior is appealing to all children.

Geschenkprodukt für frischgebackene Eltern. Darin befinden sich Süßigkeiten, die allen Kindern schmecken und von sehr hoher Qualität sind.

Produit conçu comme cadeau pour jeunes parents. A l'intérieur, les sucreries qui plaisent à tous les enfants, sont de qualité supérieure.

Producto pensado como regalo para nuevos padres. En su interior, los dulces que gustan a todos los niños, pero de gama alta.

Prodotto concepito come regalo per nuovi genitori. All'interno, i dolci che piacciono ai bambini, ma d'alta gamma.

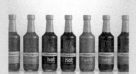

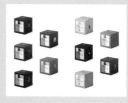

pp. **262-263**
Nando's Peri-Peri Sauces

Nando tells the consumer how hot each sauce is with a scale on the side of its jars with a draw.

Die Saucen der Marke Nando informieren den Verbraucher mithilfe einer Zeichnung über den Schärfegrad.

Les sauces de la marque Nando informent le consommateur si elles sont fortement épicées avec un desin.

Las salsas de la marca Nando informan al consumidor de su grado de picante con un dibujo.

Le salse della casa Nando informano il consumatore di quanto siano piccanti con un disegno.

306

p. **264**
Mini Rajoles Box

Chocolate bars in the shape of the popular modernist paving tiles found on the streets of Barcelona.

Schokoladentafeln, die die Form der traditionellen, modernistischen Pflastersteine auf den Straßen Barcelonas imitieren.

Tablettes de chocolat qui reproduisent la forme des pavés traditionnels modernistes des rues de Barcelone.

Tabletas de chocolate que reproducen la forma de las tradicionales baldosas modernistas de las calles de Barcelona.

Tavolette di cioccolato che riproducono la forma delle tradizionali mattonelle moderniste delle strade di Barcellona.

p. **265**
Chicken Curry

The package created for this culinary preparation conveys the harmony of flavors and complex preparation of the dish.

Die Gestaltung der Verpackung dieses Curryhähnchens vermittelt den harmonischen Geschmack des Produktes und die Komplexität seiner Herstellung.

Le design de l'emballage de ce poulet au curry vise à transmettre les saveurs harmonieuses du produit et la complexité de leur préparation.

El diseño del envase de este pollo al curry pretende transmitir la armonía de sabores del producto y la complejidad de su elaboración.

Il design del recipiente di questo pollo al curry vuole trasmettere l'armonia dei sapori del prodotto e la complessità della sua elaborazione.

pp. **266-267**
Bombolas

Cubic chocolate boxes for Enric Rovira. The main ingredient is pictured on the side of each box.

Würfelförmige Kartons für Schokoladenpralinen der Marke Enric Rovira. Auf der Seite ist ein Bild der Hauptzutat.

Boites cartonnées cubiques pour truffes en chocolat de la marque Enric Rovira. Sur le côté figure l'image du principal ingrédient.

Cajas de cartón cúbicas para bombones de chocolate de la marca Enric Rovira. En el lateral, la imagen del ingrediente principal.

Scatole di cartone cubiche per cioccolatini della casa Enric Rovira. Lateralmente, l'immagine dell'ingrediente principale.

p. 268
Hexàgon Gaudí

Chocolate bars in the hexagonal shape of the paving tiles Gaudí designed for Barcelona's emblematic Passeig de Gràcia.

Schokoladentafeln, die die Form der traditionellen Pflastersteine nachahmen, die Gaudí für den Passeig de Gràcia in Barcelona entworfen hatte.

Tablettes de chocolat qui reproduisent la forme des carrelages traditionnels créés par Gaudí pour le Passeig de Gràcia à Barcelone.

Tabletas de chocolate que reproducen la forma de las tradicionales baldosas diseñadas por Gaudí para el Passeig de Gràcia barcelonés.

Tavolette di cioccolato che riproducono la forma delle tradizionali mattonelle disegnate da Gaudí per il Passeig de Gràcia di Barcellona.

p. 269
Rajola

Chocolate bars moulded as Barcelona paving tiles.

Schokoladentafeln, die die gleiche Zeichnung haben wie die Pflastersteine auf vielen Straßen in Barcelona.

Tablettes de chocolat gravées du même de dessin que les pavés de nombreuses rues barcelonaises.

Tabletas de chocolate grabadas con el mismo dibujo que el de las baldosas de muchas calles barcelonesas.

Tavolette di cioccolato incise con lo stesso disegno delle mattonelle di molte strade di Barcellona.

p. 270
Karintou

Almost wholly transparent packets for snacks, which allow the consumer to check the product inside.

Fast völlig durchsichtiger Snackbeutel, durch den man den Zustand des Produktes sehen kann.

Sachet pour snacks presque totalement transparent, ce qui permet de vérifier l'état de fraîcheur du produit.

Bolsa para snacks casi totalmente transparente, lo que permite comprobar el estado de conservación del producto.

Sacchetto per snack quasi completamente trasparente, cosa che consente di verificare lo stato di conservazione del prodotto.

p. 271
Accents

Dark chocolate marbles, slotted so that they fit onto the rim of champagne glasses.

Schwarze Schokoladenkugeln mit einem Einschnitt, mit dem man sie auf ein Sektglas aufstecken kann.

Truffes de chocolat noir avec une rainure qui permet des les insérer sur le bord d'une coupe de champagne.

Bolas de chocolate negro con un corte que permite insertarlas en el borde de una copa de champán.

Palline di cioccolato nero con un taglio che consente di inserirle sul bordo di una coppa di champagne.

pp. 272- 273
Chocolate a la Taza

Packaging for hot drinking chocolate powder decorated exclusively in different shades of chocolate brown.

Verpackung für Kakaopulver, die nur mit einer Reihe von Brauntönen spielt.

Emballages pour chocolat en poudre déclinant uniquement la gamme des couleurs brunes.

Envases para chocolate en polvo que juegan únicamente con la gama de los marrones.

Recipienti per cioccolato in polvere che giocano unicamente con la gamma dei marroni.

307

p. 274

Morinaga Pudding Koubou

Containers for traditional Japanese puddings.

Gefäße für Pudding traditioneller, japanischer Geschmacksrichtungen.

Récipients pour puddings aux saveurs japonaises traditionnelles.

Recipientes para puddings de sabores tradicionales japoneses.

Recipienti per pudding dai tradizionali sapori giapponesi.

p. 275

Kodomono Puti-Zeri

Baby-food jars (from 16 months) favoring bold, colorful designs.

Verpackungen für Babynahrung (ab 16 Monaten). Die Gestaltung ist auffallend und sehr farbig.

Emballages pour repas de bébé (de 16 mois et plus). Le design de couleurs vives, attire le regard.

Envases para comida de bebé (de 16 meses en adelante). El diseño es llamativo y de vibrantes colores.

Recipienti per cibi per bebè (dai 16 mesi in poi). Dal design sgargiante e dai colori vibranti.

pp. 276-277

Soleil

Gift pack inspired on traditional models for bean paste and tea. This design strives to blend the image of the food within and the material used for the package.

Traditionelle Geschenkverpackung, die Bohnenpastete und Tee enthält. Das Design bringt das Bild des Lebensmittels mit dem Verpackungsmaterial in Einklang.

Coffret cadeau d'inspiration traditionnelle contenant des pâtes de haricot et du thé. Le designer essaie d'harmoniser l'image de l'aliment et le matériau d'emballage.

Pack de regalo de inspiración tradicional que contiene pasta de judías y té. El diseño ha pretendido armonizar la imagen del alimento con la del material del envase.

Pack regalo d'ispirazione tradizionale che contiene pasta di fagioli e tè. Il design ha voluto rendere armonica l'immagine dell'alimento con quella del materiale del recipiente.

p. 278

Round Box for Confectionery Gift

Harmonised colors and shapes make these round gift boxes appealing to consumers of all kinds.

Die gelungene Harmonie der Farben und Formen dieser runden Schachteln gefällt jedem Typ von Verbraucher.

L'harmonie très réussie des couleurs et des formes de ces boites arrondies, plaira à tous les consommateurs.

La conseguida armonía de colores y formas de estas cajas redondas satisfarán a consumidores de todo tipo.

L'armonia dei colori e delle forme di queste scatole arrotondate piaceranno a tutti i tipi di consumatori.

p. 279

Potato Confectionery Bag

Appetizers need to be packed in bags which carry the product image on the front.

Snackbeutel für Snacks, auf dem das wichtigste Element das Bild des Produktes auf der Vorderseite ist.

Sachets de snacks apéritifs où l'image du produit est mise en valeur sur le devant de l'emballage.

Bolsas de snacks para aperitivo en la que se da total preeminencia a la imagen del producto en la parte frontal del envase.

Sacchetti per snack per aperitivo in cui predomina totalmente l'immagine del prodotto sulla parte frontale della confezione.

p. 280
Ice Cream of Natural Taste

Strict minimalism for these 100 % natural ice cream tubs.

Ein radikales minimalistisches Design für die Verpackung dieses zu 100 % natürlichen Speiseeises.

Design radicalement minimaliste pour ces bacs à glaçons 100 % naturels.

Diseño radicalmente minimalista para estos cubiletes de helado 100 % naturales.

Design radicalmente minimalista per questi bicchierini di gelato 100 % naturali.

p. 281
Assortment of Tempura for Souvenir

Paper bags containing an assortment of tempura to be taken home as a souvenir.

Papierbeutel für dieses Tempura-Sortiment, das als Reisemitbringsel gedacht ist.

Sachet de papier pour cet assortiment de tempura destiné à se transformer en souvenir touristique.

Bolsita de papel para este surtido de tempura destinado a convertirse en souvenir turístico.

Sacchetto di carta per questa varietà di tempura destinato a diventare un souvenir turistico.

p. 282
Gift Package for Cheese Cake

These containers allow cheesecakes to be gift-wrapped. The yellow ribbon contrasts with the white carton and matches the product inside.

Verpackung für Käseküchlein. Die gelbe Schleife hebt sich von der weißen Schachtel ab und schafft eine Verbindung zu der Farbe des Produktes im Inneren.

Emballage pour des biscuits au fromage. Le ruban jaune se détache sur le blanc de la boite et se conjugue à la couleur du produit à l'intérieur.

Envase para pastelitos de queso. El lazo amarillo destaca sobre el blanco de la caja y liga con el color del producto en su interior.

Recipienti per dolci al formaggio. Il laccio giallo spicca sul bianco della scatola e lega con il colore del prodotto interno.

p. 283
Coockie Gift Neige

Box for cookies. This store is located in a paper-producing quarter, which explains the wrappers on the cookies.

Schachtel für Plätzchen. Der Laden befindet sich in einem Viertel, in dem Papier hergestellt wird, das inspirierte zur Verpackung der Plätzchen.

Boite pour coffret cadeau. La boutique se trouve dans un quartier où l'on fabrique du papier et les enveloppes des biscuits.

Caja para galletas. La tienda está localizada en un barrio en el que se produce papel, y de ahí los envoltorios de las galletas.

Scatola per biscotti. Il negozio si trova in un quartiere in cui si produce la carta, qui presente per avvolgere i biscotti.

p. 284
Ice Creams for Families

Dessert ice-cream products. Packaging is fully transparent so that the beauty of the ice-cream's delicate shades can be appreciated.

Eis als Nachtisch. Die Verpackung ist vollkommen transparent, so dass man die elegante Farbe des Produktes im Inneren sehen kann.

Glaces pour desserts. Le packaging est totalement transparent, ce qui permet de voir l'élégante couleur du produit à l'intérieur.

Helados para postres. El packaging es totalmente transparente, lo que permite ver el elegante color del producto en su interior.

Gelati per dessert. Il packaging è completamente trasparente, cosa che consente vedere l'elegante colore del prodotto interno.

p. 285
Shimannto Sodachi

This product is packaged to make a visual impact from the huge extensions of shelves in large surface stores.

Das Verpackungsdesign dieses Produktes ist visuell sehr auffallend und hebt sich in den riesigen Regalen der großen Supermärkte ab.

Le design du packaging de ce produit vise à créer un fort impact visuel sur les immenses étagères des grandes surfaces commerciales.

El diseño del packaging de este producto pretende crear un gran impacto visual en los inmensos estantes de las grandes superficies comerciales.

Il design del packaging di questo prodotto vuole creare un grande impatto visivo sulle immense scaffalature delle grandi superfici commerciali.

p. 286

Old-fashioned look for these Juchheim desserts. The cover contrasts sharply with the bright colors of the product inside.

Vom Retrostil inspirierte Verpackung für diese Nachspeisen der Marke Juchheim. Der Deckel der Verpackung bildet einen Kontrast zu den Farben im Inneren.

Emballage d'inspiration rétro pour ces desserts de la marque Juchheim. Le couvercle de l'emballage contraste avec le coloris intérieur.

Envase de inspiración retro para estos postres de la marca Juchheim. La tapa del envase contrasta con el colorido de su interior.

Recipiente d'ispirazione retro per questi dolci della casa Juchheim. Il coperchio del recipiente contrasta con il colore interno.

p. 287

A newly re-designed package after a leading supermarket chain rejected this product's previous out of date packaging design.

Ein neues Design, nachdem eine große Supermarktkette die vorherige Verpackung des Produktes als veraltet abgelehnt hatte.

Redesign effectué pour une chaîne de supermarchés qui a refusé le packaging antérieur du produit pour être démodé.

Rediseño efectuado para una cadena de supermercados que rechazó el anterior packaging del producto por anticuado.

Nuovo design realizzato dopo che una catena di supermercati non ha accettato il packaging precedente considerandolo antiquato.

pp. 288-289

Plastic containers on which colors are the main indication of their content.

Kunststoffverpackungen, bei denen hauptsächlich die Farbe über das Produkt im Inneren informiert.

Emballages de plastique où les couleurs sont le principal élément qui renseigne sur le produit à l'intérieur.

Envases de plástico en los que el color es el principal elemento que proporciona información sobre el producto de su interior.

Recipienti di plastica in cui il colore è il principale elemento che fornisce informazioni sul prodotto interno.

p. 290

Yogurt pots in different flavors. The covers give the product a traditional look.

Joghurtbecher für verschiedene Geschmacksrichtungen. Der Deckel der Verpackung verleiht dem Produkt einen traditionellen Touch.

Pots de yaourt aux différents parfums. Le couvercle de l'emballage confère au produit une certaine allure qui fleure bon la tradition.

Tarrinas de yogur de diferentes sabores. La tapa del envase da un cierto aire tradicional al producto.

Tarrine di yogurt di vari sapori. Il coperchio conferisce al prodotto una certa aria tradizionale.

p. 291

These containers are successful in giving an impression of freshness and coolness of the product inside despite using vivid, warm colors.

Diese Verpackungen vermitteln perfekt die Idee von Frische und Kälte des Produktes im Inneren, obwohl warme Farben eingesetzt wurden.

Ces emballages transmettent à merveille l'idée de fraîcheur et de froideur du produit à l'intérieur, malgré l'emploi de couleurs chaudes.

Estos envases transmiten perfectamente la idea de frescor y frialdad del producto de su interior, a pesar de utilizar colores cálidos.

Queste confezioni trasmettono perfettamente l'idea di freschezza e freddezza del prodotto interno, nonostante l'uso dei colori caldi.

p. 292
Dessert Selection

Tubs for different varieties of desserts united by a visual motto.

Kleine Behälter für verschiedene Arten von Nachtisch, die jedoch eine gewisse visuelle Einheit wahren.

Petits pots pour un assortiment de desserts, conservant, toutefois, une certaine unité visuelle.

Tarrinas para diferentes tipos de postre que, sin embargo, conservan una cierta unidad visual.

Tarrine per vari tipi di dolci che, però, conservano una certa unità visiva.

p. 293
Crefer

Cartons for snack sticks. The color of the featured fruit predominates over the entire packet.

Kartons für stäbchenförmige Snacks. Die Farbe der Frucht beherrscht vollständig die Verpackung des Produktes.

Boites de carton pour snacks en forme de bâtonnets. La couleur des fruits prédomine totalement sur le packaging du produit.

Cajas de cartón para snacks en forma de bastoncillo. El color de la fruta predomina por completo en el packaging del producto.

Scatole in cartone per snack a forma di bastoncini. Il colore della frutta predomina completamente sul packaging del prodotto.

p. 294
Hot and Steamed Cake Mix

These dessert cake mix cartons feature the Sun as a friendly character to draw the attention of the youngest members of the family.

Die Gestaltung dieser Schachteln für Dessert-Fertigmischungen spielt mit einer Figur (die Sonne), die die Aufmerksamkeit der Kinder auf sich zieht.

Le design de ces boites d'ingrédients pour desserts joue avec un personnage (le soleil) pour attirer l'attention des plus petits.

El diseño de estas cajas de ingredientes para postres juega con un personaje (el sol) que llamará la atención de los más pequeños.

Il design di queste scatole d'ingredienti per dolci gioca con un personaggio (il sole) che colpisce l'attenzione dei più piccoli.

p. 295
Koiwai Ice Cream

Ice cream tubs. The only indication of the flavor inside is a minute label on the side of each container.

Eisbecher. Nur das winzige, farbige Etikett auf der Seite sagt etwas über den Geschmack des Produktes aus.

Petits pots de glace. Seule l'étiquette minuscule de couleur sur le côté donne une idée du goût du produit.

Tarrinas de helado. Sólo la minúscula etiqueta de color en su lateral da una idea del sabor del producto.

Tarrine di gelato. Solo la minuscola etichetta colorata, sul lato, da un'idea del sapore del prodotto.

pp. 296-297
Yoggi Yalla

Yoggi's drinkable yogurt cartons feature this well-known design of concentric color circles.

Die berühmten Verpackungen des Trinkjoghurts der Marke Yoggi mit ihren typischen konzentrischen Farbkreisen.

Les fameux emballages de yaourt liquide de la marque Yoggi, avec leurs typiques cercles concentriques de couleurs.

Los ya famosos envases de yogur líquido de la marca Yoggi, con sus característicos círculos concéntricos de colores.

Le già note confezioni di yogurt liquido della casa Yoggi, con i loro caratteristici anelli concentrici colorati.

311

312 *Title, year* | A AGENCY | C CLIENT | P PHOTOGRAPHER | I ILLUSTRATOR

Advertising Can food advertising be re-invented without betraying the ultimate goal: selling a product that above all has to be appealing? The answer is, quite obviously, that it can. Playing with sense of humour, direct impact, paradox, visual effects, the use of kitsch or through applying new typography techniques, graphic resources, materials and colors, some of the most innovative international designers have discovered the recipe for giving advertising in gastronomical circles a new flavor.

Werbung Ist es möglich, die Werbung für Lebensmittelprodukte moderner zu gestalten, ohne dabei das letztendliche Ziel aus den Augen zu verlieren, nämlich ein Produkt zu verkaufen, das vor allem appetitlich sein soll? Offensichtlich ist das möglich. Der Sinn für Humor, die Wirkung auf den ersten Blick, die Widersprüche und die visuellen Spiele, berauschender Kitsch oder die einfache Anwendung neuer Typografien, neuer grafischer Mittel und von Farben und Formen waren die Werkzeuge einiger der innovativsten, internationalen Designer, um der Werbung im Bereich Gastronomie ein neues Aroma zu geben.

Publicité Est-il possible de rénover la publicité de produits alimentaires sans trahir son objectif ultime (celui de vendre un produit qui doit être surtout appétissant)? Apparemment, oui. Le sens de l'humour, l'impact direct, les contrastes et les jeux visuels, le délire kitsch ou la simple application de nouvelles typographies, nouveaux recours graphiques, matières et couleurs ont permis à certains designers internationaux les plus innovateurs de donner une nouvelle saveur à la publicité gastronomique.

313

Publicidad ¿Es posible renovar la publicidad de productos alimenticios sin traicionar su objetivo último (el de vender un producto que ha de resultar, por encima de todo, apetitoso)? Obviamente, sí. El sentido del humor, el impacto directo, las paradojas y los juegos visuales, el delirio kitsch o la simple aplicación de nuevas tipografías, recursos gráficos, materiales y colores han servido a algunos de los más innovadores diseñadores internacionales para darle un nuevo aroma a la publicidad gastronómica.

Pubblicità E' possibile rinnovare la pubblicità dei prodotti alimentari senza tradire il loro obiettivo finale (quello di vendere un prodotto che deve risultare, soprattutto, appetitoso)? Ovviamente, sì. Il senso dell'umore, l'impatto on-the-face, i paradossi ed i giochi visivi, il delirio kitsch o la semplice applicazione di nuove tipografie, risorse grafiche, materiali e colori sono stati utili ad alcuni dei designer internazionali più innovativi per dare un nuovo aroma alla pubblicità gastronomica.

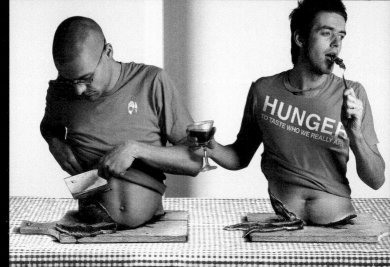

Hunger I & II, 2004 | **A** Paperkut | **C** Belio Magazine | **P** Luca Saini

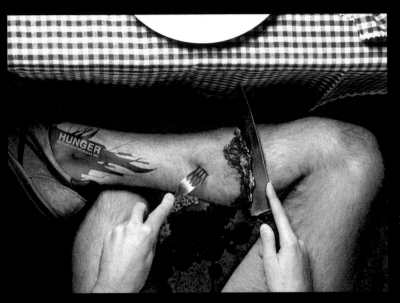

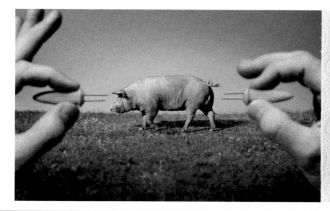

Small-batch Sauce with the Big Taste, 2004 | **A** Sullivan Higdon & Sink | **C** Big Rick's | **P** Allan Davey

316

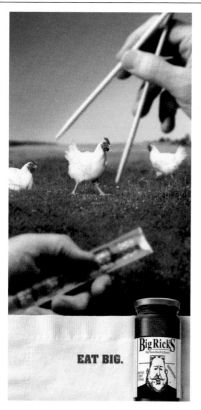

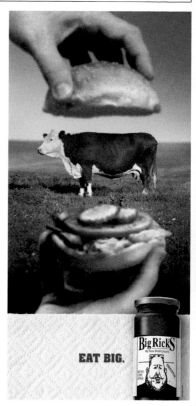

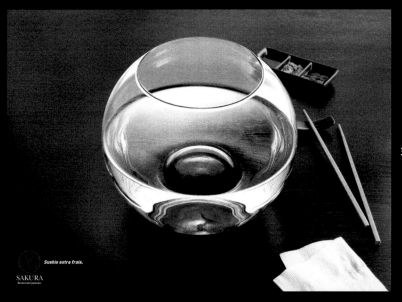

Sushis extra frais.

SAKURA
Restaurant japonais

Very Fresh Sushi, 2003 | **A** DDB BELGIUM | **C** SAKURA | **P** GREGOR COLLIENNE

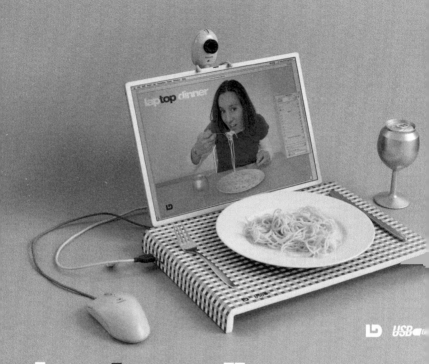

lap**top** dinner

the real workaholic tool

get online! www.laptopdinner.com

the pleasure of working late and
score at the office, without losing your
personal relations

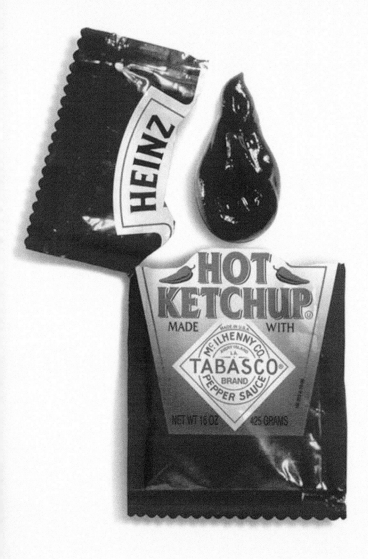

Zippo, 2002 | **A** Leo Burnett Argentina | **C** Heinz | **P** Carlos Mainardi

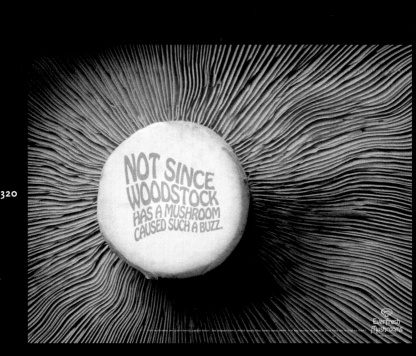

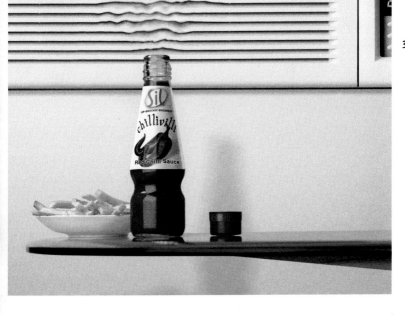

Heat Waves, 2003 | **A** AMBIENCE PUBLICIS | **C** MARICO INDUSTRIES | **P** ATUL PATIL

Keyboard, 2002 | **A** Scholz & Friends Hamburg | **C** Intersnack | **P** Frank Evers

Happy Hour, Fast Lunch, 2001 | **A** JWT | **C** Mexicali | **P** Riccardo Bagnoli | **I** Claudio Luparelli

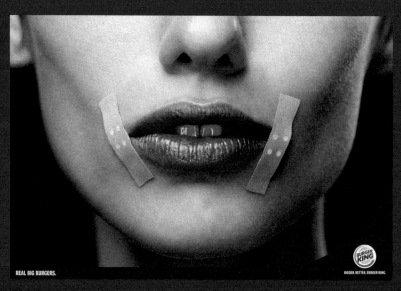

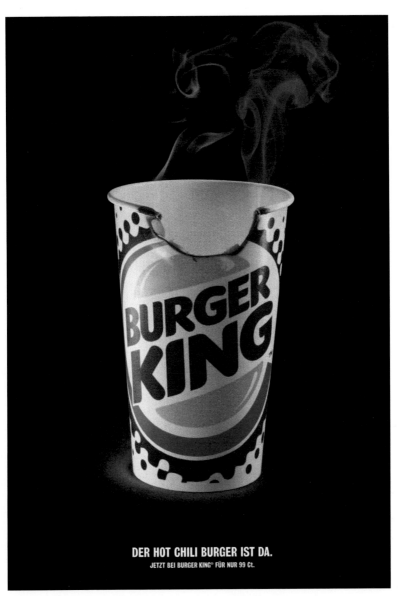

DER HOT CHILI BURGER IST DA.

JETZT BEI BURGER KING® FÜR NUR 99 Ct.

Ticklish, 2003 | **A** START | **C** BURGER KING | **P** UWE DÜTTMANN

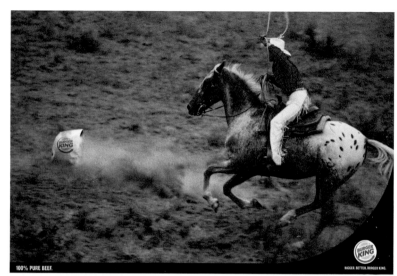

328

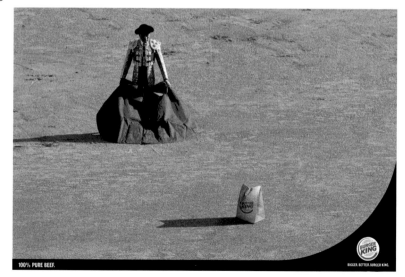

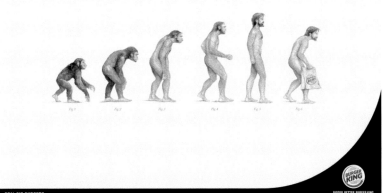

REAL BIG BURGERS.

BIGGER. BETTER. BURGER KING.

329

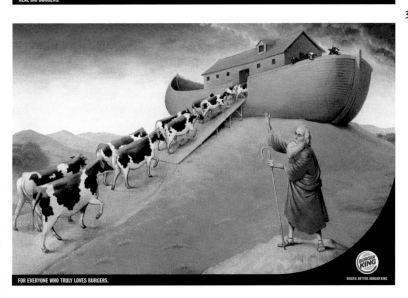

FOR EVERYONE WHO TRULY LOVES BURGERS.

BIGGER. BETTER. BURGER KING.

Noah's Ark, 2004 | **A** START | **C** BURGER KING | **I** MARTIN HARGREAVES

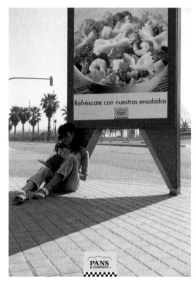

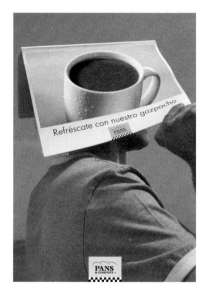

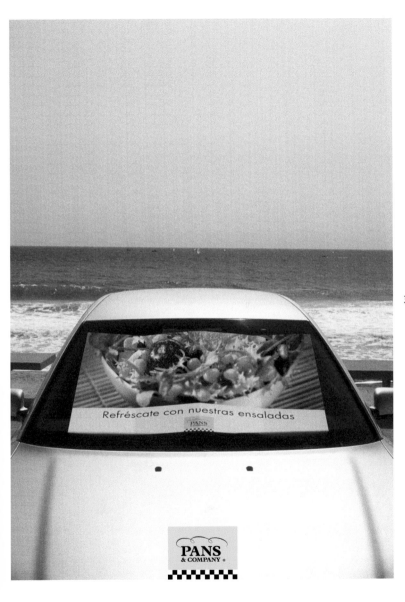

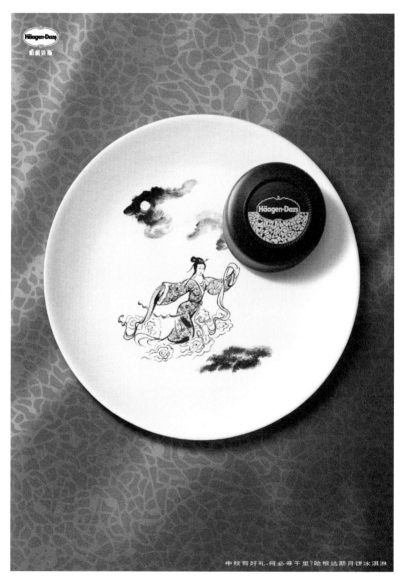

332

Chang Er, 2003

333

Wu Gang, 2003

Rabbit, 2003

A TBWA | **C** Häagen-Dazs | **P** Jun Li

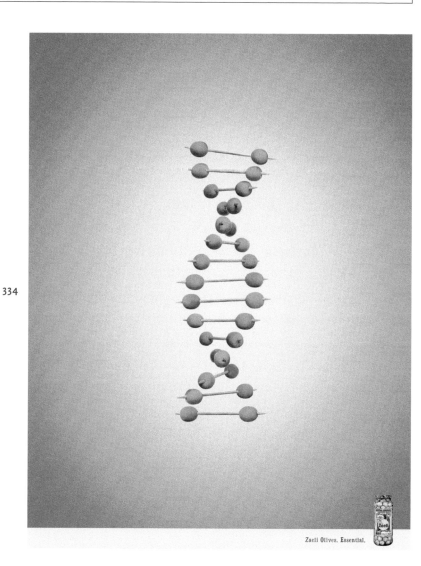

Olive DNA, 2004

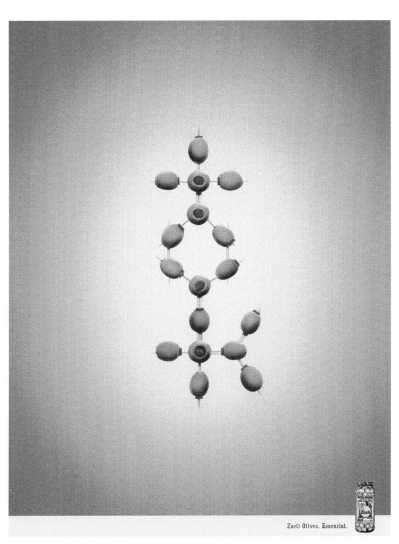

Zaell Olives. Essential.

Olive Formula, 2004

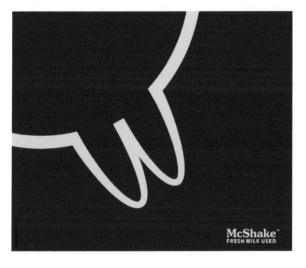

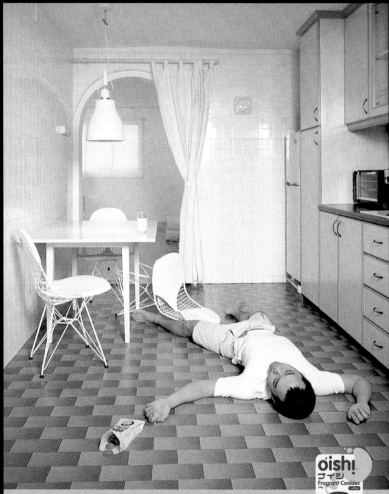

338

oishi
コイシ
Fragrant Cookies

Remember to exhale

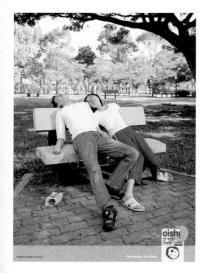

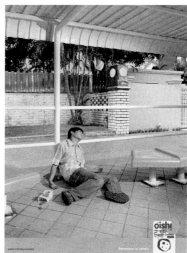

339

Park, 2003

Bus Stop, 2003

A KINETIC SINGAPORE | **C** OISHI FRAGRANT COOKIE | **P** JIMMY FOK

340

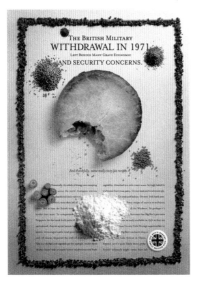

Withdrawal, 2004

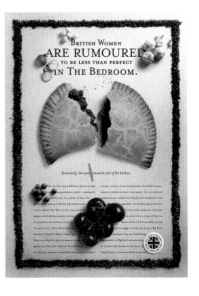

Women, 2004

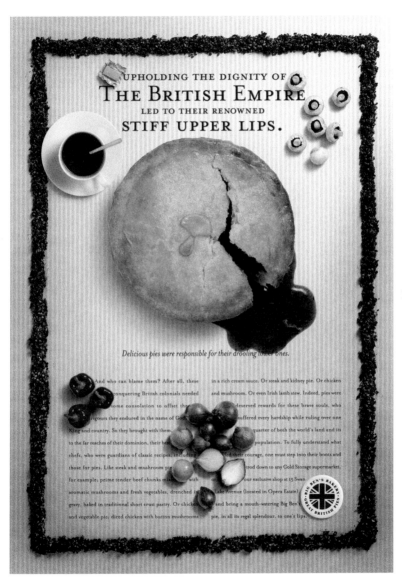

Lips, 2004

Estamos en el mundial

McFries, 2002 | **A** Manuel Méndez | **C** McDonald's | **P** Paúl Aragón

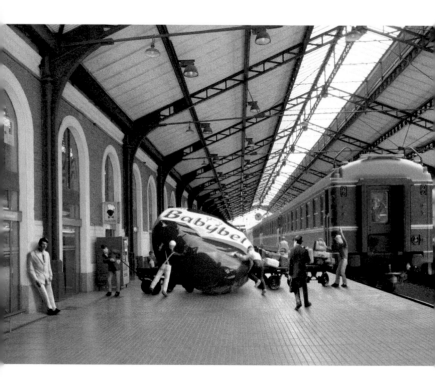

Station, 2004

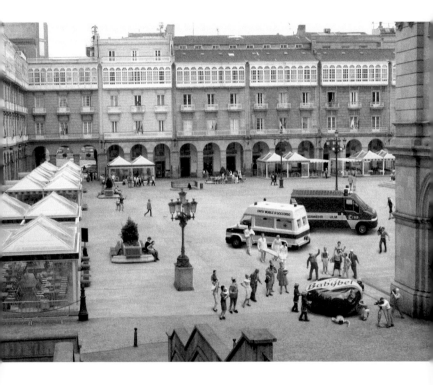

Square, 2004

Cheese on Cheese, 2002 | **A** JWT | **C** KRAFT | **P** RICCARDO BAGNOLI | **I** CLAUDIO LUPARELLI

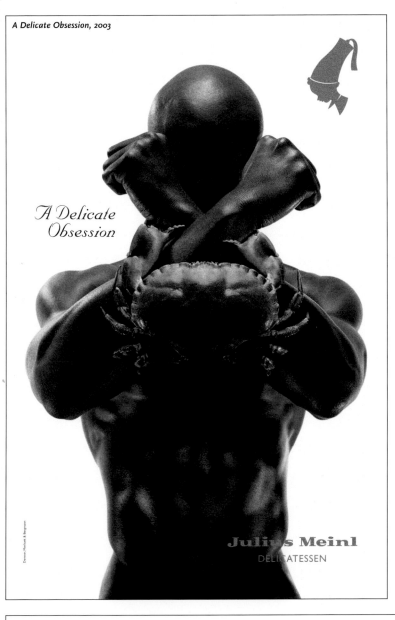

A Delicate Obsession, 2003

A Delicate Obsession

Julius Meinl
DELICATESSEN

A DEMNER, MERLICEK & BERGMANN | C JULIUS MEINL AM GRABEN | P JOACHIM HASLINGER

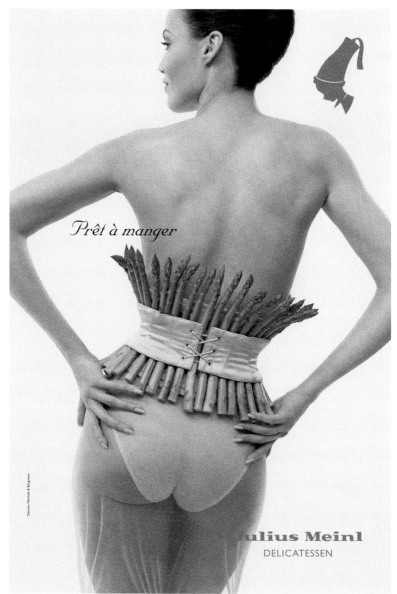

348

Prêt à Manger, 2003

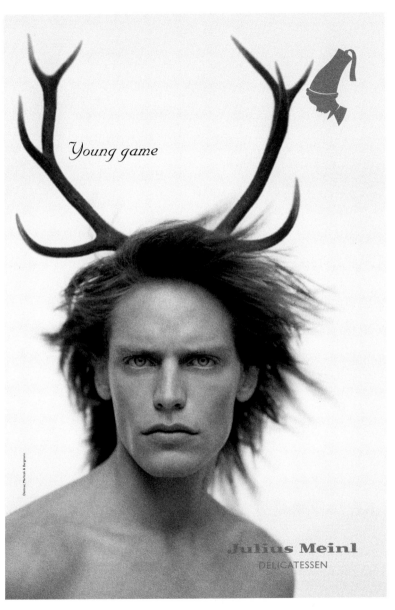

Young Game, 2003

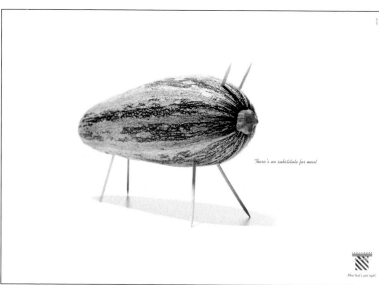

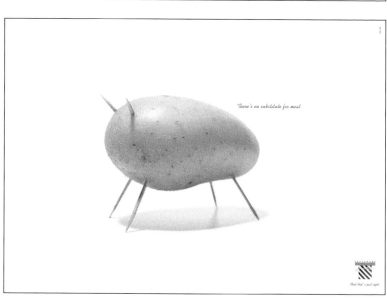

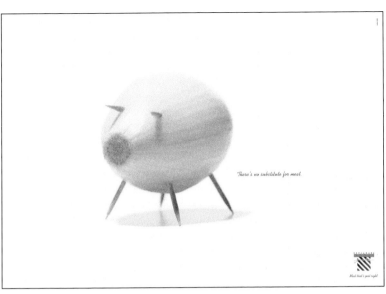

There's no substitute for meat.

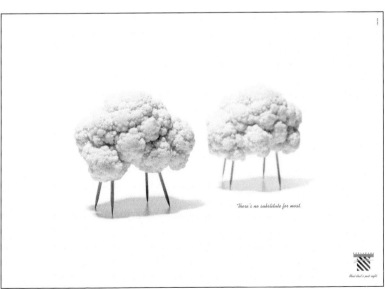

There's no substitute for meat.

Nothing Beats Meat, 2003 | **A** Lew Lara Propaganda | **C** Esplanada Grill | **P** Luis Moreti

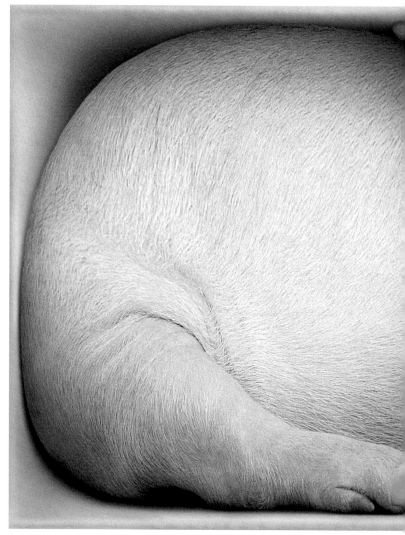

352

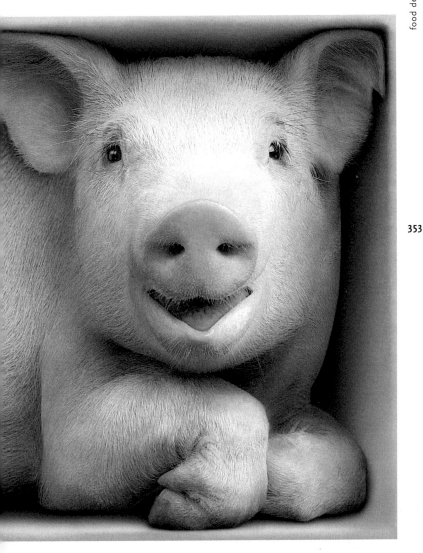

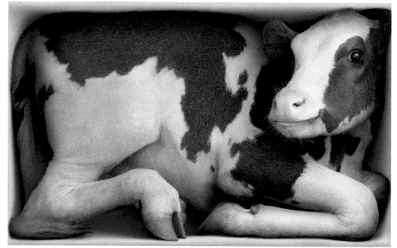

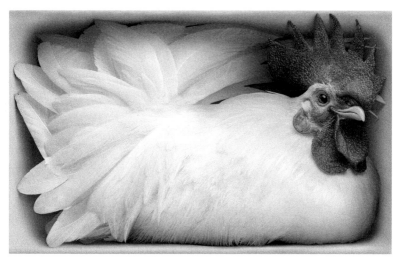

355

356

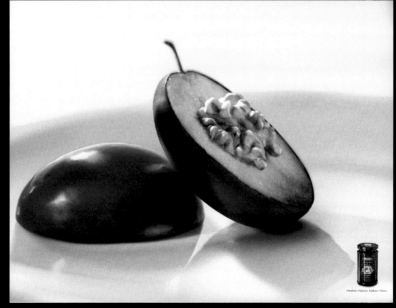

Mother: Nature. Father: Hero.

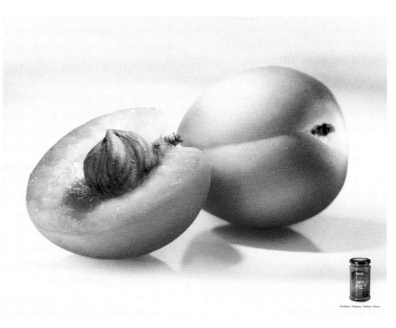

Mother: Nature. Father: Hero.

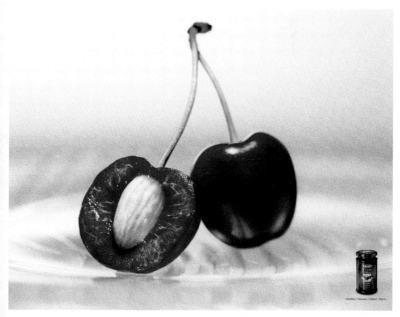

Mother: Nature. Father: Hero.

358

In 1974, we opened our first restaurant.

In 1979, we introduced cutlery.

Serving Sundanese cuisine from a time gone by. In a setting where time stands still.
JAKARTA ★ BOGOR ★ PUNCAK ★ SURABUMI ★ CIANJUR

Lembur Kuring.

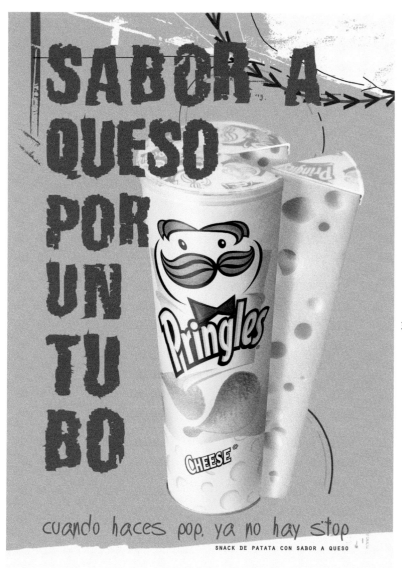

SABOR A
QUESO
POR
UN
TU
BO

359

cuando haces pop, ya no hay stop

SNACK DE PATATA CON SABOR A QUESO

Pringles Cheese, 2003 | **A** GREY & TRACE | **C** PROCTER & GAMBLE | **P** PEDRO LÓPEZ

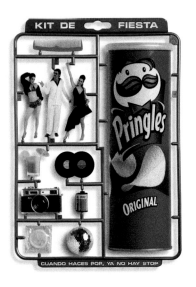

Party Kit, 2004

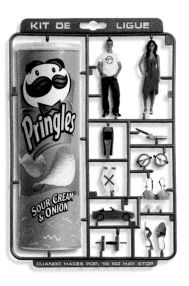

Seduction Kit, 2004

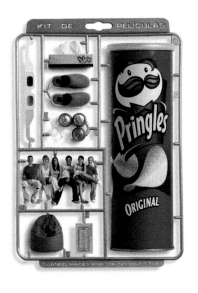

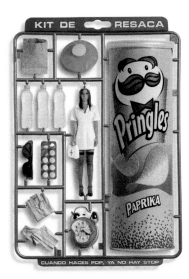

Film Kit, 2004

Hangover Kit, 2004

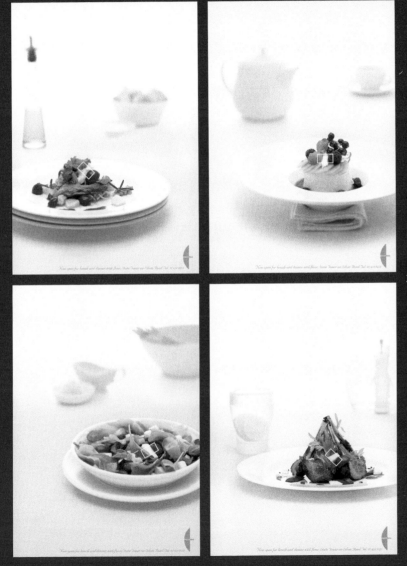

Sorprendentes. Únicos. UNEXPECTED BOCADILLOS

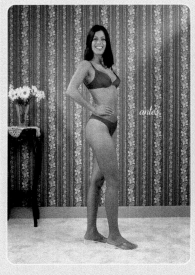

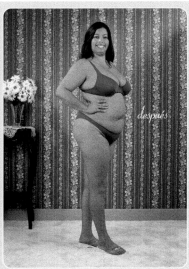

Calle Diez De Andino #104, Esq. Calle Loíza, Santurce, PR 787 977 0134

Da Luigi
ristorante italiano

Before and After, 2003 | **A** BADILLO NAZCA | **C** DA LUIGI RISTORANTE ITALIANO | **P** ESTUDIO DOMINÓ

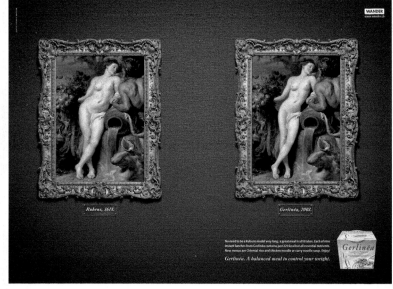

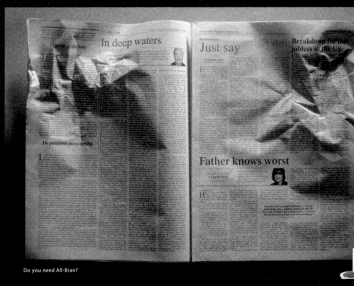

Do you need All-Bran?

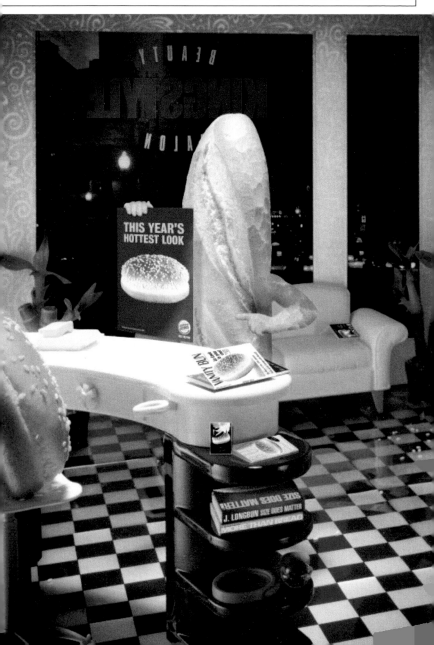

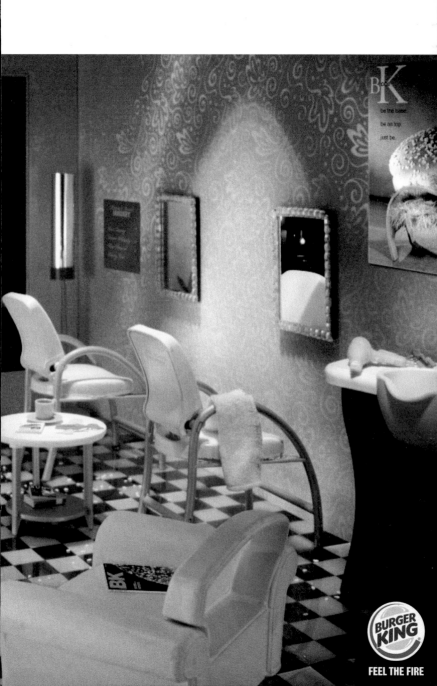

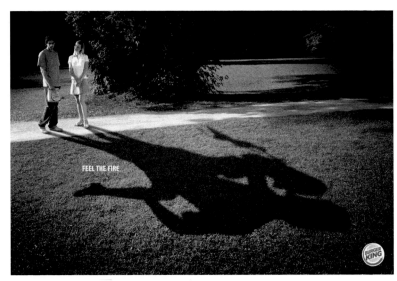

FEEL THE FIRE

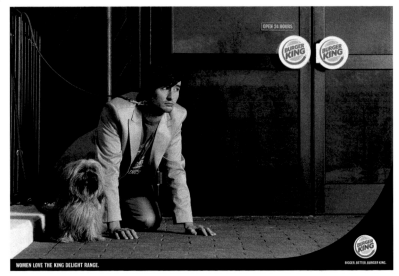

OPEN 24 HOURS

WOMEN LOVE THE KING DELIGHT RANGE.

BIGGER. BETTER. BURGER KING.

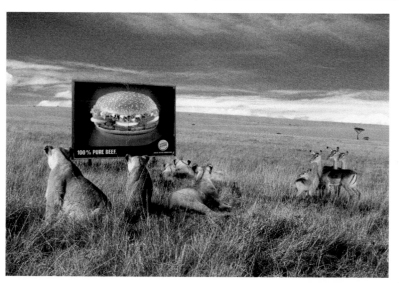

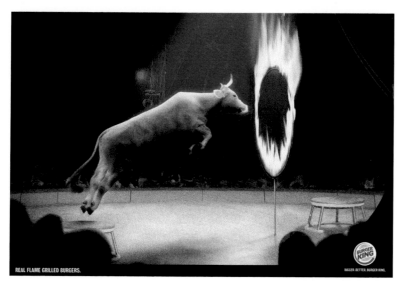

Cow, 2004 | **A** Start | **C** Burger King | **P** Fritz Heinze

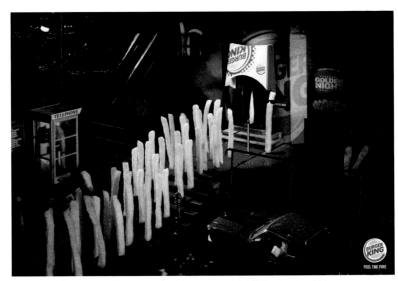

372

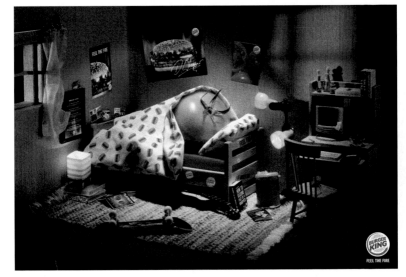

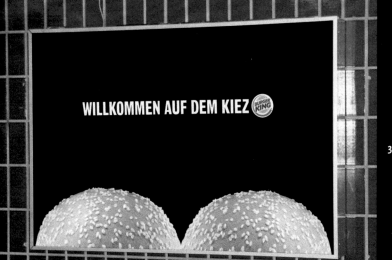

WELCOME TO THE KIEZ. The poster is directly situated at the underground station "Kiez", the red light district of Hamburg.

Welcome to the Kiez, 2003 | **A** START | **C** BURGER KING | **P** MARCEL KOOP

374

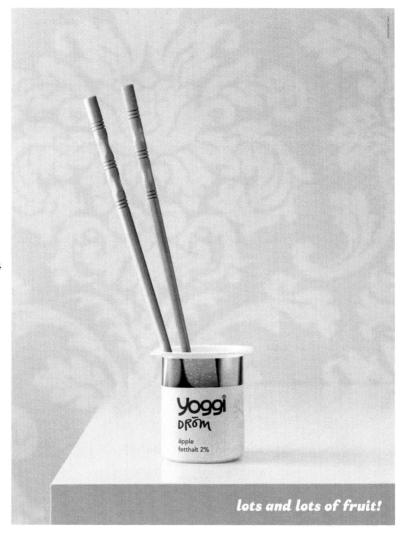

Dream Fork, 2004

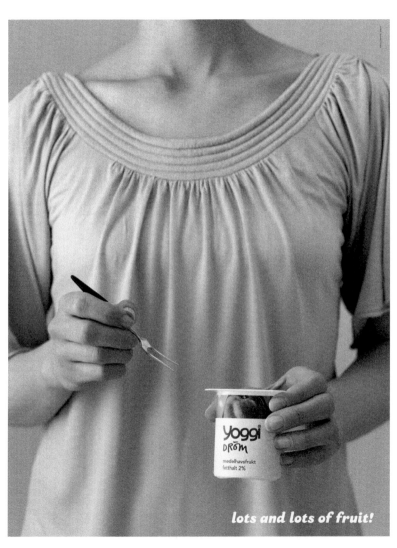

lots and lots of fruit!

Dream Vanilla, 2004

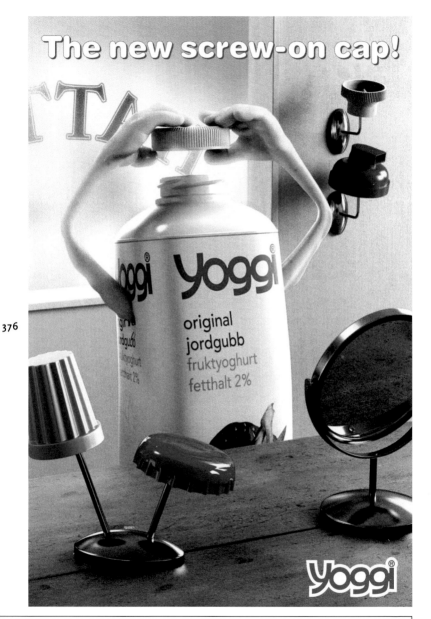

The new screw-on cap!

New Cap, 2004 | **A** Lowe Brindfors | **C** Arla Foods, Yoggi | **P** Tobias Dalén

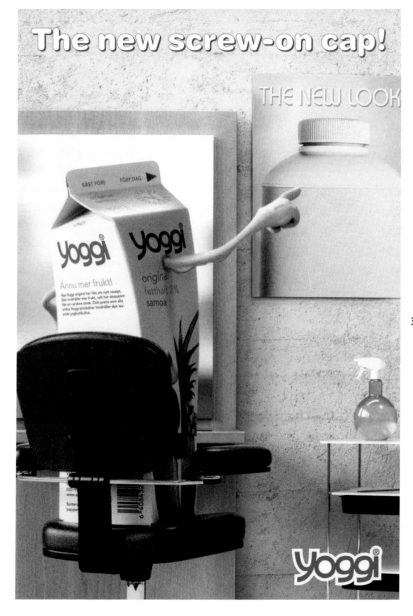

378

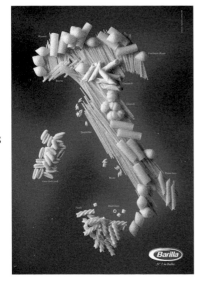

Boot, 2001

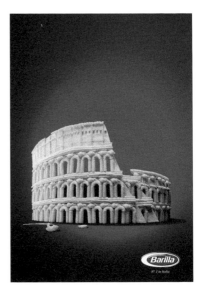

Colosseum, 2003

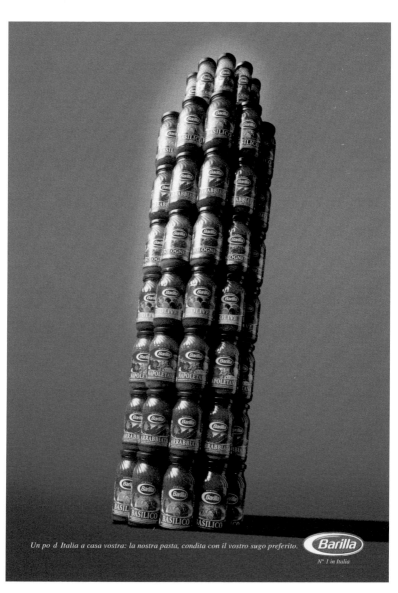

Un po d Italia a casa vostra: la nostra pasta, condita con il vostro sugo preferito.

Barilla

N° 1 in Italia

Leaning Tower of Pisa, 2003

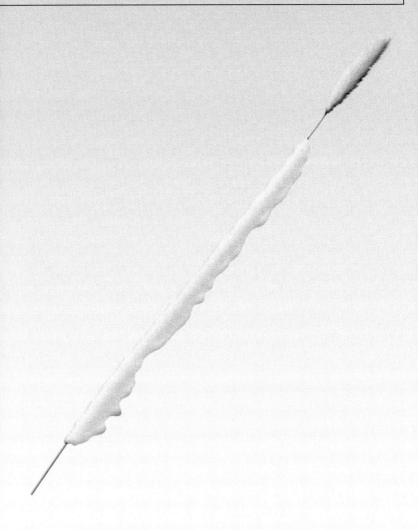

Yoggi
Wild strawberry

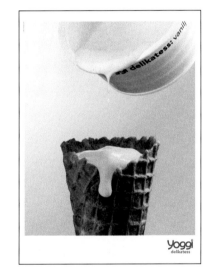

Delikatess Chokolate & Vanilla, 2004 | **A** LOWE BRINDFORS | **C** ARLA FOODS, YOGGI | **P** PHILIP KARLBERG

382

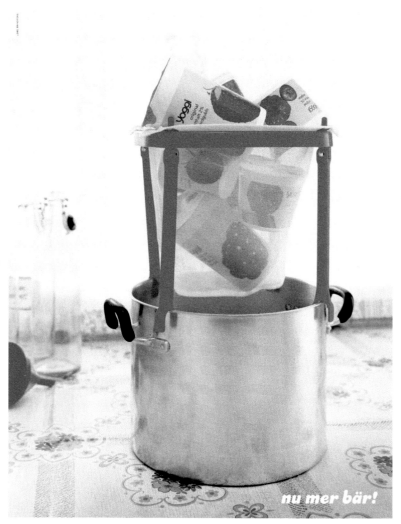

nu mer bär!

Fruit Syrup, 2003

Now More Berries!, 2002

Rubarb Peeler, 2002

384

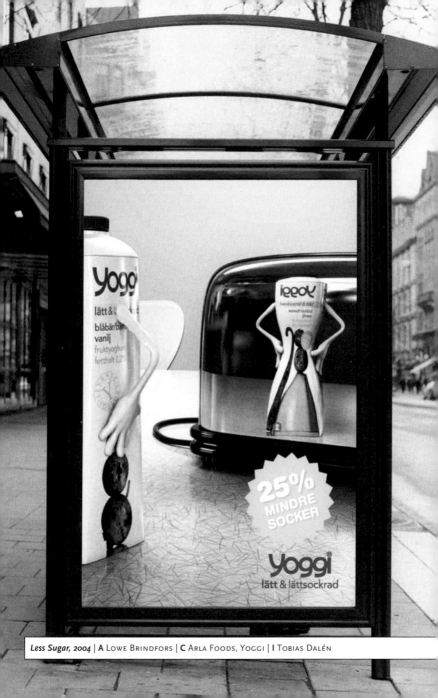

Less Sugar, 2004 | **A** Lowe Brindfors | **C** Arla Foods, Yoggi | **I** Tobias Dalén

pp. 314-315

Hunger I & II

Provocation as a means to create an impact on the spectator. Published in the Spanish magazine *Belio*.

Die Provokation als Mittel, um die Aufmerksamkeit des Betrachters auf sich zu ziehen. Veröffentlicht in der spanischen Zeitschrift *Belio*.

La provocation comme moyen d'attirer l'attention du spectateur. Publié dans la revue espagnole *Belio*.

La provocación como medio para llamar la atención del espectador. Publicado en la revista española *Belio*.

La provocazione come mezzo per attrarre l'attenzione dello spettatore. Pubblicato sulla rivista spagnola *Belio*.

p. 316

Small-batch Sauce with the Big Taste

Aim: to convey the idea that the product has hardly been handled before reaching the consumer.

Das Ziel? Es soll die Idee vermittelt werden, dass das Produkt, bis es zum Endverbraucher gelangt, kaum manipuliert wurde.

L'objectif? Convaincre que le produit parvient au consommateur sans trop de manipulations.

¿El objetivo? Transmitir la idea de que el producto no ha sufrido apenas manipulación hasta su llegada al consumidor final.

L'obiettivo? Trasmettere l'idea che il prodotto ha sofferto la minima manipolazione sino all'arrivo nelle mani dell'utente di destinazione.

p. 317

Very Fresh Sushi

This famous sushi advert for Sakura broadcasts the product's extreme freshness.

Diese berühmte Anzeige für Sushi von Sakura vermittelt den Eindruck von extremer Frische des Produktes.

Cette fameuse annonce sushi pour Sakura procure la sensation de fraîcheur extrême du produit.

Este famoso anuncio de sushi para Sakura contagia una sensación de frescura extrema del producto.

Questo famoso annuncio di sushi per Sakura contagia una sensazione di freschezza estrema del prodotto.

p. 318

Laptop Dinner

Irony and self-parody employed as alternative advertising resources.

Die Ironie und Selbstparodie als Alternative zu den üblichen Werbemitteln.

L'ironie et la caricature comme alternative aux recours publicitaires habituels.

La ironía y la autoparodia como alternativa a los recursos publicitarios al uso.

L'ironia e l'autoparodia come alternativa alle risorse pubblicitarie da usare.

p. 319

Zippo

The image on this poster for Heinz's Hot Ketchup plays on a pop icon: Zippo lighters.

Das Poster des scharfen Ketchups der Marke Heinz spielt mit dem Bild einer Ikone der Popkultur, den Feuerzeugen von Zippo.

Le poster du ketchup épicé de la marque Heinz joue avec l'image d'une icône de la culture pop : les briquets Zippo.

El póster del ketchup picante de la marca Heinz juega con la imagen de un icono de la cultura pop: los mecheros Zippo.

Il poster del ketchup piccante della casa Heinz gioca con l'immagine di un'icona della cultura pop: gli accendini Zippo.

p. 320
High on Freshness

A daring ad for mushrooms, flirting with the taboo on drugs and using the legendary Woodstock Music Festival as a setting.

Werbung für Champignons, die mit dem Tabu der Drogen spielt und das Produkt mit Woodstock in Verbindung bringt.

Annonce pour champignons qui ose jouer avec le tabou des drogues en établissant une relation entre le produit et le Festival de Woodstock.

Anuncio de champiñones que se atreve a jugar con el tabú de las drogas al relacionar el producto con el Festival de Woodstock.

Annuncio di funghi che osa giocare con il tabù delle droghe mettendo il prodotto in relazione con il Festival di Woodstock.

p. 322
Curry Ketchup

A single chip on the traditional fish & chips tray. The unexpected is used to attract consumers' attention.

Ein einsamer Kartoffelchip auf dem traditionellen *Fish and Chips*-Pappteller. Die Provokation als Mittel, um die Aufmerksamkeit des Betrachters auf sich zu ziehen.

Un chip solitaire sur le plat traditionnel de *fish and chips*. Le contraste comme moyen d'attirer l'attention du consommateur.

Una solitaria patata chip en la tradicional bandeja de *fish and chips*. El contraste como medio para llamar la atención del consumidor.

Una solitaria patatina per *fish and chips*. Il contrasto quale mezzo per cogliere l'attenzione del consumatore.

pp. 324-325
Happy Hour, Fast Lunch

Advertisements for a Mexican restaurant which stress the traditional fare served there, for which purpose the old wooden table is central.

Werbung für ein mexikanisches Restaurant, das ein traditionelles Bild seiner Küche vermitteln will, wozu der auf alt gemachte Tisch beiträgt.

Annonces pour un restaurant mexicain visant à donner une image traditionnelle de sa cuisine, grâce à la vieille table en bois.

Anuncios para un restaurante mexicano que pretende dar una imagen tradicional de su cocina, a lo que contribuye la envejecida mesa de madera.

Annunci per un ristorante messicano che vuole dare un'immagine tradizionale della sua cucina, alla quale contribuisce il tavolo di legno invecchiato.

387

p. 321
Heat Waves

The concept behind this advertisement for hot spicy sauce is the warped visual effect formed in the heat.

Das Konzept dieser Grafikkampagne für scharfe Sauce spielt mit dem visuellen Effekt, der die geraden Linien an extrem heißen Tagen verzerrt.

Le concept de cette annonce de sauce épicée joue avec l'effet visuel qui déforme les lignes droites les jours de canicule.

El concepto de este anuncio de salsa picante juega con el efecto visual que distorsiona las líneas rectas en los días extremadamente calurosos.

Il concetto di quest'annuncio di salsa piccante gioca con l'effetto visivo che distorce le linee rette nei giorni d'estremo calore.

p. 323
Keyboard

A very original way to make the consumer identify the name of the product and its qualities quickly.

Eine originelle Art und Weise, wie der Verbraucher rasch den Produktnamen und seine Eigenschaften miteinander in Verbindung bringt.

Une forme originale pour que le consommateur identifie rapidement le nom du produit et ses caractéristiques.

Una forma original para que el consumidor identifique rápidamente el nombre del producto y sus características.

Un modo originale per consentire al consumatore d'identificare rapidamente il nome del prodotto e le sue caratteristiche.

p. 326
Band-aid

An easy and direct way to put a message across: the biggest hamburgers in the world.

Eine einfache und direkte Art und Weise, die Botschaft zu vermitteln: die größten Hamburger der Welt.

Un moyen facile et direct de passer le message : les hamburgers les plus grands du monde.

Una manera fácil y directa de transmitir el mensaje: las hamburguesas más grandes del mundo.

Un modo facile e diretto di trasmettere il messaggio: le hamburger più grandi del mondo.

388

p. 327
Ticklish

Burger King's Hot Chili Burger is only a step away from neat sulphuric acid. Adverts with a strong punch directed mainly at a young audience.

Der scharfe Hot Chili Burger von Burger King steht der Schwefelsäure in nichts nach. Eine Werbung mit einschlagender Wirkung für ein Produkt, das hauptsächlich die Jugend anspricht.

La Hot Chili Burger de Burger King n'a rien à envier à l'acide sulfurique. Publicité à fort impacte pour un produit essentiellement destiné à la jeunesse.

La Hot Chili Burger de Burger King no tiene nada que envidiar al ácido sulfúrico. Publicidad de impacto para un producto mayoritariamente juvenil.

L'Hot Chili Burger di Burger King non ha nulla a che invidiare all'acido solforico. Pubblicità d'impatto per un prodotto rivolto ai giovani.

p. 328
Cowboy, Torero

Once again, the freshness of the ingredients is the main asset. To place all the weight on this feature, the advert is laced with a few drops of irony.

Noch einmal ist es die Frische der Zutaten, die hervorgehoben werden soll. Dazu wurde die Werbung mit Tropfen von Ironie gewürzt.

Une fois de plus, la fraîcheur des ingrédients est l'élément à mettre en valeur. A cet effet, l'annonce est pimentée d'une pointe d'ironie.

Una vez más, la frescura de los ingredientes es el valor que destacar. Para conseguirlo, se adereza el anuncio con unas gotas de ironía.

Ancora una volta, la freschezza degli ingredienti è il valore da mettere in evidenza. Per riuscirci, l'annuncio è condito con alcune gocce d'ironia.

p. 329
Evolution, Noah's Ark

Self-parody is one of the most effective barriers against criticism of the alleged ill effects of fast food.

Die Selbstparodie ist das beste Mittel gegen die Kritik an der mutmaßlich gesundheitsschädlichen Wirkung des Fastfoods.

La caricature est le meilleur remède aux critiques exaltant les effets supposés néfastes des repas pris sur le pouce.

La autoparodia es el mejor remedio contra las críticas a los supuestos efectos perjudiciales para la salud de la comida rápida.

L'autoparodia è il miglior rimedio per contrarrestare le critiche ai possibili effetti negativi dei cibi fast-food.

pp. 330-331
Get Fresh

Aim: to convey the notion of freshness during the worst of the hot season through the use of visual paradox.

Das Ziel? Es soll die Vorstellung von Frische in der heißesten Jahreszeit mittels visueller Widersprüche vermittelt werden.

L'objectif? Transmettre l'idée de fraîcheur à une époque spécialement chaude aux moyens de contrastes visuels.

¿El objetivo? Transmitir la idea de frescura en una época especialmente calurosa por medio de paradojas visuales.

L'obiettivo? Trasmettere l'idea di freschezza in un'epoca estremamente calda grazie a dei paradossi visivi.

pp. **332-333**

Chang Er, Wu Gang, Rabbit

Characters borrowed from Chinese mythology that prefer Häagen-Dazs ices to their traditional roles.

Traditionelle Figuren der chinesischen Mythologie, die das Eis von Häagen-Dazs ihrer üblichen Rolle vorziehen.

Personnages traditionnels de la mythologie chinoise préférant les glaces de la marque Häagen-Dazs à leur rôle habituel.

Personajes tradicionales de la mitología china que prefieren los helados de la marca Häagen-Dazs a su papel habitual.

Personaggi tradizionali della mitologia cinese che preferiscono i gelati della casa Häagen-Dazs a loro ruolo abituale.

pp. **334-335**

Olive DNA, Olive Formula

Paradoxical visual effects playing on the concept of chemical formulation and compounding for mere, unassuming olives.

Visuelle Widersprüche, die mit der Idee der Formel und der chemischen Zusammensetzung einfacher, gefüllter Oliven als Vorspeise spielen.

Contrastes visuels jouant avec l'idée de la formule et la composition chimique de quelques olives farcies pour l'apéritif.

Paradojas visuales que juegan con la idea de la fórmula y la composición química de unas simples olivas rellenas para aperitivo.

Paradossi visivi che giocano con l'idea della formula e la composizione chimica di alcune semplici olive ripiene da aperitivo.

pp. **336-337**

M

Or how to play with a brand's logo to make up figures that suggest the product to the consumer: a fish, a cow's udder, etc.

Oder wie man mit einem Markenlogo spielt, um Figuren zu formen, die eine Idee des Produktes vermitteln, der Fisch, ein Kuheuter ...

Ou comment jouer avec le logo de la marque pour créer des personnages qui transmettent l'idée du produit : un poisson, les mamelles d'une vache...

O cómo jugar con el logo de la marca para formar figuras que transmitan la idea del producto: un pez, las ubres de una vaca...

O come giocare con il logo del marchio per formare figure che trasmettano l'idea del prodotto: un pesce, le mammelle di una vacca...

pp. 338-339
Kitchen, Park, Bus Stop

The message: Oishi cookies are so tasty you will forget to breathe while you are eating one.

Die Botschaft: Die Kekse von Oishi sind so lecker, dass du das Atmen beim Essen vergisst.

Le message : les biscuits Oishi sont tellement bons qu'on en oublie de respirer en les mangeant.

El mensaje: las galletas Oishi son tan sabrosas que te olvidarás de respirar mientras las comes.

Il messaggio: i biscotti Oishi sono così saporiti che ti dimenticherai di respirare mentre li mangi.

pp. 340-341
Withdrawal, Women, Lips

Or how to use sarcasm to bring a renewed image to traditional products.

Oder wie man mit dem Sarkasmus spielt, um das Bild eines traditionellen Produktes zu erneuern.

Ou comment jouer avec le sarcasme pour renouveler l'image d'un produit traditionnel.

O cómo jugar con el sarcasmo para renovar la imagen de un producto tradicional.

O come giocare con il sarcasmo per rinnovare l'immagine di un prodotto tradizionale.

p. 342
Double Quarter Pounder

The idea is simple yet effective: giant hamburgers (therefore very heavy) rip the bottom out of a paper bag.

Eine einfache, aber wirksame Idee: gigantische (und deshalb schwere) Hamburger, die dazu in der Lage sind, den Boden einer Papiertüte zu durchbrechen.

Une idée simple mais efficace : hamburgers géants (donc lourds) capables de briser le fond d'un sachet de papier.

Una idea sencilla pero efectiva: hamburguesas gigantes (y, por lo tanto, pesadas) capaces de romper el fondo de una bolsa de papel.

Un'idea semplice ma efficace: hamburger giganti (e, dunque, pesanti) capaci di sfondare un sacchetto di carta.

p. 343
McFries

McDonald's fried potato chips emulate the gloves used by goalkeepers.

Die Pommes frittes der Marke McDonald's imitieren in dieser Werbung die Form der Handschuhe des Torwarts.

Les frites de la marque McDonald's imitent dans cette pub la forme des gants des gardiens de but.

Las patatas de la marca McDonald's imitan en este anuncio la forma de los guantes de los guardametas.

Le patate fritte della casa McDonald's imitano in quest'annuncio la forma dei guanti da portiere.

pp. 344-345
Station, Square

A Babybel cheese may not be as tiny as it seems. All you have to do is give it the right scale.

Ein kleiner Käse von Babybel ist nicht so klein, wie er anfangs ausschaut. Man muss ihn nur in die richtige Skala einordnen.

Un petit fromage Babybel n'est pas aussi petit qu'il le paraît. Il faut simplement le replacer dans son contexte.

Un quesito Babybel no es tan pequeño como puede parecer en un principio. Sólo hay que situarlo en la escala correcta.

Un formaggino Babybel non è poi così piccolo come può sembrare a prima vista. Basta solo metterlo sulla giusta scala.

p. 346
Cheese on Cheese

Who needs a cracker when you can eat one cheese slice upon another slice of the same brand of cheese?

Wer braucht Cracker, wenn er eine Käsescheibe über einer anderen Scheibe Käse der gleichen Marke essen kann?

Qui a besoin d'un biscuit salé lorsque l'on peut manger une tranche de fromage par-dessus une autre tranche de la même marque?

¿Quién necesita una galleta salada cuando puede comer una loncha de queso sobre otra loncha de queso de la misma marca?

Chi ha bisogno di un cracker salato quando può mangiare una fetta di formaggio sopra un'altra fetta di formaggio della stessa casa?

p. 347
A Delicate Obsession

This is a perfect example of how, at times, it may be worth omitting information about the product to gain in visual impact.

Manchmal ist es notwendig, die Information über das Produkt zu opfern, um etwas an visueller Wirkung zu gewinnen. Dies ist ein perfektes Beispiel.

Il faut parfois sacrifier les renseignements sur le produit au profit de l'impact visuel. En voici l'exemple parfait.

A veces es conveniente sacrificar la información sobre el producto para ganar algo de impacto visual. Este es el ejemplo perfecto.

A volte vale la pena sacrificare le informazioni sul prodotto per guadagnare un qualcosa d'impatto visivo. Eccone un esempio perfetto.

pp. 348-349
Prêt à Manger, Young Game

Julius Meinl's advertisements border on art photography, far removed from traditional forms of food commercials.

Die Anzeigen von Julius Meinl sind fast in den Bereich der künstlerischen Fotografie einzuordnen. Sie entfernen sich von der traditionellen Werbung für Lebensmittel.

Les annonces de Julius Meinl frôlent la photographie artistique, s'éloignant des traditionnelles réclames de produits liés à la gastronomie.

Los anuncios de Julius Meinl rozan la fotografía artística, alejándose de la tradicional publicidad de productos relacionados con la gastronomía.

Gli annunci di Julius Meinl sfiorano la fotografia artistica, allontanandosi della tradizionale pubblicità dei prodotti del settore gastronomico.

pp. 350-351
Nothing Beats Meat

Understated advertisement to encourage consumers to eat meat. Obviously, it's not the same.

Einfache Zahnstocher dienen der Werbung für den Fleischverzehr. Es ist nicht das Gleiche, das ist wahr.

De simples cure-dents servent à encourager la consommation de viande. Cela n'est en effet pas la même chose.

Unos simples palillos sirven para promocionar el consumo de carne. No es lo mismo, efectivamente.

Dei semplici stecchini servono a promuovere il consumo di carne. Non è lo stesso, effettivamente.

pp. 352-353
Box

Tremendous visual effect. How to fit a whole suckling pig on a double-page spread in a magazine or on a rectangular billboard.

Visuell beeindruckend. Oder wie man ein ganzes Spanferkel auf eine Doppelseite in einer Zeitschrift oder ein rechteckiges Plakat bekommt.

Fort impact visuel. Ou l'art faire entrer un cochon de lait sur la page double d'une revue ou sur une affiche rectangulaire.

Visualmente impactante. O cómo encajar un lechón entero en la doble página de una revista o en un cartel rectangular.

Visivamente impattante. O come inserire un porcellino interno in una doppia pagina di una rivista o di un cartellone rettangolare.

pp. 354-355
Box

A calf or a cockerel can also be arranged without too much trouble on a rectangular package.

Ein Kalb oder Hahn können ebenfalls ohne große Anstrengungen in eine rechteckige Verpackung passen.

Un veau ou un coq peuvent aussi entrer dans un emballage rectangulaire sans trop d'efforts.

Una ternera o un gallo también pueden caber en un envase rectangular sin demasiado esfuerzo.

Della vitella o un gallo possono anche loro entrare in una confezione rettangolare senza troppi sforzi.

pp. 356-357
Hero Fruit & Nut

Visual paradox again: this time, fruit stuffed with nuts offer a clue to mix of ingredients and flavors in the product.

Noch mehr visuelle Widersprüche: Diesmal sind die Früchte mit Nüssen gefüllt und geben Aufschluss über die Geschmacksrichtungen und die Zutaten des Produktes.

D'autres contrastes visuels : cette fois, il s'agit de fruits remplis de fruits secs, donnant une idée du mélange de saveurs et d'ingrédients du produit.

Más paradojas visuales: esta vez, frutas rellenas de frutos secos que dan una idea de la mezcla de sabores e ingredientes del producto.

Altri paradossi visivi: questa volta, frutta ripiena di frutta secca che danno un'idea del mélange dei sapori e degli ingredienti del prodotto.

p. 358
1974

Another case of self-parody. On this occasion, it is used to highlight the genuine qualities of the cooking at this restaurant.

Noch einmal die Selbstparodie. In diesem Fall dient sie dem Hervorheben der Authentizität der Küche dieses Restaurants.

Encore la caricature. Dans ce cas pour exalter l'authenticité de la cuisine de ce restaurant.

De nuevo, la autoparodia. En este caso, para resaltar la autenticidad de la cocina de este restaurante.

Nuovamente, l'autoparodia. In questo caso, per sottolineare l'autenticità della cucina di questo ristorante.

p. 359
Pringles Cheese

A cheese portion on the well-known Pringles potato cylinder instantly identifies the flavor of the product within.

Ein Stück Käse, das aus der berühmten Chipspackung von Pringles gerissen wird, identifiziert schnell den Geschmack des Produktes.

Une portion de fromage arrachée du fameux tube des frites Pringles permet de reconnaître rapidement la saveur du produit.

Una porción de queso desgajada del famoso tubo de las patatas Pringles identifica rápidamente el sabor del producto.

Una porzione di formaggio uscita dal famoso tubo delle patate Pringles identifica rapidamente il sapore del prodotto.

pp. 360-361
Party Kit, Seduction Kit, Films Kit, Hangover Kit

A droll way to convey the notion that Pringles potatoes are just right on every occasion.

Eine lustige Art und Weise, die Idee zu vermitteln, dass die Chips von Pringles für jede Art von Anlässen geeignet sind.

Une façon amusante de transmettre l'idée que les frites Pringles sont bonnes pour toutes les occasions.

Una manera divertida de transmitir la idea de que las patatas Pringles son adecuadas para todo tipo de ocasiones.

Un modo divertente di trasmettere l'idea che le patate Pringles sono giuste per tutte le occasioni.

393

pp. 362-363
Mezzaluna

Mezzaluna is renowned for using exclusively Italian produce to manufacture its goods.

Mezzaluna ist dafür bekannt, dass nur Zutaten aus Italien verwendet werden.

Mezzaluna est connu pour n'utiliser que des produits en provenance d'Italie.

Mezzaluna es conocida por utilizar únicamente ingredientes procedentes de Italia.

Mezzaluna è nota per usare unicamente ingredienti provenienti dall'Italia.

394

p. 364
Fotomaton

Paradox and surrealism to assert the unique personality of the product.

Eine paradoxe und fast surrealistische Situation, um den einzigartigen Charakter des Produktes zu unterstreichen.

Une situation paradoxale et presque surréaliste pour affirmer la personnalité unique du produit.

Una situación paradójica y casi surrealista para afirmar la personalidad única del producto.

Una situazione paradossale e quasi surrealista per affermare la personalità unica del prodotto.

p. 365
Before and After

An excellent strategy for promoting a restaurant, bending a negative stereotype to advantage.

Eine interessante Form, um für ein Restaurant zu werben, indem ein Stereotyp verwendet wird, das traditionell als negativ eingestuft wird.

Une bonne façon de promouvoir un restaurant en utilisant favorablement un stéréotype considéré habituellement comme négatif.

Una buena manera de promocionar un restaurante utilizando a su favor un estereotipo considerado tradicionalmente como negativo.

Un buon modo di promuovere un ristorante usando a suo favore uno stereotipo considerato tradizionalmente negativo.

p. 366
Rubens

In this composition, Young & Rubicam play on a positive slant of the same stereotype present in the ad shown on the previous page.

Im Gegensatz zu der Anzeige auf der vorhergehenden Seite spielt Young & Rubicam wieder mit dem gleichen Stereotyp, aber dieses Mal im positiven Sinne.

Contrairement à l'annonce de la page antérieure, cette pub de Young & Rubicam joue avec le même stéréotype, mais dans le sens positif.

Al contrario que el anuncio de la página anterior, este de Young & Rubicam juega con el mismo estereotipo, pero en sentido positivo.

Contrariamente all'annuncio della precedente pagina, questo della Young & Rubicam gioca con lo stesso stereotipo, ma in senso positivo.

p. 367
Newspaper

A visual joke can be more effective than a traditional and boring advert that describes the product's qualities.

Ein Bilderwitz kann genauso wirksam oder noch wirksamer sein als eine traditionelle Anzeige, in der oft auf langweilige Art die Qualitäten des Produktes gezeigt werden.

Une blague visuelle peut être plus efficace que la pub traditionnelle où l'on décline de façon ennuyeuse les qualités du produit.

Un chiste visual puede ser más efectivo que el tradicional y aburrido anuncio que detalla las cualidades del producto.

Una barzelletta visiva può essere più efficace del tradizionale e noioso annuncio che detaglia le qualità del prodotto.

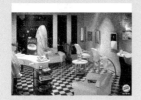

pp. 368-369
Baguette

Anthropomorphism of a baguette sandwich, complete with a trip to the hairdresser's, can be an option for promoting a new product.

Ein Baguette zu vermenschlichen und zum Friseur gehen zu lassen, kann ein gutes Mittel sein, um für ein neues Produkt zu werben.

Donner une apparence anthropomorphique à un sandwich et le porter chez le coiffeur, ou une façon judicieuse de promouvoir un nouveau produit!

Antropomorfizar un bocadillo y llevarlo a la peluquería puede ser un buen recurso a la hora de promocionar un nuevo producto.

Antropomorfizzare un panino e portarlo dal parrucchiere può essere una buona risorsa per promuovere un nuovo prodotto.

p. 370
Shadow, Dog

Two different ways to play on sexual stereotypes to convey the idea of a product with a strong personality.

Zwei Arten, um mit sexuellen Stereotypen zu spielen, die das Bild eines Produktes mit starker Persönlichkeit vermitteln.

Deux façons de jouer avec des stéréotypes sexuels pour transmettre l'image d'un produit de caractère.

Dos maneras de jugar con estereotipos sexuales para transmitir la imagen de un producto de fuerte personalidad.

Due modi di giocare con gli stereotipi sessuali per trasmettere l'immagine di un prodotto dalla forte personalità.

p. 371
Lions, Cow

Comical and original gags for much-repeated messages needing new means of expression.

Komische und originelle Situationen für offensichtliche Botschaften, die neue Ausdrucksmittel brauchten.

Situations comiques et originales pour des messages évidents qui nécessitent de nouveaux modes d'expression.

Situaciones cómicas y originales para unos mensajes obvios que necesitaban nuevas vías de expresión.

Situazioni comiche ed originali per dei messaggi ovvi che richiedono nuove vie d'espressioni.

p. 372
French Fries, Tomato

Another case of anthropomorphism to identify the product with its potential consumer.

Noch einmal wird ein Produkt vermenschlicht, um es mit dem möglichen Konsumenten zu identifizieren.

Une fois de plus, le produit prend une apparence humaine pour l'identifier au consommateur potentiel.

Una vez más, se antropomorfiza el producto para identificarlo con su consumidor potencial.

Ancora una volta, il prodotto viene antropomorfizzato per identificarlo con il suo consumatore potenziale.

p. 373
Welcome to the Kiez

An example of how to play on a geographical location: in this particular case, the underground station in the Hamburg red-light district.

Ein Beispiel für eine Anzeige, die mit dem Standort spielt, in diesem Fall die U-Bahn-Haltestelle des Rotlichtviertels in Hamburg.

Un exemple d'annonce qui joue avec la situation géographique : dans ce cas, la station souterraine du quartier rouge de Hambourg.

Un ejemplo de anuncio que juega con su localización geográfica: en este caso, la estación subterránea del barrio rojo de Hamburgo.

Un esempio d'annuncio che gioca con la sua ubicazione geografica: in questo caso, la stazione sotterranea del quartiere rosso d'Amburgo.

395

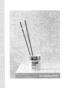

pp. 374-375
Dream Fork, Dream Vanilla

In this yogurt, there are so many fruit chunks, and they are so large, that you need a fork or chopsticks to eat it.

Ein Joghurt, in dem es so viele Frucht-stückchen gibt (und so große), dass man eine Gabel oder Stäbchen braucht, um ihn zu essen.

Un yaourt dans lequel les morceaux de fruits sont si nombreux (et si grands) que l'on a besoin de couverts ou de baguettes pour les manger.

Un yogur en el que los trozos de fruta son tantos (y de tan considerable tamaño) que hace falta tenedor o palillos para comerlos.

Uno yogurt con così tanti pezzettini di frutta (e di dimensione molto con-siderevole) che ci vogliono le posate o i bastoncini per mangiarli.

pp. 376-377
New Cap

Another product whose image has been re-vamped, and promotional package anthropomorphised and given a hair-do or taken shopping.

Noch einmal wird ein neues Bild von einem Produkt geschaffen, indem seine Verpackung vermenschlicht wird und zum Friseur oder einkaufen geht.

Une fois encore, on utilise l'image rénovée d'un produit, personnifiant son emballage et l'emmenant faire les courses chez le coiffeur.

De nuevo, se promociona la renovada imagen de un producto antropomor-fizando su envase y llevándolo a la peluquería o de compras.

Di nuovo, si promuove l'immagine rinnovata di un prodotto antropo-morfizzando la confezione e portan-dolo dal parrucchiere, od allo shop-ping.

pp. 378-379
Boot, Colosseum, Leaning Tower of Pisa

Identification of products with their place of origin through the use of visual paradox.

Das Produkt wird durch visuelle Widersprüche mit seiner geografi-schen Herkunft in Verbindung gebracht.

Identification d'un produit avec son origine géographique au moyen de paradoxes visuels.

Identificación de un producto con su procedencia geográfica mediante paradojas visuales.

Identificazione di un prodotto con la sua provenienza geografica mediante paradossi visivi.

p. 380
Wild Strawberry

Visual minimalism effectively transmits the relevant concept to the consumer: wild strawberries.

Ein visuell minimalistisches Bild, das dazu dient, dem Verbraucher das Konzept des Produktes zu vermitteln, wilde Erdbeere.

Une image minimaliste pour transmettre au consommateur le concept du produit : fraise des bois.

Una imagen visualmente minimalista sirve para transmitir al consumidor el concepto del producto: fresa salvaje.

Un'immagine visivamente minimalista serve a trasmettere al consumatore il concetto del prodotto: fragola selvaggia.

p. 381
Delikatess Chokolate & Vanilla

Taking a product out of its usual context is another instant method of attracting the consumer's attention.

Indem man ein Produkt seinem üblichen Kontext entreißt, lenkt man schnell die Aufmerksamkeit des Verbrauchers auf das Produkt.

Situer le produit hors de son contexte habituel pour attirer rapidement l'attention du consommateur.

Situar el producto fuera de su contexto habitual como método para llamar la atención del consumidor rápidamente.

Situare il prodotto fuori del suo contesto abituale come metodo per cogliere rapidamente l'attenzione del consumatore.

pp. 382-383
Fruit Syrup, Now More Berriesl, Rubarb Peeler

Why go to the trouble to make fruit syrup when Yoggi yogurts are just as natural as any other home-made fare? Putting this idea across was a real challenge.

Warum einen Fruchtsirup herstellen, wenn die Joghurts von Yoggi genauso natürlich sind wie jedes Lebensmittel, das zu Hause gekocht wird? Die Herausforderung besteht darin, visuell diese Idee zu vermitteln.

Pourquoi créer des sirops de fruit lorsque les yaourts Yoggi sont aussi naturels que n'importe quel aliment de cuisine fait à la maison? Le défi est de transmettre cette idée par l'image.

¿Para qué elaborar jarabe de frutas cuando los yogures Yoggi son igual de naturales que cualquier alimento cocinado en casa? El reto consistía en transmitir visualmente esa idea.

Perché elaborare uno sciroppo di frutta quando gli yogurt Yoggi sono altrettanto naturali come gli alimenti cucinati in casa? La sfida consisteva nel trasmettere visivamente quest'idea.

p. 384
Now More Fruit!

A clever way to signal the idea that Yoggi products are almost as natural as the fruit itself.

Eine interessante Art und Weise, die Botschaft zu vermitteln, dass die Produkte von Yoggi fast genauso natürlich sind wie ein Stück Obst.

Une façon judicieuse de passer le message : les produits Yoggi sont presque aussi naturels qu'un fruit.

Una buena manera de comunicar la idea de que los productos Yoggi son casi tan naturales como una pieza de fruta.

Un buon modo di comunicare l'idea che i prodotti Yoggi sono naturali quasi quanto un frutto fresco.

397

p. 385
Less Sugar

One of the earliest messages used in food advertising: Our products help you watch your "figur". Here, it is given an original twist.

Die älteste Botschaft aus der Lebensmittelwerbung: Unser Produkt hält schlank. Dieses Mal wird sie sehr originell vermittelt.

Le message le plus ancien de la publicité alimentaire : gardez la ligne grâce à nos produits. Cette fois, l'idée est transmise de manière originale.

El mensaje más viejo de la publicidad gastronómica: nuestro producto ayuda a mantener la línea. Esta vez, comunicado de manera original.

Il messaggio più vecchio della pubblicità gastronomica: il nostro prodotto aiuta a mantenere la linea. Questa volta, però, comunicato in modo originale.

Directory

398

399

Other Designpocket titles by teNeues

African Interior Design 3-8238-4563-2
Airline Design 3-8327-9055-1
Asian Interior Design 3-8238-4527-6
Bathroom Design 3-8238-4523-3
Beach Hotels 3-8238-4566-7
Berlin Apartments 3-8238-5596-4
Boat Design 3-8327-9054-3
Café & Restaurant Design 3-8327-9017-9
Car Design 3-8238-4561-6
Cool Hotels 3-8238-5556-5
Cool Hotels Africa/Middle East 3-8327-9051-9
Cool Hotels America 3-8238-4565-9
Cool Hotels Asia/Pacific 3-8238-4581-0
Cool Hotels Europe 3-8238-4582-9
Cosmopolitan Hotels 3-8238-4546-2
Country Hotels 3-8238-5574-3
Furniture Design 3-8238-5575-1
Garden Design 3-8238-4524-1
Italian Interior Design 3-8238-5495-X
Kitchen Design 3-8238-4522-5
London Apartments 3-8238-5558-1
Los Angeles Houses 3-8238-5594-8
Miami Houses 3-8238-4545-4
New Scandinavian Design 3-8327-9052-7
Office Design 3-8238-5578-6
Pool Design 3-8238-4531-4
Product Design 3-8238-5597-2
Rome Houses 3-8238-4564-0
San Francisco Houses 3-8238-4526-8
Ski Hotels 3-8238-4543-8
Spa & Wellness Hotels 3-8238-5595-6
Sport Design 3-8238-4562-4
Staircase Design 3-8238-5572-7
Sydney Houses 3-8238-4525-X
Tropical Houses 3-8238-4544-6

Each volume:
12.5 x 18.5 cm, 5 x 7 in.
400 pages
c. 400 color illustrations